William Hogarth

A Freemason's Harlot

By Jeremy Bell

Published by **Kendall Tavern Press**

William Hogarth—A Freemason's Harlot.

Copyright © 2017 by Jeremy Bell.
All rights reserved. Printed in the United Kingdom.
www.brotherhogarth.com

Design/typesetting by Nate Silva
www.nate-silva.com

Printed by Holywell Press Ltd., Oxford, England.
www.holywellpress.com

ISBN 978-0-9988342-1-4

First Edition, June 2017.
10 9 8 7 6 5 4 3 2

E-book version available at *www.brotherhogarth.com*

Dedication

───────────

… not dedicated to any one particular friend,
for fear of offending another;
therefore dedicated to nobody;

but if for once we may suppose
nobody to be everybody,
as everybody is often said to be nobody,
then *this work is dedicated to everybody*.

By their most humble and devoted,

William Hogarth, 1753.

— from Hogarth's 'non-dedication'
to his unpublished History of the Arts.

Foreword

by Professor Sean Shesgreen

For the past ten years, I have been reading,
with pleasure, profit and interest, the results
of Jeremy Bell's researches on English art
and more specifically on William Hogarth
and his milieu. Bell's work is both wide
in scope and inventive in themes.

From the time when John Trusler published The
Works of Mr Hogarth Moralized in 1768, down
to our own day, scholarship on Hogarth has been
lively, controversial, stimulating, and provocative; all
of these virtues appear in Jeremy Bell's new book.

I am of the view that he has unearthed a whole
new aspect of Hogarth previously missed.

Sean Shesgreen is the author of two best selling books on Hogarth:

— Engravings by Hogarth (Dover, 1973)
— Hogarth and the Times-Of-The-Day Tradition (Cornell, 1983)

Table of Contents

Preface: ..6

I: Elope *Sleeping Congregation, The Bad Taste of the Town, Gormogons*9

II: The Harlot *A Harlot's Progress* ...21

III: The Rake *A Rake's Progress* ...37

IV: Red Slippers *Wanstead Assembly, Chiswick Villa* ..51

V: Sodomy *Walpole, Kent, Pope, Gay, Handel, Castrati, Bramston* 63

VI: William KNT *Burlesque, Wanstead Assembly, Herms, Kensington, Lambert* 79

VII: Fart Catcher *The Man of Taste, Indian Emperor, Hervey and Friends, Sleeping Congregation*91

VIII: Chamber Pot *Night* ...103

IX: Empty Headed *Orator Henley, Denunciation, Rogers, Popple, Hudibras, Peregrination* 114

X: Hellfire *Night, Black Joke, Dashwood, Charity, Constitutions, Bathos* 127

Epilogue: *Invasion, March to Finchley, Gate of Calais* .. 138

Notes: *Walpole Portraits, Royalty, Midnight, Capt. Graham*146

Index of Books: ..218

Paintings: ...220

Preface

Two hundred and fifty years after these words were written, we are still amazed at the genius of Britain's most popular artist. Recently, three novels and a film have rekindled an interest in William Hogarth. Several new academic books on his work have been published in the last decade, and he even made the short list for Brian McQuade's book: *'Seven Painters Who Changed the Course of Art History.'*

Research has focused on single attributes of the artist's work, most recently *'Hogarth's Blacks'* (Dabydeen, 1985); *'Hogarth's China'* (Tharp, 1997); and *'Hogarth's Musical Imagery'* (Barlow, 2005). This publication will study William Hogarth's connection to Freemasonry.

Publication of *A Freemason's Harlot* was timed to coincide with the 300th anniversary of the United Grand Lodge of England, which was officially established in June of 1717, on the feast day of St. John the Baptist, the patron saint of stonemasons.

<p style="text-align:center">*
* *</p>

From the original four lodges that had come together in 1717, 60 lodges had joined the group by 1725. The 'Premier Grand Lodge,' as the umberella organisation was first called, had quickly succeeded in revamping the venerable fraternity. It soon attracted nobility, which raised its public profile further.

When Hogarth joined in 1725, membership was reported to be around a fifth of London's gentry.

Five years later 100 lodges had affiliated, and by 1740 that number was 200—this new form within Freemasonry was flourishing.

As part of its successful revival, this Premier Grand Lodge had developed a new level of initiation with the addition of a 'Third Degree.' The previous system of inducting and graduating apprentices had just two grades which dated back to medieval guild rituals.

It just so happened that Hogarth became a Freemason in the very year that this new ceremony had been introduced. He learned these age-old passwords and signs, along with the newly created ritual. Then, for reasons that will become clear in this book, he exposed all the signs by including them masterfully within his artwork. They were so cleverly hidden within the storyline that they have not been noticed since.

This passion for hiding Masonic symbols continued throughout Hogarth's lifetime. One appears in his final painting that the artist worked on from his deathbed.

This publication will uncover over one hundred of these hidden Masonic details, many of which are being seen for the first time, after nearly three centuries.

In researching this new genre of Hogarth's work, I discovered a more sinister development—evidence that Hogarth became heavily involved in a government sponsored attack on a completely different fraternal order. This rival organisation was attempting to take over the Premier Grand Lodge. It was being supported by a foreign nation, and was identified as a risk to national security.

Hogarth played a direct role in the ensuing confrontation, using his artwork to launch several attacks to hinder the advance of these competing forces.

Only by surviving this serious confrontation was Freemasonry in England able to flourish into the *United Grand Lodge of England* that many experience today.

It was Hogarth's initial cooperation with the Premier Grand Lodge that gave his career a welcomed boost, exposing him to a wealthy group of influential Masonic patrons. We should be grateful for this, as it resulted in many of his first commissions which now hang in galleries all around the world.

By studying this fascinating interaction, we learn more about the development of Hogarth's work while discovering much about the early history of Freemasonry.

*
* *

This publication would not have been possible without the continuing encouragement from Professor Sean Shesgreen. He passed my work onto Robin Simon, editor of the British Art Journal, who published my first papers.

I have my good friends to thank for bringing those papers into book form: Larry Young, for editing; Nate Silva for designing and typesetting; Michele Liguori and Donna Peronace for proof-reading.

Nate Silva also advised in set up of a website, *www.brotherhogarth.com*, where a digital copy of this book is available, along with other information connected to this project.

I am so grateful to them all for managing to pull this publication together in time for the tercentenary celebration of the United Grand Lodge of England, which first formed in June, 1717.

— June, 2017.

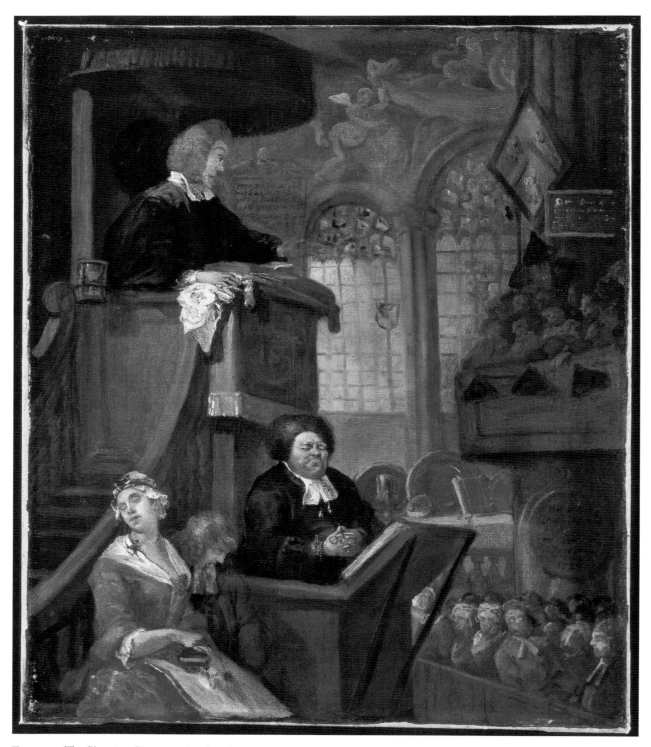

Figure 1.1: **The Sleeping Congregation** (1728).

Chapter I
Elope

In celebration of its 100th anniversary year, the *Art Institute of Minneapolis* ran a monthly theme of 'Surprises' within their gallery. They certainly got a last minute 'surprise' when they were told that their Hogarth painting, *The Sleeping Congregation (1728)* held a previously unseen self-portrait of the most famous British artist himself *(Figure 1.1)*.

Scan the line of faces at the bottom right of the scene and you will find a young girl who looks rather shocked as she stares up at the gallery *(Figure 1.2 bottom)*. Follow her bug-eyed gaze to where an open hand can be seen directly above her. I believe this is the hand of Hogarth.

The woman is Jane Thornhill *(1709–1789)*. Hogarth eloped with Jane just months after finishing this painting. Follow my red line between her face and Hogarth's open hand and you will find the faint smudge of a red rose being dropped between the two lovers.

Jane sits next to her father, James Thornhill *(1675–1734)*, Sergeant Painter to George II and famous for his frescoes in the dome of St Paul's Cathedral. When you compare Hogarth's tiny rendition of Thornhill's face to Thornhill's self-portrait, there are definite similarities, especially with his full lip and protruding jaw *(Figure 1.3)*.

There is one good reason for Thornhill to have been included in this congregation—it was actually a representation of a meeting of The Premier Grand Lodge of Freemasons. In the year of the painting, Sir James held the exalted position known as 'Senior Grand Lodge Warden.' The date of 1728 is clearly painted on the wall right above him *(see Figure 1.1)*. His post of Grand Warden for that year is mentioned in the Constitutions of the Grand Lodge (1738) *(Figure 1.4 my underlines in red)*.

Figure 1.2

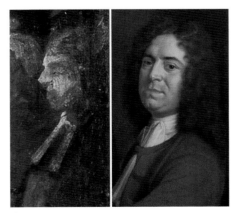

Figure 1.3

ASSEMBLY and FEAST at *Mercers-Hall*, on St JOHN's Day, *Friday 27 Dec.* 1728. *Deputy Grand Master* CHOKE, with his *Wardens*, several *noble* Brothers, former *Grand* Officers, and many Brethren, duly clothed, attended the *Grand Master Elect* in Coaches, from his Lordship's House in *Leicester-Square*, and conducted him from the *West* to the *East*: And all Things being regularly transacted, as on such Occasions had been usual, *Deputy Grand Master* CHOKE proclaimed aloud our noble Brother

VIII. JAMES KING, Lord KINGSTON, of the Kingdom of *Ireland*, 𝕲𝖗𝖆𝖓𝖉 𝕸𝖆𝖘𝖙𝖊𝖗 of *Masons*.

Who appointed

NATHANIEL BLAKERBY, Esq; *Deputy Grand Master.*
Sir *James Thornhill*, } *Grand Wardens.*
Mr *Martin O Connor*, }

Figure 1.4

On that same page is a description of *'a rich cushion, with golden Knobs and Fringes' (Figure 1.5)*. This had been a gift from Grand Master Lord Kingston upon which to rest the Bible, square and compass. You can see the cushion in the painting *(Figure 1.6)* along with a faint delineation of the compasses beside the opened Bible *(Figure 1.6, my red circle)*. Today, these same cushions adorn Freemason's lodges all over the world.

The minister in the pulpit has been identified as Reverend Dr. John Theophilis Desaguliers (1683–1744). What has been overlooked is that Desaguliers held the top position of 'Grand Master' of the recently formed fraternity.

Desaguliers addresses the gentlemen in the balcony with his outstretched hand and pointed stare *(Figure 1.7)*. We know that he is lecturing a Lodge of Freemasons because the men are positioned in a

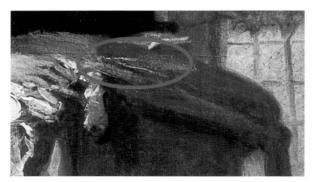

KINGSTON, *Grand Mafter*, at his own Coft, provided a curious *Pedeftal*, and a rich *Cufhion*, with golden *Knobs* and *Fringes* for the *Top* of the *Pedeftal* ; a fine *Velvet Bag* for the *Secretary*, and a Badge of *two golden Pens* a-crofs on his Breaft : For which very handfome Prefents, the *Lodge* returned hearty Thanks in folemn Manner.

Figure 1.5

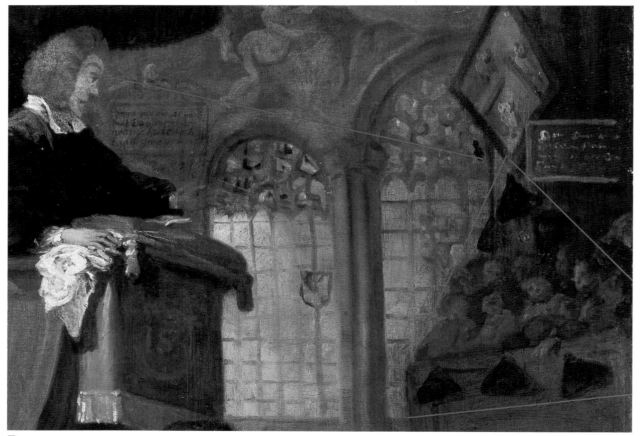

Figure 1.6

Figure 1.7

Figure 1.8

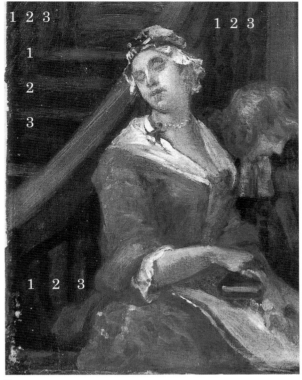

pyramid. The shape is created with the help of a tri-angle of tri-cornered hats. A horizontal line of hats form the base of this shape. The pyramid features greatly in all the early Masonic writings.

THE LETTER 'G' AND NUMBER 3

A newspaper of 1726 announced that *'the Doctor'* would give *'several Lectures on Ancient Masonry, particularly on the signification of the letter G.'* —Knoop, *Early Masonic Pamphlets*, London (1945).

This is the first time that the masonic letter ('G' for Geometry) was mentioned. Hogarth included this very letter by incorporating it into the top of the pulpit in his print of the same work *(Figure 1.8 with my markings in red on reversed print)*. This is the first depiction of the Masonic 'letter G' in any artwork.

Desaguliers was famous for his speeches on Freemasonry. Hogarth was attempting to illustrate the very topics on which Desaguliers lectured

Figure 1.9

by adding related details within his painting. One recurring theme in Desaguliers' lectures was his grouping of items into threes. We hear about the Grand Master's *'obsession with triplicities which proliferate throughout the trigradal system.'* —Trevor Stewart, *English Speculative Freemasonry and the Enlightenment*, (London, 2004).

Figure 1.10

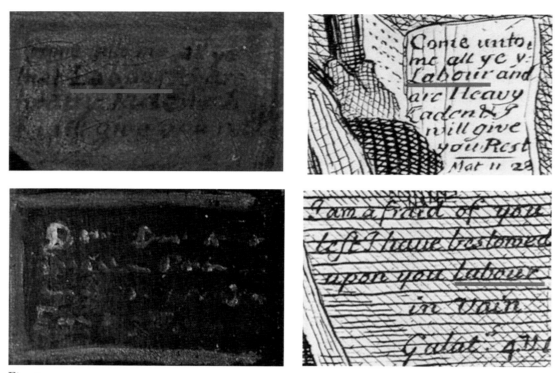

Figure 1.11

An exposé of the time warned *'If a Master-Mason you would be, You must rightly understand the Rule of Three.'* —Prichard, *Masonry Dissected*, (1730).

When in Lodge, the Master now sat on a platform of three steps. You can see these three steps leading up to the Desaguliers' lectern *(Figure 1.9)*. There are also three groups of banisters, (each having three spindles).

At the top of the stairs is an hourglass. Desaguliers lectured on the symbolism of this Masonic prop. Non-Masonic viewers assumed this was a church scene because it was common for a preacher to use an hourglass in order to time the sermon. Today, the hourglass is featured in all Masonic lodges as a symbol of the fleeting time in a man's life.

INIGO JONES

Desaguliers lectured on the history of the Freemasons and praised the brilliant architect Inigo Jones as *'one of the first Grand Masters.'* Hogarth cleverly includes a visage of this architect by hiding a likeness of his face in Desaguliers' handkerchief. Take a closer look and you will see the same features from a known portrait of Jones *(Figure 1.10 left)*. This face was part of a Masonic painting from a ceiling in *Chiswick Villa, London*. I am sure many others have noticed a form of a face in the handkerchief before, but without this new Masonic reading there would be no reason to identify it as Grand Master Inigo Jones.

FROM LABOUR TO REFRESHMENT

Further evidence that Hogarth was trying to depict a Mason's Lodge within this church is to be found on the wall inscriptions. We have to inspect the print to see them in detail *(Figure 1.11)*. You can make out the word 'labour' in both painting (top left) and print (top right). The other painted script (lower of the two) is impossible to decipher. We must imagine that Hogarth meant the other inscription concerning *'labour in vain'* as this is shown clearly in the print *(Figure 1.11 bottom right)*.

There is a deeper Masonic meaning to this wording. In a lodge, lectures and ritual are known as the *'work'* or the *'labour'* of the meeting. The Masonic ceremony is paused when refreshment is served. This break in the proceedings is still known as the 'rest' and is supposed to emulate a working day in a stonemason's lodge.

We see the word 'rest' in the print *(Figure 1.11 top right)*. In Premier Grand Lodger, the *'rest'* would consist of bowls of rum punch!

'The Lodge is said not to be closed, but to be called from labor to refreshment. The phrase is an old one, and is found in the early rituals of the eighteenth Century.' —Mackey's *Encyclopedia of Freemasonry (1929).*

Apparently, the Premier Grand Lodge meetings were noisy affairs with gentlemen coming in and out of the tavern room as the meeting progressed. Some physical signal had to be given when the 'work' (ceremony) had commenced. The Premier Grand Lodge devised a system of small hand-held

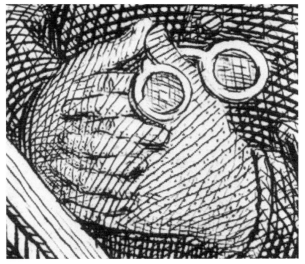

Figure 1.12

columns to indicate when a change in procedure was taking place. They look like the miniature pillars seen in *(Figure 1.16)*.

'The command to refresh themselves' was whispered from the Master to the Deacons and Wardens until *'he proclaims it openly to the Lodge, and sets his Column up right.'* —Jachin and Boaz, 1762 (an early Masonic exposé).

I believe that Hogarth had witnessed this procedure in the 1720s and devised a vulgar way of representing the raised column in the scene by painting the Deacon with an erection *(Figure 1.12)*. This is masterfully illustrated with a thumb. His pair of spectacles are drawn to look like testicles.

Once Hogarth had included this *'raised column'* (often described as 'erect column' in the ritual books), he needed to add a reason for the Deacon's excitement, hence the addition of the young couple sitting next to him.

Follow the Deacon's line of sight *(Figure 1.13 my red arrow)*. When seen from his viewpoint, the woman's husband would appear to have his face deep in her

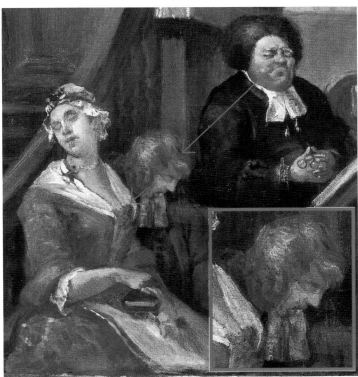

Figure 1.13

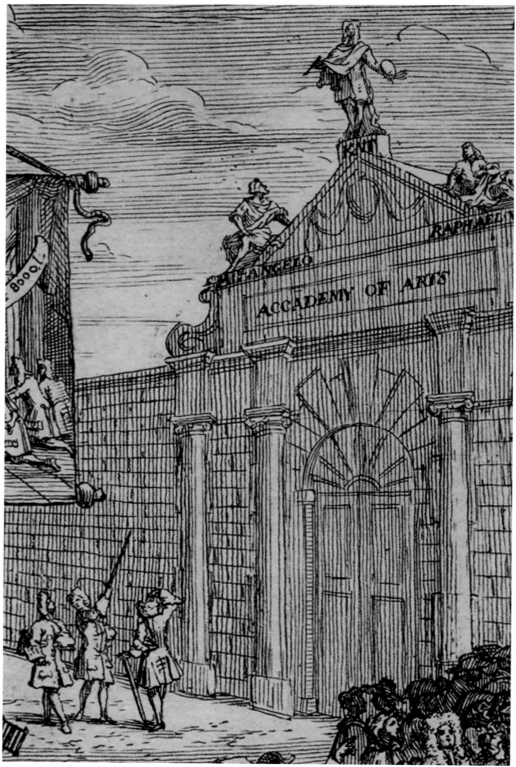

Figure 1.14

cleavage! He is slumped over awkwardly in order to create this angle. Previous work on his shoulder is 'ghosting' through, evidence that the painter worked on this positioning. The Deacon's eyes are actually shut, as if he is imagining the couple in the act of foreplay. His glasses (read testicles) however, are staring straight at the woman's bosom.

In a later chapter I will identify this 'randy Deacon' as a prominent Freemason, giving further proof of this Masonic intention. For now, let us step back and admire the imagination of Hogarth, and his skill in combining concepts of both the church and lodge together. Let us also admit the gall of a man who could paint such a sexual scene in front of his soon-to-be father-in-law!

How did Hogarth, a lowly engraver of business cards (from a family who had spent much time in debtor's prison) marry the daughter of a Member of Parliament and Sergeant Painter to King George II? The reason has all to do with Freemasonry.

Sir James Thornhill

Thornhill's remarkable career had just been thwarted. The first English-born artist to be knighted had just been snubbed by a young, talentless coach painter by the name of William Kent *(1685–1748)*. Kent, had recently returned from a tour of Italy with a few spurious credentials, but had the audacity to underbid Thornhill for a commission to decorate the Royal Apartments at Kensington Palace in 1723.

William Kent's commission was the result of court-politics chicanery. Thornhill had every right to feel aggrieved, and Kent's coup earned him the lifelong enmity of the sergeant painter and his son in law, William Hogarth.

> —William Kent: Designing Georgian Britain.
> Victoria & Albert Catalogue (2013) p201.

Kent's patron and shameless promoter was Richard Boyle, the 3rd Earl of Burlington *(1694–1753)*. He was a prominent gentleman-architect of the time. It was he who had personally orchestrated this *'gross intrusion of a favourite.'* Thornhill blamed the Lord personally for destroying his career.

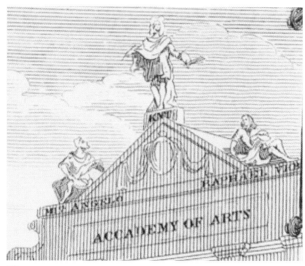

Figure 1.15

The Bad Taste of the Town (1724)

Well before he was acquainted with the family, Hogarth jumped to Thornhill's defence with a print entitled *The Bad Taste of the Town (Figure 1.14 whole print not shown)*. It became known as *Masquerades and Operas* because it lampooned both of these foreign fads. I draw your attention to the central three figures, identified as Burlington and his architects William Kent and Colen Campbell. They are looking up at a statue of Kent that is being lauded by the statuary of Raphael and Michelangelo who seem to bow down on either side of him *(Figure 1.15)*.

This obvious mockery was compounded by a clever omission of a letter from Kent's name, rendering it as the vulgar 'KNT.'

Another print entitled 'The Taste OR Burlington Gate.' This satirical performance was thought to be invented and drawn at the instigation of Sir James Thornhill, out of revenge, because Lord Burlington had preferred Mr. Kent before him to paint for the king at his palace at Kensington.

> —The Works of William Hogarth, Trustler, (1768).

While Hogarth removed one letter from Kent's name, he added another to the word 'academy' below him in order to mock Kent's foreign taste further. I believe this refers to the *Accademia di St. Luca'* from which Kent had boasted a medal.

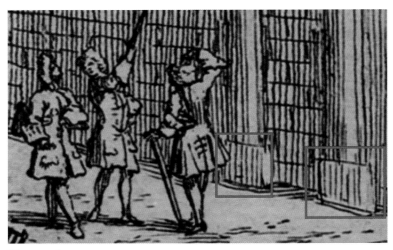
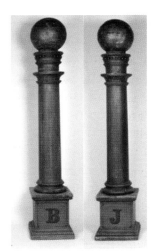

Figure 1.16

The xenophobic Hogarth spent his whole life attacking such pretension.

The ridicule which Hogarth had thus thrown on Kent was very acceptable to James Thornhill, who was jealous of the four-fold reputation of (William Kent).
—Anecdotes of William Hogarth.
John Timbs, 1881, p17.

On close inspection, I discovered that Hogarth superimposed a letter to the base of the right-hand column *(Figure 1.16 my red markings)*. You can clearly see the letter 'J.' It is created by the only over-scored line in that vicinity. There is also a faint indication of a lowercase letter 'b' on the left column.

Compare the two Masonic columns that Thornhill would have known from the lodge at the time. 'J' and 'B' are the first letters of the names of the columns of Solomon's Temple as given in the Bible. The Grand Lodge of England still refers to these columns by their first letters. I have inserted a photograph of two miniature columns as used in lodges today.

Outside the lodge, Freemasons use signs of recognition to identify each other. The three men in the centre of the print are sporting such Masonic signs *(Figure 1.17 bottom)*. Two have their hands at their chest, while another holds a staff,

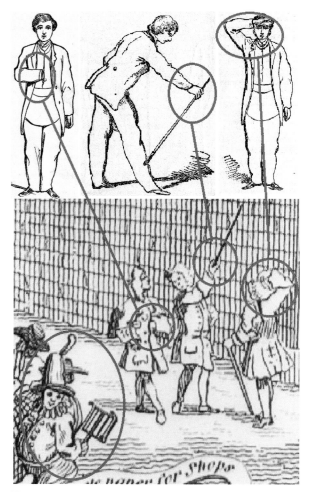

Figure 1.17

and has his hand on his forehead, shielding his eyes as he looks up.

While I realise these postures were common in the day, they correspond exactly to these depictions Masonic signs of recognition which makes them pertinent to this study. These signs were all exposed in a well known book called *Duncan's Masonic Ritual and Monitor,* (1866) *(Figure 1.17 above)* and will be explained later.

Burlington's gates never had these classical embellishments. The main reason then, for including this statuary was in order to position the men looking up. In this way, Hogarth was able to place one man in a posture of shielding his eyes which cleverly disguises one of the hand signals for this degree.

The sign was described from a coded ritual book of 1740, recently deciphered: *'one has to lift his hand to his forehead, so that the thumb is placed on the forehead and the four fingers are stretched up.'*

—*Copaile Code.*

Freemasons today who recognise these signs from a current degree might be interested to find that these signs are part of a modern 'higher' degree which originated abroad. All will be revealed as the story unfolds.

Hogarth was accusing Burlington of promoting a foreign Order that was very unpopular with the Premier Grand Lodge. This explains the title of the print 'The Bad Taste of the Town.' It also explains the addition of the clown, looking directly at the viewer (circled in red) *(Figure 1.17)*. He holds a gridiron behind his back that is pointing towards Burlington as if in mockery *(Figure 1.18)*. I believe this is connected with the *Goose and Gridiron*, the tavern in which the Grand Lodge first met in 1717.

The date of this print is most pertinent to this chapter for the simple reason that when the artist added these symbols in 1724, he was not yet a Freemason. Hogarth was made a Mason November 27th 1725, at the Tavern at the Hand and Apple Tree, (Little Great King Street, London). He must have been supplied with these details by someone who understood the signs of this foreign Order.

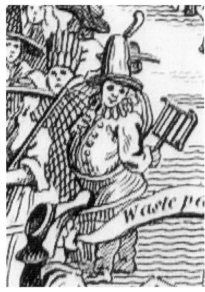

Figure 1.18

'MASONRY BROUGHT TO LIGHT BY THE GORMOGONS,' (1724)

Hogarth produced another print with even more Masonic additions well before he was a Freemason. *Masonry brought to light by the Gormogons, (1724)* was a preemptive strike by the Premier Grand Lodge against a similar group which had advertised themselves with the curious moniker 'The Gormogons.'

A newspaper announcement boasted that the Gormogons were *'much greater Antiquity and Reputation than the Free-Masons … a great many eminent Freemasons have come over to this Society …'* —*Mist's Weekly Journal (Oct. 1724).*

Hogarth mocked this group by featuring the members parading from their Lodge with a monkey in Masonic gloves and several other Masonic details that are covered in the notes *(Figure 1.19)*.

The ladder, bucket and mop, tavern signs and other emblems show Hogarth to be au fait with Masonic matters. —Yasha Beresiner, William Hogarth: The Man, The Artist and His Masonic Circle, Pietre-Stones Review of Freemasonry.

Again, the date is of great interest to this book, because, as with *The Bad Taste of the Town*, Hogarth was not yet a Mason when he made the *Gormogon's*

print (both produced in 1724). He must have received help with the inclusion of Masonic imagery and symbolism here.

So far, I have discovered several Masonic details which Hogarth included in this work at a time he would not have understood them (as he was not yet a Mason). This book will show other Masonic inclusions within Hogarth's later work, to which he would not have had access. I intend to show that Sir James Thornhill supplied Hogarth with the information he needed to discredit these rival groups.

Thornhill was in a perfect position to orchestrate this. In 1724 he was preparing to become Master of his Lodge (he was Master of the Swan Lodge in 1725). Thornhill would have been in constant communication with Desaguliers and the nascent Grand Lodge. As Sergeant Painter to the King, Thornhill would be the obvious choice to organise a pictorial slander of the Gormogons. Indeed, Thornhill had designed the frontispiece to the Constitutions of

Grand Lodge (published 1723) which put him in a pseudo role of 'Art Director to the Grand Lodge.'

Hogarth was in the right place at the right time. He had joined Thornhill's drawing academy in November 1724, and was a known satirical printer (having just produced the *South Sea Scheme (1721)* which mocked a recent financial scam). Thornhill must have approved of the Masonic themed prints, for he would not have continued to teach Hogarth had the Grand Lodge been upset with the artist's work. Hogarth would not have ridiculed his mentor's Fraternity without at least his tacit approval. Indeed, Hogarth was welcomed as a Freemason the following year, which might be viewed as a reward for his labour.

These prints must have been approved by Thornhill and his Grand Lodge, namely: *The Bad Taste of the Town* (1724) and *Masonry Brought to Light by the Gormogons*, (1724) which we have studied, and *Royalty, Episcopacy and Law (1725)* and *A Burlesque*

Figure 1.19

18

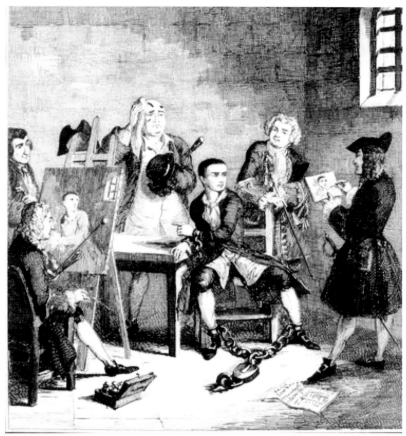

Figure 1.20: **Illustration for 'Jack Sheppard' 1839. Print by George Cruikshank (1792–1878).**

on Kent's Altarpiece at St. Clement Danes (1725), which we still have to inspect.

Thornhill and Hogarth are recorded as working together on painting the famous criminal Jack Sheppard in November, 1724 *(Figure 1.20 by G. Cruikshank)*. Here we see the master and student in collaboration. Hogarth stands on the far right, sketching the criminal while Thornhill is seated at his easel. Freemasonry would bring these two great artists together.

'There is little doubt that Hogarth's successful career, both as an artist and a Freemason, was influenced, even motivated, by Sir James Thornhill, his father-in-law.' —Yasha Beresiner, ibid.

Thornhill would have proposed Hogarth to the Fraternity. At his initiation, Hogarth would have repeated the following vow. *'Furthermore, do I promise and swear that I will not violate the chastity of a Master Mason's wife, mother, sister, or daughter.'*

However, three years later, Hogarth broke his first and foremost Masonic promise and ran away with Thornhill's daughter!

'The couple was promptly cold-shouldered by Thornhill [for two years], who thought that his low-born protégé had betrayed the trust he had bestowed on him.' —Anecdote Biography of William Hogarth, John Timbs, 1860.

They were eventually reunited over a curious incident that involved Freemasonry. The full story involves a new reading of one of the most famous series of prints—*A Harlot's Progress.*

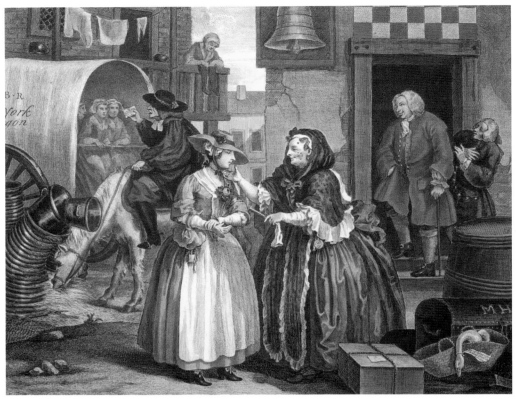

Figure 2.1 i: **Moll Hackabout arrives in London and meets Mother Needham, a notorious procuress.**

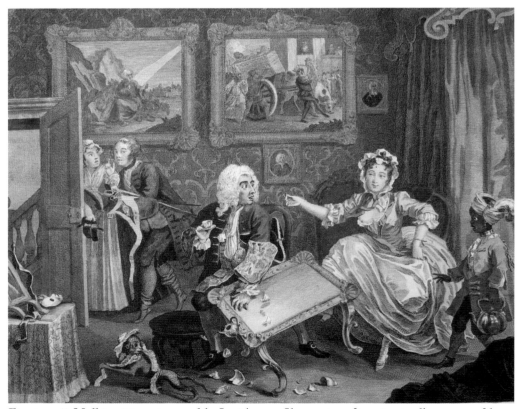

Figure 2.1 ii: **Moll is mistress to a wealthy Jewish man. She creates a diversion to allow a second lover to escape.**

Chapter II
The Harlot

Thornhill was much offended at his daughter's unequal match; Sir James' wrath lasted for two years; but the entreaties of his wife, the submissiveness of his daughter, and above all, the rising reputation of Hogarth, prevailed, and Thornhill forgave the young painter.

During the interval, Hogarth designed and etched "A Harlot's Progress," so much to the gratification of Lady Thornhill, that she advised her daughter to place it in her father's way. Accordingly, one morning, Mrs. Hogarth conveyed it secretly into his dining-room. When he rose, he inquired whence it came, and by whom it was brought? When he was told, he cried out, "Very well, very well! The man who can make works like this can maintain a wife without a portion."

—Anecdote Biography of William Hogarth, John Timbs, 1860.

An important part of this story has been missed out. I will show that Thornhill's reported accolade was based upon his realization that *A Harlot's Progress* incorporated all the secret signs of the new Grand Lodge ritual. William Hogarth, who by 1732 had been a Mason for several years, had managed to disguise these signs, passwords and 'knocks' so skilfully within the paintings, that they have not been noticed since.

Let me paint the scene: mother and daughter are trying to reunite a father and his banished son-in-law. By leaving Hogarth's artwork where Thornhill could see it, they thought to impress Sir James with this moralistic tale of the life of a London prostitute. Sir James would in fact see much more.

"Well, what do you think of them?" asked Lady Thornhill as she showed her husband the first scene *(Figure 2.1 i)*. "Can you see a young girl recently arrived in London? She is about to be ensnared by this awful woman? Look how the old bawd chucks her on the chin."

Sir James stared at the detail being pointed out to him. There was something familiar about the position of this open hand at the young woman's throat. He had been a Freemason for many years and, as a Master of his lodge, had initiated dozens of candidates. Suddenly, the wording of the ritual came to mind: *'Extending the Four Fingers of the Right Hand and drawing of them cross his Throat is the sign.'* Prichard, Masonry Dissected (1730).

"Yes, yes, I see it!" Sir James had his eye-glass out now, and was staring at the fan that was pointed at the young girl *(Figure 2.2)*. He remembered another line from the ceremony: *'After one comes in at the door … the open compasses pointed to his breast.'* —The Mason's Confession (1727).

Thornhill would have recognised the clumsy position of the young girl's hands as the sign of the First Degree. Compare it to illustrations from the first graphic exposé by Avery Allyn in 1865 *(Figure 2.3 right)*.

I share these illustrations in confidence because, while Freemasonry is nominally a secret society, these static illustrations of the signs by Allyn were recently republished in its entirety by the Supreme Council of the Ancient and Accepted Scottish Rite of Freemasonry (Southern Jurisdiction, USA) in a publication by Arturo de Hoyos, their Grand Historian: *Light on Masonry: The History and Rituals of America's Most Important Masonic Exposé, (Scottish Rite Research Society, 2008)*.

Hogarth cleverly portrays this method of preparing the new Masonic initiate by having the young woman blush in order to feature her with her eyes closed. Her face is veiled by her extremely large brimmed hat, that serves as a virtual blindfold

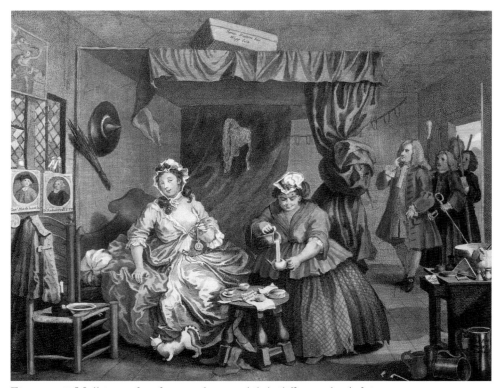

Figure 2.1 iii Moll, in a reduced state, takes tea while bailiffs enter her lodgings.

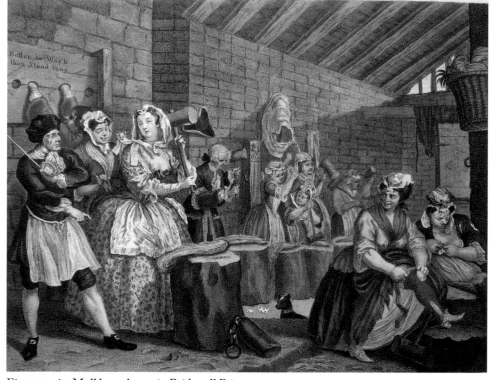

Figure 2.1 iv: Moll beats hemp in Bridewell Prison.

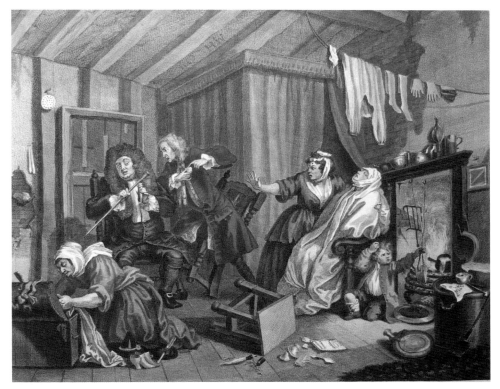

Figure 2.1 v: Moll is dying while two doctors argue over her treatment.

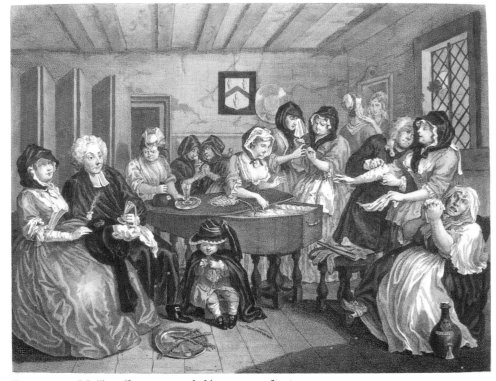

Figure 2.1 vi: Moll's coffin is surrounded by a group of insincere mourners.

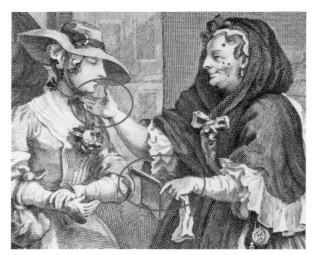

Figure 2.2

Figure 2.3

(Figure 2.4). Indeed, on close inspection her eye seems to be closed. The hat is closely tied under her chin, giving the semblance of a rope. She is also dressed in a large white apron—the badge of Freemasonry.

All of these details correspond to the description in the Allyn exposé: *'The conductor then ties a handkerchief or hoodwink over his eyes, and afterwards puts a rope, called a cable-tow, round his neck.'*

The Masonic line of moving *'from darkness to light'* is quoted in the exposé. Now look at the shadow on the building behind her *(Figure 2.4 my red arrow).* The shaft of light hits the young girl's eyes as 'the candidate' appears to move out of the shadow on the wall behind her. *'A poor blind candidate who has long been desirous of being brought from darkness to light.'* —Allyn.

You can almost hear Sir James Thornhill gasp at this ingenious graphic *(Figure 2.4).*

Even *'the Three Distinctive Knocks'* that accompany a candidate's entrance into the lodge had been masterfully disguised *(Figure 2.5).* The knocks are featured as nails in the door lintel (two and then one) rather like a Morse Code: *'Another signe is knocking at any door two little knocks and the third a big one'* *(Sloane MS, c.1700).* I believe that Hogarth hints that this clue is to be sounded, by putting the lintel in line with the clapper of the bell. The exposé mentions 'claps' as part of the ceremony. *(Figure 2.5 my red dots underneath nails in the print.)*

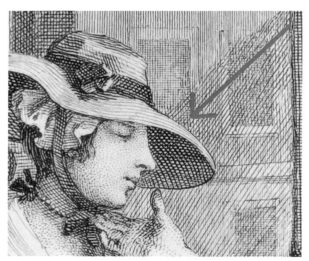

Figure 2.4

Concerning the bell, the Constitutions of the Grand Lodge (1738) mention that *'Grand Lodge met in ample form at the Bell Tavern Westminster, 1724–25.'*

The chequer-board sign that leads you to the clue is also a Masonic pointer. It is listed as a 'mosaic pavement' in *Prichard (1730)* and comes from a biblical passage (John 19:13).

SCENE 2: SECOND DEGREE

You can imagine that Lady Thornhill would be thrilled that her husband was taking so much interest in the first painting as she ushered him along to the second scene. "… and look darling, now the poor

harlot has been kept as a society lady." Thornhill now actively looked for signs of the second degree. They instantly jumped out at him.

If Freemasons are reading this, they might like to take a moment and look through all six coloured prints at the beginning of this chapter to see how many signs they can find. Again, the brethren can be assured that these illustrations and descriptions from Allyn's and Morgan's exposes have already been reprinted in their entirety by the Supreme Council.

Compare the fop in Scene 2 *(Figure 2.6 left)* to the illustration on the right. This was printed in another popular exposé by Malcolm Duncan in 1866. Non-Masons will see a sign made by holding one's right hand flat out, while the left is held up. Hogarth cleverly hides this hand position in the scene by depicting the fop, steadying an overturned table while holding a teacup.

While it may seem impossible to actually hold both cup and saucer in his manner, this was a way in which Hogarth could show the man's left palm while his right hand was faced down. These rather awkward actions can be so easily explained when you realize that the artist was trying to incorporate a hand signal into the action taking place. Note that the painting (destroyed) would have been reversed *(Figure 2.6)*.

The harlot shows her naked breast, hinting at another part of the sign of the Second Degree. This action is part of the ancient oath in which a candidate vowed that before he revealed the secrets, he would have *'my left breast torn open, my heart plucked out and given to the wild beasts of the field.'* I believe the 'wild beast' is symbolised by the pet monkey *(Figure 2.7)*. Note that the right breast is shown in the reversed print, but would have been the correct left breast in the painting.

> *'The sign is given by taking hold of the left breast, as though you intended to tear out a piece of it, then draw your hand with the fingers partly clenched … with some quickness.'* —Avery Allyn.

Thornhill's trained eye might alight upon the foot position of both characters *(Figure 2.7 my red*

Figure 2.5

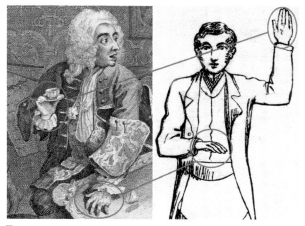

Figure 2.6

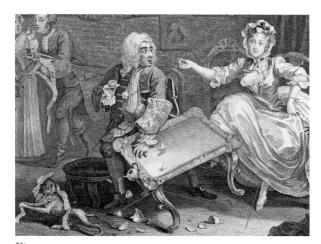

Figure 2.7

lines). I believe that Hogarth drew the harlot kicking over the table so he could position her feet at right angles, a posture not normally associated with a lady. The words *'my feet forming a square'* are repeated a dozen times in *Morgan's Exposé of Freemasonry (1827)*. Hogarth cleverly shows just a heel but this hint creates a perfect square which, according to Morgan, is the prescribed foot position when these signs are given. The harlot's keeper is close to kneeling on the

stool, which Freemasons will recognise as another detail from the ritual.

SCENE 3 – 'LABOUR TO REFRESHMENT'

Back to Thornhill's parlour, where Sir James is laughing at the third painting which shows the harlot's fall from grace *(Figure 2.8)*. He has realized the Masonic joke intended for him alone.

"From labour to refreshment at high twelve", he blurts out to his wife's confusion. "Sorry, darling, it's one of the oldest Masonic terms which old Desaguliers is always harping on about. You see, the prostitute has finished her *labour* of love."

"Just look at the cat's rear end, and the curtains that are showing an orgasmic state *(Figure 2.9)*. Do you see it? The face hidden in the curtains is making an 'ohh' sound as this courtesan enjoys a *refreshing* cup of tea! Oh capital fun!! Look! There is a condom in the wash bowl!"

Lady Thornhill gasps. "Oh Good Lord, I thought that was a lemon peel for punch!" They both laugh out loud! *(Figure 2.10 bottom from another Hogarth print N9.4)*.

"Look how the artist has masterfully kept the feet at a square by positioning one of her stockings at a right angle to her shoe under the table *(Figure 2.11*

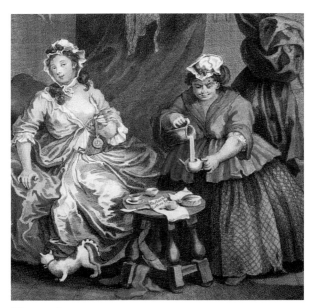

Figure 2.8

top)." Thornhill returned to Scene 1 to examine the position of how her feet were depicted when the young Harlot was theoretically just a 'candidate.' They were drawn correctly, at an uncomfortable parallel position *(Figure 2.11 bottom)*. All feet in the series are positioned at either a square or are clearly drawn to be more parallel like this.

SCENE 4: FOURTH DEGREE

Lady Thornhill now looked a little more carefully at the fourth painting, which showed a jail scene. She could never appreciate the masterfully disguised signs of the Mark Mason degree (which many called the Fourth Degree). Here is a description of the relevant ritual from *Morgan's Monitor*:

'Each brother walks up and thrusts his right hand through the hole in the window [and gives a sign]. The candidate does not know the sign and so has his hand seized. "An impostor! an impostor!" Another person exclaims, "Strike off his hand! strike off his hand!" and at the same time runs up with a drawn sword to give the blow.' (Figure 2.13 from Allyn).

The jailer is dressed in a Mason's apron with his feet at a square *(Figure 2.12)*. He is making the sign of chopping off a hand, as he points at the hemp that the harlot is beating as part of her prison sentence. Hogarth has cleverly combined her mallet with the tricorn hat on the wall behind her, to produce the appearance of an axe *(Figure 2.14)*. She uses it to cut off what looks like an arm with curled fingers. You will never look at that hemp again without seeing a severed limb (bottom right).

I include a photograph of these Lodge props that are still used today *(Figure 2.14 top right)*. The axe lies alongside a 'wicket' through which the candidate puts his hands during the ceremony. Hogarth has included this very same contraption in the scene. The man in stocks, who stands directly behind the jailer has his hands in a contraption exactly the same as this 'wicket.'

Many Hogarth scholars have commented on the jailer's curious hat *(Figure 2.15)*. Hogarth used it to blend with the large cuff of the man in the stocks in order to connect the two and send a message. I have

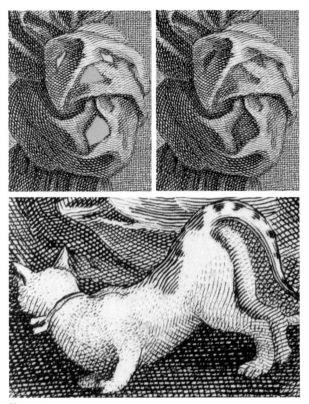

Figure 2.9

Figure 2.10
Bottom image from *Midnight Modern Conversation*

Figure 2.11

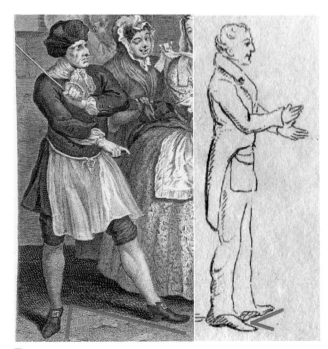

Figure 2.12

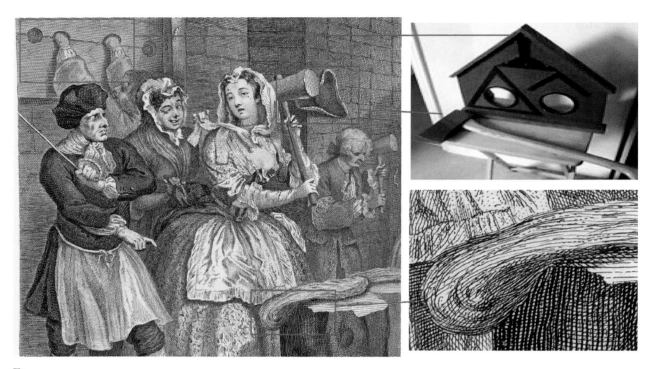

Figure 2.14

Figure 2.13

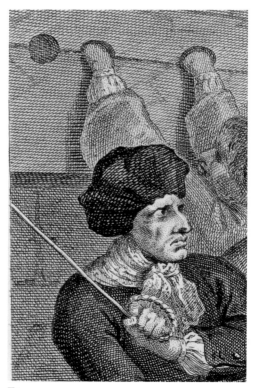

Figure 2.15

shown Hogarth using this technique of overlapping characters to connect details many times in this book.

SCENE 5: FIVE POINTS OF FELLOWSHIP

"Ah, what have we here?" His wife starts to explain how the poor girl's corpse has been wrapped in a shroud *(Figure 2.16 left)*. Sir James would recognise this as the blanket used to cover the candidates during their third degree initiation *(Figure 2.16 right)*. He is busy scanning for something less obvious. "Of course!" he eventually blurts out. "The fifth scene has the Five Points of Friendship—the ancient form of passing the secret word."

According to the exposés, the password of the Third Degree can only be whispered when two Master Masons are standing in this curious position.

The two doctors are touching feet, knees and shoulders *(Figure 2.17 red circles)*. One is talking directly into the other's ear. Now read a line from the *Dundee Manuscript of 1727*: *'placing himself hand to hand, foot to foot, knee to knee, ear to ear and says [the Master's Word].' (Figure 2.17 right from Duncan)*

'In Freemasonry King Solomon is said to have established a secret word 'MHB' that is a passkey to the third degree.' —The Builder Magazine, February 1915.

The first two letters of this password are clearly written upside down on the ceiling above the two doctors *(Figure 2.18 red square)*. It is as if the words are appearing as they are being whispered. Hogarth thus creates a sense that some action is taking place. He is known to use this clever technique in many of his works.

Lady Thornhill saw the letters MH and assumed the were the initials of 'Moll Hackabout' (the name

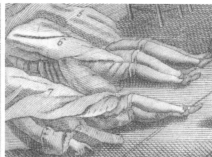

Figure 2.16

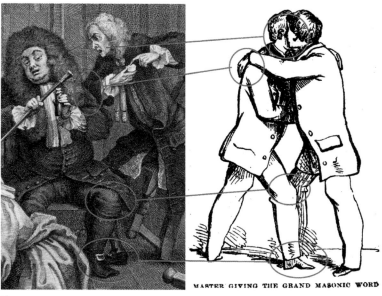

MASTER GIVING THE GRAND MASONIC WORD

Figure 2.17

of the Harlot as given in the final scene). The same initials 'M.H.' are given on the trunk in scene 1. Lady Thornhill saw the last two letters on the rafters, ('CU') and thought these were the beginning of a vulgar word *(Figure 2.18)*. Indeed, Jenny Uglow assumed this in *Hogarth: A Life and a World, Faber (1998)*. Many reprints missed out the letters altogether out of disgust, while others admitted their confusion: *'MH CU? on the ceiling of a Harlot's Progress. No satisfactory explanation has been proposed,'* wrote Robert Cowley as late as 1983 *(Hogarth's Marriage A-La-Mode, (Cornell, 1983))*.

James Thornhill however, would have had a satisfactory explanation. He would have read *'MHCU'*

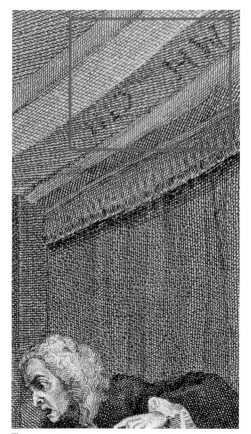

Figure 2.18

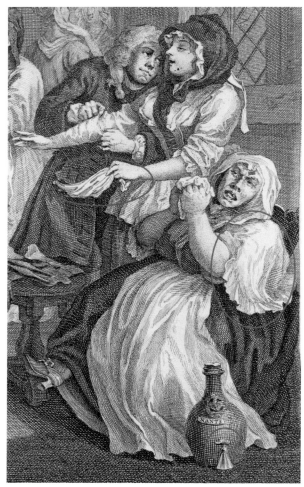

Figure 2.19

as '*Most High Contriver of the Universe.*' This was a term first used in the new ritual, of which Hogarth would have been one of the first Freemasons to hear. It appears in *Prichard's Masonry Dissected* of 1730, exposing the word in full, but would have been written down in this acronym form in the Lodge to keep the word secret. Of course, Hogarth would have enjoyed splitting up these letters to mislead non-Masons that a vulgar word had been etched into the rafters.

"Wait", Sir James looks a little more carefully and bursts into laughter "Why that is Dr. Misaubin, a well known Freemason from France. And I believe I recognized the magistrate Sir John Gonson back there apprehending the harlot. And look, that is Colonel Charteris fondling himself in the first painting! Ha, what a lovely little slander!" Thornhill scanned the faces for anyone else he might recognise.

SCENE 6: THE FUNERAL

"Oh Good Lord, is that Desaguliers in the final scene?" His wife shakes her head. "No, James, that is an old woman crying at the funeral!" *(Figure 2.19)*. "But she does have a manly forearm! Why, so it is! It is Desaguliers! His wart is covered with a plaster and look, he has a bottle of his favourite Nantes at his feet. Was he not telling us he was from that part of France?"

"Yes", agrees her husband, "but I think the glass is overturned on purpose because he came here after the Revocation of Nantes and there he is refusing a glass—*'Revoking' the Nantes!* Oh what a clever little riddle!"

"There is his gouty foot and his ubiquitous white handkerchief, and he is praying just like a minister! I just heard a lecture of his on an experiment which is now called *'Desaguliers' Balance.'* There he is falling off a chair!! Oh capital!"

They were right. It was indeed Reverand Desaguliers dressed up as a woman. Hogarth was the one of the first candidates to go through these new rituals in 1725, which were written by the 'father of Freemasonry.' Hogarth would have been initiated by Desaguliers, who performed this Third Degree on all candidates in the first years of its introduction.

Sir James saw other things in this corner of the print that he was not going to divulge to his wife; they were the signs that Masons used to recognise each other in public. Desaguliers' glass was one, as described in *The Grand Mystery of Freemasonry Discovered (1724) 'signs to know a true mason: turn a glass, or any other thing that is hollow, downward after you have drank from it.'*

Desaguliers seems to sport another sign in the way he wears his dress off his shoulder *(Figure 2.19 red circle)*. *The Sloane Manuscript (1700)* gives a list of *'Freemason's signs,'* one of which involves: *'taking their handkerchief ... and throw it over their Left shoulder letting it hang down their back ... then holding it Straight out before them they give it two Little shakes and a big one.'* This last part of the sign is given by the harlot next to Desaguliers, who steals a handkerchief with an extended arm *(Figure 2.19 red circle)*.

Thornhill looked through the funeral scene, hunting for symbols like a child searches through a 'Where's Waldo' puzzle *(Figure 2.20)*. There had been nothing like this before. We often laud Hogarth for being the first to put a story in cartoon form like this, but the real reason for his initial success might just have come from his fellow Masons who enjoyed hunting around for symbols.

SIGNS WITHIN THE HARLOT'S FUNERAL

Indeed, the final scene is a veritable hide-and-seek! Hogarth has hidden several of the tools of the mason's trade within the Harlot's funeral. Take a moment and see if you can find these within the print *(Figure 2.1 vi)*, or read on if you want a clue. Hogarth has hidden the following: square, plumb, level, trowel, moon, maul, rough stone and smooth block, callipers, gloves and plumb line.

Let me start with the form of a Mason's square that can be detected in the door jamb. The hinges of the screen also make the shape of a plumb rule. The other most important tools of the Master Mason are the level, found in the shape on top of the mirror on the right.

The order in which these three tools are hidden in the print, corresponds to the order they are printed in *Duncan's Monitor*, as seen in the illustration included alongside them *(Figure 2.20)*.

The shield on the wall is made up of three trowels—the basic tool for any bricklayer. The lattice window is taken straight from an illustration in *Duncan's Monitor* (which I have added to the periphery). It is the floor design of Solomon's Temple. A hole in the window (which is moon shaped), has been stuffed by a sponge. I believe this is a representation of the rough rock (or 'ashlar') next to the smooth stone made by the window's lintel. When you compare them to known depictions on Mason's aprons of the time, they match (see notes). There is no other explanation ever given for these details.

The Masonic white gloves are found on the stool, next to a glove stretcher that suggests a Mason's compass. The orphaned boy represents the widow's son, mentioned so frequently in the Third Degree ritual. He is sitting in front of his mother's coffin, playing with a plumb rule.

The coffin has acacia on it, exactly as so many Masonic paintings show. *Prichard's Masonry Dissected*, published two years before the print, mentions the plant and how important it is in the ritual: *'... a Sprig of Cassia at the Head of his Grave.'* Hogarth places a sprig on the very coffin.

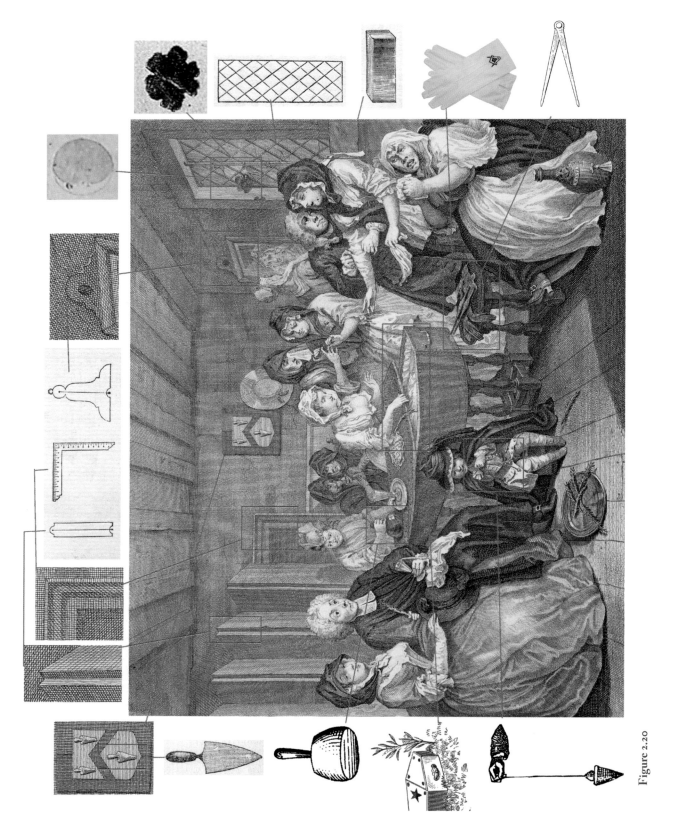

Figure 2.20

32

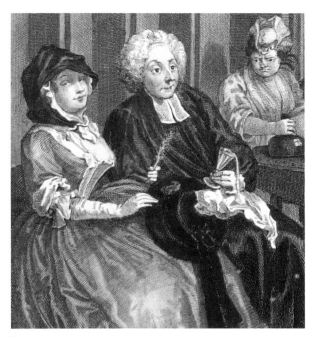

Figure 2.21

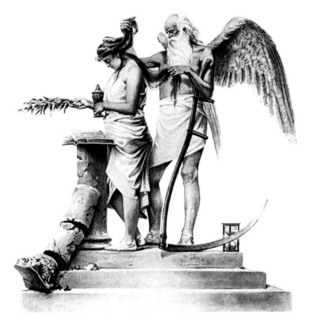

Figure 2.22: Father Time and the Virgin, by Amos Doolittle (1754–1832).

FATHER TIME AND THE VIRGIN'S RINGLETS

One last clever Masonic inclusion concerns the character in the corner, who has given commentators most grief as they skirt about trying to describe the wandering hands of the horny clergyman *(Figure 2.21)*! I believe that Hogarth brilliantly illustrated a very well known Masonic symbol entitled *'Father Time counting the Ringlets of the Weeping Virgin's Hair.'* This is usually found as statuary at Masonic gravesites, as seen in *(Figure 2.22)*.

We read in *Duncan's Monitor, (1866)*: *'Masonic tradition informs us that there was erected to his memory a Masonic monument, consisting of <u>a beautiful virgin, weeping over a broken column</u> ... <u>in her right hand a sprig of acacia</u> ... behind her stands <u>Father Time, unfolding and counting the ringlets of her hair.</u>' (my underlining)*

The beauty spot makes the youngest looking prostitute shed a tear like the *'weeping virgin.'* She is holding a sprig of acacia' as described above. (The acacia is in her right hand in the original painting, left in this reversed print.)

The 'broken column,' represented by 'father Time's wine glass stands in for an erection, and the spilled wine and handkerchief represents his ejaculate.

You can almost hear those dirty old men chuckle as they realise the vulgar joke: the minister has his hand up her skirts, counting the 'ringlets' of her pubic hair!

Lady Thornhill would only see a mourner in a funeral parlour holding a sprig of rosemary for remembrance. Masons would recognise the importance of acacia in a scene that was an obvious depiction of the Third Degree in Freemasonry.

Thornhill looked around the paintings in the parlour with different eyes, searching for clues. It was so much fun. One sign eluded him—that of the Third Degree. Can you find it?

Let me superimpose the sign of the degree from Duncan's well-known exposé. It shows how the artist hid the extended arms of this degree sign by showing a woman putting on her gloves

Figure 2.23

(Figure 2.23). Hogarth manipulated the perspective a little to allow this to happen. He needed a reason for both of her hands to be held straight out, and so he has figured her stealing a silk handkerchief from the undertaker's pocket.

THE UNDERTAKER'S GLOVES

"Do you remember those gloves I brought back for you the night I was initiated into the lodge?" Thornhill asked his wife. "You are instructed to go home and give a pair of gloves to the woman you most esteem. This scoundrel is giving them to a common prostitute—it's a joke. He is no undertaker, he has just gone through the Third Degree, and there he is, rewarding a prostitute for a recent tryst." He began to laugh.

Lady Thornhill was also laughing at the sexual connotation of the glove stretcher next to the prostitute. It was a pseudonym for penis used in the erotic novel *'Memoirs of a Woman of Pleasure'* by John Cleland. Sir James did not know his wife was reading such smut!

Thornhill was amused by the dreamy look on the undertaker's face as he gave a post-coital gift to the dishevelled prostitute. Notice that her dress is still undone exposing her breast.

Thornhill suddenly shrieked, and collapsed in his chair. "Wait there! I recognise this undertaker's face! It is that scoundrel William Hogarth!" Thornhill pointed at the undertaker in the painting. "There he is, as clear as day—it's William bloody Hogarth! That chancer who ran away with my daughter. This is all his work! Bring him forth!"

When I juxtapose Hogarth's self-portrait (c.1735), you can see the uncanny likeness to the funeral director! How cheeky of the artist to hide himself in the scene giving gloves to a hooker! *(Figure 2.24)*

As Thornhill's daughter went to fetch her husband, Sir James stared at the paintings. He was amazed that this man he introduced into the Freemasons was able to hide all these Masonic signs. They were all there: the first, second and third degrees and the Mark Master Mason, along with the

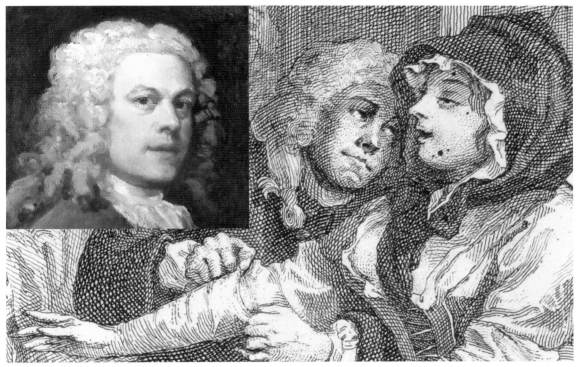

Figure 2.24: **Hogarth Self portrait, c.1735. Yale Center for British Art, Paul Mellon Collection, Yale, USA.**

Points of Fellowship and several other signs and symbols—all so cleverly hidden within six beautifully detailed paintings; it was truly amazing and like nothing he had ever seen before.

It was not that the signs were hidden randomly within a set storyline. They were made by the main characters, and so provided the basis from which the narrative proceeds. The secrets dictate the drama in each print. With some amazing character contortions, Hogarth had managed to dovetail all this into the fascinating plot of a Harlot's downfall, and create enough ambiguity in the details to allow non-Masons to devise their own separate narrative. This very idea of telling a story was revolutionary.

Thornhill pondered his son-in-law's brilliance at this remarkable camouflage. He returned to that depiction of the Grand Master in drag. He could not wait to show his fellow brethren. They would all want a copy. The artist was going to make a fortune just within the lodges alone. It was then that this realisation came over him—"the man who can produce this can afford to keep my daughter."

Indeed, we are told that *A Harlot's Progress* was an overnight success. Over a thousand came to Hogarth's studio and the prints sold out at a guinea a piece. One can imagine that much of this momentum would have been from Thornhill telling fellow brethren at Grand Lodge about his son-in-law's Masonic based artwork.

If Hogarth's first success concealed well known gentlemen exhibiting Masonic activities, then you would expect his sequel to include the same. That is exactly what the next three chapters will show. Indeed, the Harlot was nothing when you compare her to what the Rake was going to expose.

I believe that Thornhill and Hogarth had already collaborated on *Bad Taste* and *Gormogons*. Let me show you how these two artists teamed up again to produce *A Rake's Progrss*.

While the breaking of his Masonic vow had strained their friendship, the same Fraternity had brought Hogarth and Thornhill back together. As the Masonic toast goes: 'Happy to meet, Sorry to part, Happy to meet again!'

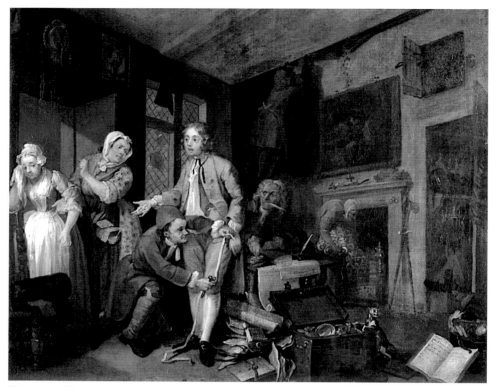

Figure 3.1 i Tom Rakewell's father has just died and Tom is preparing for the funeral.

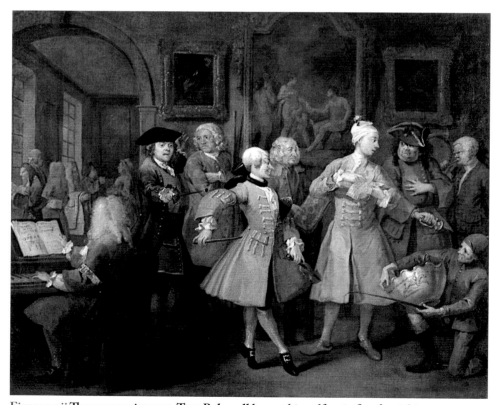

Figure 3.1 ii The young aristocrat, Tom Rakewell has set himself up in fine furnishings.

The Rake

It may look as if Hogarth has made a huge mistake in the print of the first scene—the initials on the chest (P.G.) stand for 'Positive Gripe' *(Figure 3.2)*. We are told that *'Gripe'* was the main character's original name before Hogarth changed it to the more descriptive *'Rakewell.'* I do not believe Hogarth makes such mistakes. This is actually the first of many Masonic clues in the series.

While this surname might conjure up the image of a cantankerous old man who 'gripes' and complains, Hogarth chose it for its Masonic connotation. This was the old spelling of 'grip' or handshake as would have been read in an exposé dated 1730 (my underlining throughout).

Q. How shall I know that you are a Mason?
A. By Signs and Tokens ...

Q. What are Tokens?
A. Certain Regular and Brotherly <u>Gripes.</u>

Q. What are Signs?
A. All Squares, Angles and Perpendiculars.
　　　　　—Prichard, Masonry Dissected, (1730).

There are *'Squares, Angles and Perpendiculars'* within the print made by the lantern, chest and hat box. (I have drawn a red circle around a set of squares) *(Figure 3.3)*. Masons would immediately recognise that Tom's feet are positioned at a recognizable Masonic stance. Even the discarded boots 'stand' to attention.

After learning the proper stance during his initiation, the candidate would kneel to receive his vows. This is the position that we see the tailor assuming. All elements of the ritual, (described in Prichard below), can be seen in the print. The tailor's slipper is half off, representing 'neither barefoot nor shod' and his knee breeches are unbuckled conforming to the 'bare-bended Knee' (which is also bent at a square) *(Figure 3.4)*.

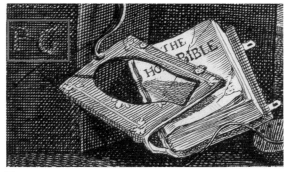

Figure 3.2

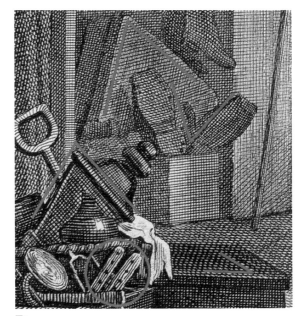

Figure 3.3

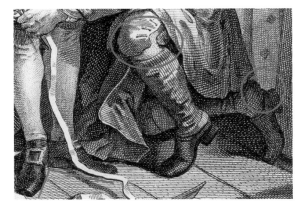

Figure 3.4

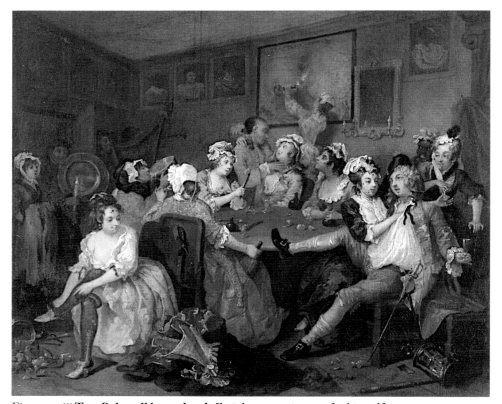

Figure 3.1 iii Tom Rakewell has ordered all night entertainment for himself.

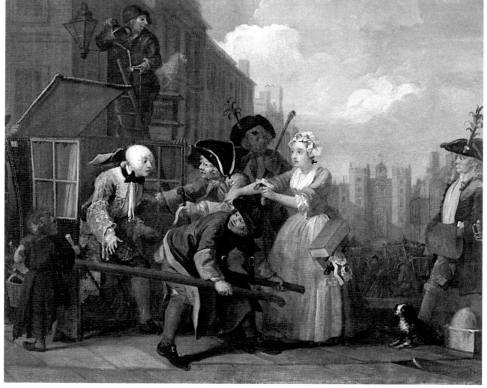

Figure 3.1 iv The first signs of Tom Rakewell's downfall.

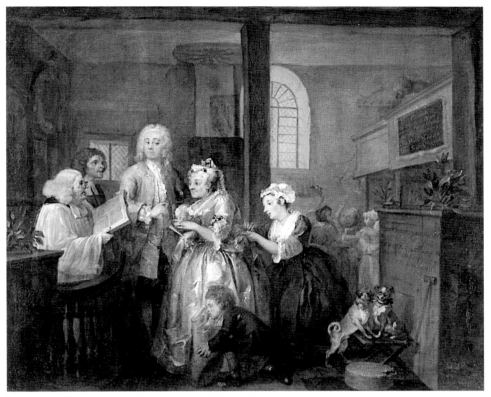

Figure 3.1 v Tom Rakewell has been saved from debtor's prison.

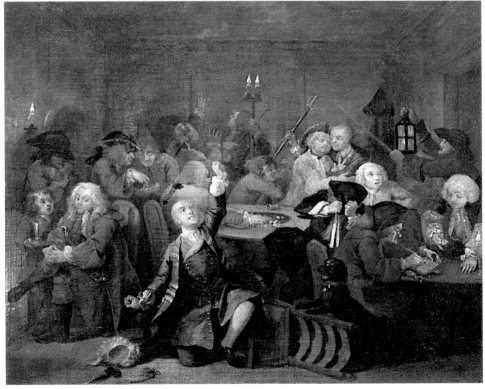

Figure 3.1 vi Tom Rakewell's gambling, second inevitable loss of fortune.

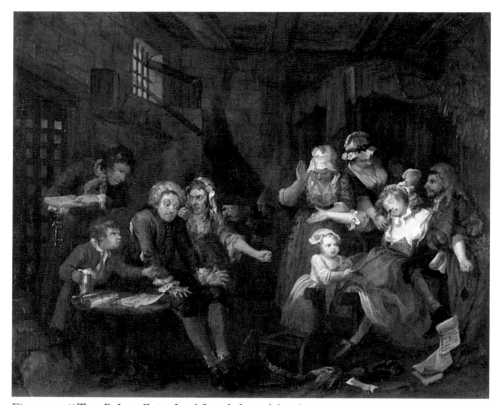

Figure 3.1 vii **Tom Rakewell sits dumbfounded in a debtor's prison.**

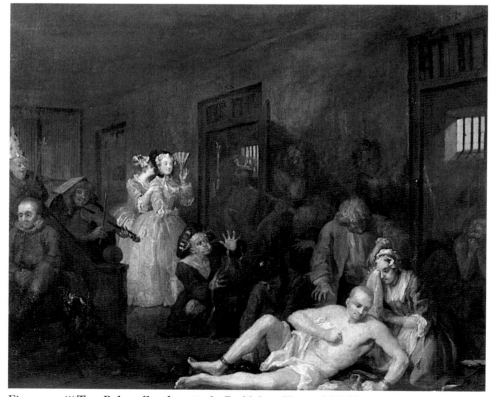

Figure 3.1 viii **Tom Rakewell ends up in the Bethlehem Hospital Madhouse.**

*Q. How did he make you
a Mason?*

*A. With my <u>bare-bended Knee and
Body within the Square</u>, the
<u>Compass</u> extended to my naked
Left Breast, my naked Right
Hand on the <u>Holy Bible</u>; there I
took the Obligation (or Oath) of
a Mason.*

Q. How did he bring you?

*A. Neither <u>naked nor cloathed,
bare-foot nor shod, deprived of
all Metal</u>*

—Prichard, (1730).

Figure 3.5

Observe Tom's fingers in the form of a compass *(Figure 3.5)*. In his other hand, he is trying to offer money to his pregnant girl-friend. In doing so, Tom is 'deprived of all metal,' mentioned in the ritual below. This comes from the biblical account of the building of King Solomon's temple in which no metal was used. Not having metal swords also helped preserve peace in the lodge.

*Q. Why was you deprived of all
metal? (Sic)*

*A. That I should bring nothing offensive or defensive
into the lodge.*

—Three Distinct Knocks (1760).

Figure 3.6

Hogarth showed this same detail concerning the metal in Scene 2 of *A Harlot's Progress*, when the young lover is without his sword *(Figure 3.6 right)*. The fact that this young man also has his knee bared and one stocking down shows that both characters are also conforming to this ancient and peculiar Masonic ritual of being *'neither naked nor cloathed.'*

This play on words can be viewed as a riddle: *'neither naked nor clothed'* (the candidate was sometimes covered by a robe); *'neither standing nor lying'* (since he was kneeling); *'neither bare-foot nor shod'* (slippers half off). These very same word-plays are to be found as riddles in folk stories collected by James Child in his 19th century anthology of ballads.

All the prescribed elements of the initiation are there, divided between the young man and his tailor. In *A Harlot's Progress*, we find this same method of dividing the several elements that make up the signs of a degree between two characters. When the harlot arrives in London, the First Degree signs are revealed between the young girl and the madam *(Figure 2.1 i)*. Scene 2 conceals the Second Degree signs that are made between the harlot and her keeper. It obviously made it easier to camouflage Masonic secrets when elements of the sign were distributed like this.

From the outset, Hogarth creates a Masonic subtext for the series. Notice the servant in a large apron, preparing the room for mourning by hanging funerary drapes *(Figure 3.7)*. This is actually part of a ritual, mentioned in a newspaper of the time: '*... there will be no Ladder in a dark Room, nor will any Mason ...*' —London Daily Post for September 3, 1724.

Hogarth hid other symbols around the room. Can you find the form of compasses created by the deceased miser's crutches? Its narrow angle resembles a set of callipers that only open slightly *(Figure 3.8)*. This insinuates that the old miser really didn't live his life to the full. The symbolism of *'encompassing your passions'* was a popular Masonic phrase, and was always represented by the sign of the compass. This message was so common that here we see the design painted on a teapot *(Figure 3.9)*.

A similar angle is to be found in the tavern scene, fabricated by the Rake's sword and scabbard *(Figure 3.10)*. They are open at a wider angle than the old man's crutches, because they 'encompass' much more. Hogarth cleverly hides this Masonic symbol by presenting us with the image of a drunken rake who has hastily put his sword through the part of the scabbard (known as the frog). The blade and scabbard now

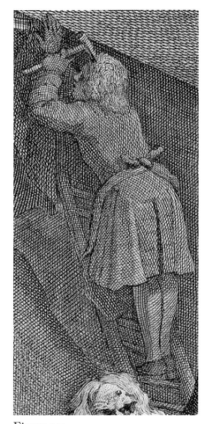

Figure 3.7

Figure 3.8

form the triangular shape that Masons would instantly recognise as a depiction of a compass. They would realise that it was a critique on the Rake's lifestyle which 'encompasses' broken glass and scattered pills (probably a treatment for syphilis). The Rake has fought with an innocent night

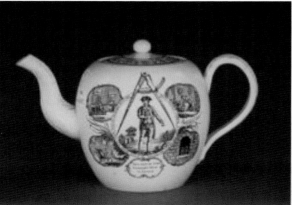

Figure 3.9

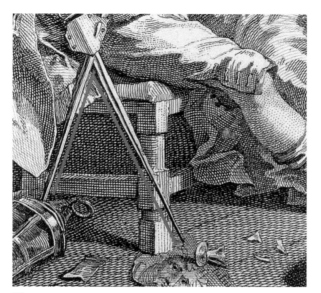

Figure 3.10

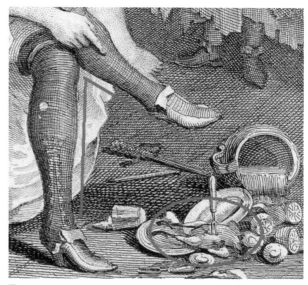

Figure 3.11

guard, stealing his battered lantern and broken cane. Rakes were notorious for torturing night guards with a cruel game of 'pinking,' in which they pricked the guards with their small swords.

By Scene 3, this Rake has become a poster child for vice and corruption and Hogarth has used this Masonic concept to criticise his wayward habits of drinking, drugs and violence.

Masons can be consoled in that Hogarth is showing that this Rake has been initiated into a foreign Order, very different from the Premier Grand Lodge.

DETAILS OF THE FOREIGN ORDER OF FREEMASONRY

Evidence of this foreign degree lies between the legs of the posture woman *(Figure 3.1 third scene)*. The angle made by her calves encompasses a pile of dishes and discarded fruit used to make the punch which the other prostitutes are all drinking. A fork has been stabbed into a chicken that is swimming in the effluent that pours from an overturned chamber pot *(Figure 3.11)*. Hogarth uses this disgusting image to show that the ritual prescribed by the Premier Grand Lodge has been abandoned by the Rake.

An exposé of the time, entitled *The Mason's Confession (1727)* divulged the manner in which a candidate is first received in the Lodge: *'After one comes in at the door … the open compasses pointed to his breast.'* Hogarth had already represented this element of the ritual in picture form when the old bawd points a fan at the Harlot's chest *(Figure 2.2)*.

You can imagine the artist wondering how he was going to represent these words again using something different. What else pricks a naked breast like a compass? Hogarth's solution was to draw a two-tined fork stabbed into the left breast of a chicken.

This one detail has generated so much commentary over the years. For centuries, millions have been disgusted by the image of a whole uneaten chicken sitting in a pool of effluent, unaware of its brilliant Masonic message.

In the previous chapter, Freemasons may have been shocked that Hogarth had revealed the Master Mason's password, by writing it in in graffiti on the ceiling of a Harlot's bedroom *(Figure 2.18)*. Hogarth identifies this foreign order by portraying the password for its degree. To show that I am not divulging anything that is not

already available to the general public, here is the Wikipedia page that explains it:

> *According [to the modern] Masonic historian Arturo de Hoyos, the word 'Jabulon' was first used in the 18th century in early French versions of the Royal Arch degree. It relates a Masonic allegory in which Jabulon was the name of an explorer living during the time of Solomon who discovered the ruins of an ancient temple. Within the ruins he found a gold plate upon which the name of God was engraved.*

How could Hogarth display this three syllable word on a large golden plate? His impish mind must have thought of the 'posturing plate' over which prostitutes danced so that men could see up their skirts! This then is the reason that the artist features the said plate being ceremoniously brought into the tavern to a fanfare of music *(Figure 3.1 iii left).*

I have included the Masonic symbol for the exposure of the word 'Ja-bu-lon,' with the name of God 'Je-Ho-Vah' *(Figure 3.12 bottom).* Above it I compare it to a detail from the print. You might notice that the man's finger is pointing at a name on the plate *(Figure 3.12 top).* It is 'John Bonvine,' a rather French sounding last name. Indeed, if you pronounced the name with a French accent you get 'Jean Bon-vaen.' This sounds as much like 'Ja-bu-lon' as Hogarth could get.

Freemasons who recognize this password from a well-known higher degree, may not be aware that it actually comes from an older ritual that was being practised in France.

In *A Harlot's Progress,* when Hogarth divulged the password for the Third Degree, *(Figure 2.18 MHB in the graffiti),* he positioned the word right next to the corresponding physical signal for that degree, (made by the two doctors). Hogarth does the very same here, placing the password right next to the hand signal that is associated with this degree. It comes from a detail in the Bible: *And the Lord said unto Moses, Put now thine hand into*

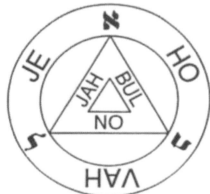

Figure 3.12

thy bosom ... and when he took it out, behold his hand was leprous as snow.' —Exodus 4:6

Notice the illustration of the sign from Duncan's exposé *(Figure 3.13 third illustration).* It is next to the same sign which we already saw outside Burlington's gates.

Hogarth did not want to be too obvious and so found two other clandestine ways of showing this signal of a hand being held to one's breast. First it is shown by the pregnant ballad singer, who holds her stomach *(Figure 3.13).* Look how skilfully the artist blends this in by making the singer appear to be warning her fellow prostitutes as to her pregnant state.

Another way of showing this secret sign, in which a hand touches a man's breast, was to use a

 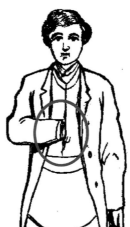 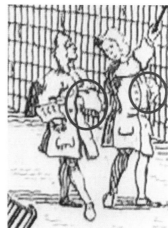

Figure 3.13

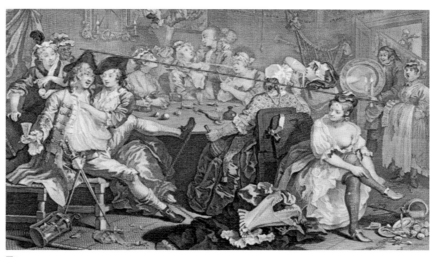

Figure 3.14

woman's hand. Notice how the prostitute strokes the Rake's chest *(Figure 3.13 left)*.

The feet of both the Rake and the ballad singer are the only ones positioned at right angles. The artist had to contort the Rake's legs by putting one foot up on the table, but he kept it at a right angle to his other foot. Hogarth drew the Rake's right foot in an unobstructed manner, so you can notice that his feet are at a square *(Figure 3.14)*.

Hogarth links these two sides of the room by naming the ballad the 'black joke' and then inserting the face of an African woman right above the

Rake. The woman locks eyes with the ballad singer. This then connects the two corners of the room in which these two characters are positioned.

While I understand that these elements are rather subtle when viewed in isolation, when all the hints are connected, they do indeed show the sign, password and foot position of this ancient degree that was originally practised in France.

WOULD THE RAKE PLEASE SHOW HIMSELF

To understand why Hogarth would focus on this foreign degree, we have to take the mask off the Rake and see who is being portrayed here.

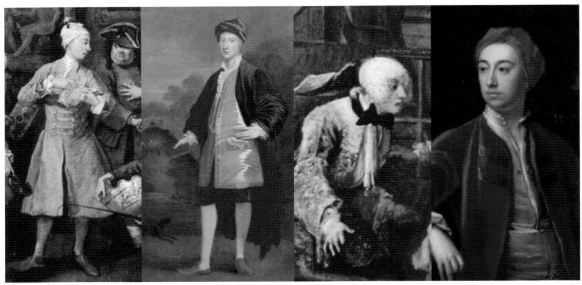

Figure 3.15: #1 & #3 from A Rake's Progress. #2 'Man, probably Burlington. Attributed to William Aikman' from a Christie's Catalogue. #4 Portrait of Richard Boyle, 3rd Earl of Burlington, Jonathan Richardson (1667–1745), National Portrait Gallery, London.

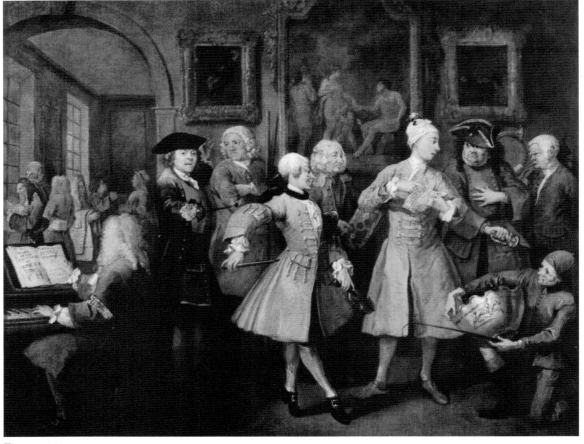

Figure 3.16

Compare Hogarth's Rake *(Figure 3.15 first and third painting)* to two known portraits of Richard Boyle, the 3rd Earl of Burlington (1694–1753). I hope you can discern the facial similarities between these four portraits. I can show many other links that prove that Hogarth cast Lord Burlington as his Rake.

For a start, Burlington's personal history fits into the narrative of *A Rake's Progress*. In the first scene, Hogarth pokes fun at Burlington's grandfather. He was known to have been a miser.

In his biography of the 1st Earl of Burlington (1612–1698), T.C. Barnard relates the *'obsessional attentiveness'* (sic) to *'arbitrarily impose footling economies.'* A few details tie into the first scene. The 1st Earl had a habit of *'reclaiming broken chairs and worn pewter dishes borrowed by poorer relations'* (see crammed cupboard); *'endless pernickety queries'* of dining expenses (diary quote of restaurant cost); and descriptions of his *'woeful house and a woeful dinner.' 'He fussed constantly ... about putting down cakes of rat poison in his Youghal house.'* This might explain the emaciated cat. *—All from 'Lord Burlington: Art, Architecture and Life,' edited by Toby Barnard, Jane Clark. (Hambleton Press, 1994).*

In the same publication, Jane Clark gives evidence of how the 2nd and 3rd Earls spent lavishly and got into huge debt. Hogarth refers to this in the Scene 4, where the Rake is arrested for monies owed. In 1737, Sir William Heathcoat noted that Lord Burlington owed 170,000 pounds, (millions by today's standards).

Burlington squandered his money on buildings and on his patronising circle of artists. Hogarth shows this in Scene 2, by featuring the Rake surrounded by foreigners, desperate for his patronage *(Figure 3.16)*.

Indeed, several of Burlington's favoured artists appear in this famous scenario. We can identify Handel, Pope, and a reference to the castrato Senesino. Hogarth exhibits his xenophobic passion by showing the French dance master and fencing teacher pushing back the English staff fighter (James Figg) and English gardener

Figure 3.17

(Charles Bridgeman). They stand at the back, looking despondent at the ridiculous fawning they see before them. This all takes place at the Rake's morning levée, a pretentious French habit which Hogarth mocks here.

This preferment of foreign talent was the reason why Hogarth first cast Burlington in *The Bad Taste of the Town (Figure 1.14)*. It featured masquerades and foreign operas which Hogarth would have despised as foreign fads.

However, these grievances were nothing in comparison to the foreign degree that Burlington was promoting. Hogarth shows Burlington in that act of discarding the English system of Freemasonry in preference for this foreign version.

The artist gives us a sordid detail to show his contempt for Burlington's foreign affiliation. It involves the letter 'G'—the most important of Masonic symbols. Burlington is shown to have urinated onto this sacred letter which has been concealed within a chamber pot *(Figure 3.17)*. It is a brilliant, yet sacrilegious inclusion which the stripper has been pointing it out to us for almost three centuries!

Figure 3.18

Notice how the handle has been manipulated to form the lower part of the letter.

The flow of urine has not been drawn in at the top of the pot (*(Figure 3.18 my red circle)*. A liquid could not flow in this manner, but it makes the letter more recognizable, and is proof of Hogarth's intentions. This unmistakable addition serves to reinforce other claims that Masonic symbols are being represented.

We already discovered how important the letter 'G' was to Desaguliers and his new degree. In urinating into the sacred Masonic symbol for the deity, Burlington has shown a huge disdain for the Premier Grand Lodge. Lord Burlington is presented as the kind of odious character that would desecrate such a sacred symbol in this manner.

However, this defamation was nothing in comparison to the malicious attack that Hogarth would serve upon Burlington in the third scene of *A Rake's Progress*. To fully comprehend it, however, we must take a moment to understand this foreign Order to which Hogarth took such aversion. Curiously, it is all given away by Burlington's red slippers!

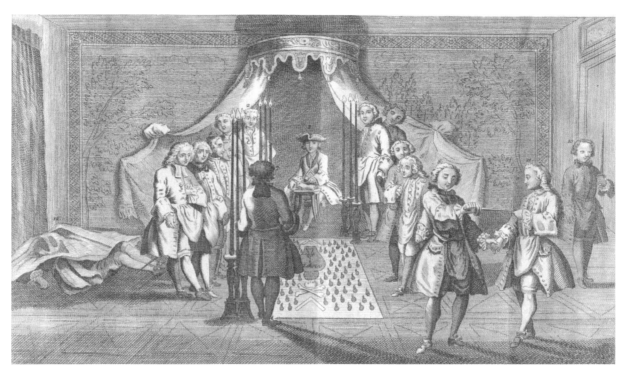

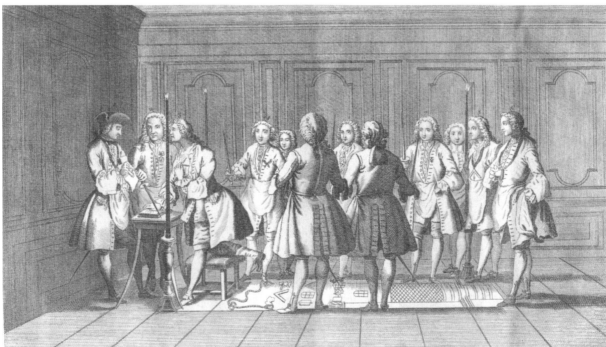

Some of the same Masonic ritual covered in Hogarth's Progresses are found in these French prints. The top illustration shows the candidate being received in the Lodge at the point of a sword (Figure 2.2 right), like the fan pointing at the Harlot's heart. The other print shows the points of compass at a naked breast, symbolised by the forked chicken in Figure 3.11. —*Assemblée de Francs-Maçons pour la réception des Apprentifs. Léonard Gabanon, 1740.*

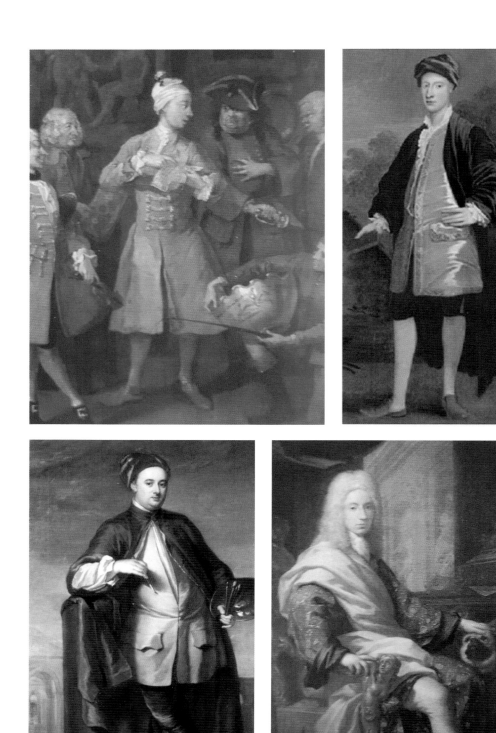

Figure 4.1: #3 William Kent (1723), by William Aikman (1683–1731). #4 Thomas Coke, 1st Earl of Leicester, Francesco Trevisani, (1656–1746).

Chapter IV
Red Slippers

Figure 4.2

Our Rake, the 3rd Earl of Burlington, stands proudly in his levée scene, sporting a pair of bright red slippers *(Figure 4.1, top left)*. I found him wearing the same footwear (with matching banyan), in another painting of the same time period *(top right)*. His architect, William Kent *(bottom left)* wears the same coloured shoes and headdress. Finally we see Burlington's friend, the Earl of Leicester, wearing red slippers *(bottom right)*.

Now that you are adept at hunting for Masonic symbols, did you notice that both depictions of Burlington have him standing at a square, and both with his fingers in the form of a compass? *(Figure 4.2)* The same Masonic finger-form is made by the Earl of Leicester *(Figure 4.2 right)*.

What is important for this chapter is that both Burlington and Leicester are dressed in the colours red, blue and green. These colours are repeated many times in Burlington's world. Take a look at the plans for his famous Villa at Chiswick *(Figure 4.3)*. The Red, Blue and Green Velvet rooms are clearly marked. Burlington also used these colours when designing Leicester's Palladian mansion, Holkham Hall.

Both these houses have been described as having ulterior functions. Their Masonic themed gardens contain obelisks, pyramids and easterly facing sphinxes. Most historians agree that Burlington's Villa was not designed as a home, and most suspect

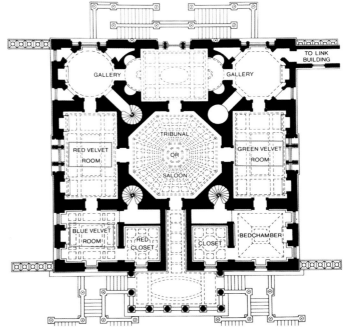

Figure 4.3

it was used as a lodge of some sort. As we will discover, these colours were important to the version of Freemasonry that Burlington was promoting.

A red velvet room of particular interest was incorporated into the design for the Palladian Mansion at Wanstead (North London), which Burlington designed for another Freemason—Viscount Castlemaine. It was situated just 10 miles from Burlington's House in Piccadilly (which also has a 'red velvet room)'.

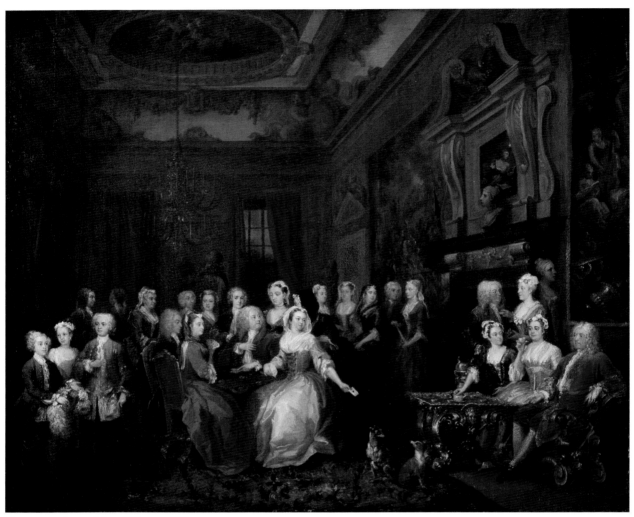

Figure 4.4: **Assembly at Wanstead House, 1728–1731.**

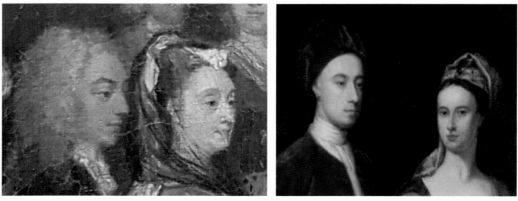

Figure 4.5: **Left, detail from above. Right, Rt. Hon. Richard Boyle and Lady Dorothy Savile, 1723, by William Aikman (1683–1731).**

In 1728, Hogarth was commissioned to paint a large group of family and friends in the house *(Figure 4.4)*. Viscount Castlemaine sits proudly with his daughters on the far right, dressed in bright red, as his wife plays cards. She intimates their great fortune by showing him the ace. In the notes to the painting, the Tate Gallery declares that none of the friends have been identified. Let me draw your attention to one couple in particular.

I believe that we can see the Duke and Duchess of Burlington at the card table, and I offer their portraits to compare *(Figure 4.5)*. If Burlington does not look happy, it is because he apparently did not enjoy playing the game!

I had always noticed that the blue coat and red dress worn by this couple seemed to stick out in an awkward manner *(Figure 4.6)*. It made me think that Hogarth was trying to communicate something. It combined with the green dress on the left to bring attention to these colours in particular.

There are three main streams of Freemasonry: the Blue, Red and lesser known 'Green Lodge' (covered in Notes.) Burlington's 'true-blue' coat will be explained in Chapter 5. This Chapter will deal with those bright red slippers and the 'Red Degrees' that were associated with them.

THE RED DEGREES

The 'Red Degrees' get their colour from the biblical story upon with they are based. The high-priests of King Solomon's Temple wore robes of blue, gold and scarlet (mentioned 25 times in Exodus). The Bible tells us that the priests removed their shoes when in the Temple and wore sandals (or slippers). Indeed, when Joshua brought the Ark to the Temple, a soldier commanded him to take off his shoes. *'And the captain of the LORD'S host said unto Joshua, Loose thy shoe from off thy foot; for the place whereon thou standest is holy. And Joshua did so.'* — Joshua Chapter 3.

This was a perfect component to add to a ceremony that was based on biblical details. In a modern version of the 'Red Degrees' (as they are still called today), the *'Captain of the Host'* commands

Figure 4.6

the candidate to remove his shoes and replaces them with sandals or slippers. (*Duncan's Monitor, p 217*).

By featuring the Rake in red slippers, Hogarth was exposing Burlington for his association with this group. These 'Red Degrees' were indeed part of a foreign order that had been brought to France by England's old enemy—the Scots. It would eventually become part of what is now known as the 'Scottish Rite' (see copious notes).

The 'Red Degrees' are a collection of French 18th century ritual which were called 'Ecossaise' in France because they were developed by exiled Jacobite Scots in Paris. —An Introduction to the High Degrees in Freemasonry, Henrik Bogdan (Heredom, Vol. 14 2006).

'Jacobite' is Latin for 'followers of James;' the last Catholic King of Britain, who had been banished by the Protestant Duke of Orange who invaded Britain in 1688. James II (1633–1701) fled the country to the protection of his Catholic cousin and

ally, Louis XIV (1638–1715). For almost a century, Britain lived under threat of invasion from a French army which they feared would reinstate the Stuart line.

These Jacobite exiles had their barracks just outside Paris (Saint Germaine-en-Laye), and after that in Rome. They formed Masonic lodges in both countries where they developed a particular ritual that would help further their plight. This colourful ceremony would also help their English brethren to recruit powerful gentry to the cause.

'The aristocratic exiles established lodges in that country which were purely associations in which the royalist conspirators encouraged one another, and by communication with their brethren in England kept alive the Jacobite spirit.' —'What Freemasonry is,' Charles Bradlaugh, (FPC, 1885).

We know that Burlington visited the lodge in France with an excuse of buying artwork from Lord Melfort, who was stationed there. Burlington would have been initiated into this 'Red Degrees' which he then tried to promote in England.

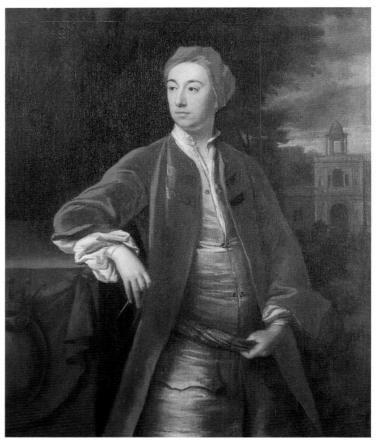

Figure 4.7: Portrait of Richard Boyle, 3rd Earl of Burlington, Jonathan Richardson (1667–1745).

MASONIC RITUAL 101

In medieval England, trade guilds staged biblical themed pageants. We still reenact the birth of Jesus during our Christmas plays and some churches present the 'Passion of Christ.' An older form of 'Mystery Plays' is still performed in York (which claims some of the oldest Masonic lodges). Each trade picked a parable relevant to their profession. The carpenters told the story of Noah's Ark, while fishermen took the story of their patron, Saint Peter. The bakers reenacted the parable of the loaves and fishes, and the stonemasons related the account of the construction of Solomon's Temple, detailed in the Book of Kings. Premier Grand Lodge developed this story to form their Third Degree, which is still reenacted today.

The Book of Ezra gives the history of the destruction of this first Temple by Nebuchadnezzar II. Zerubbabel began rebuilding the temple with the help of the High Priest Joshua. It was this story of the rebuilding of the Temple that was adopted by the Jacobite Freemasons in Paris as the theme to their ritual. It fit the story of their diaspora perfectly.

Whilst in exile, James II allowed his closest associates to fabricate certain degrees in order to extend their political views. —Encyclopedia of Freemasonry, Lenning (1822).

The parallels are obvious. Just as the first of temple in Jerusalem had been obliterated, so the first House of Stuart had been 'destroyed' by Cromwell when he beheaded Charles I. James had been exiled in a similar way to Joshua, who had

been sent into the desert for seventy years. However, just as Joshua returned to rebuild Jerusalem, so James would come back to London to take back his rightful throne. When the Jacobites were writing in code to each other, 'The Promised Land' meant Britain, and London was referred to as 'Jerusalem.'

Historically, the Stuarts had maintained a strong connection with Freemasonry. James I is actually featured as King Solomon in Rubens's ceiling painting in the Whitehall's Banqueting House (1636). James II's son (James Francis Edward Stuart, 1688–1766), declared all his ancestors to have been Grand Masters. Although dismissed in Britain as 'the Old Pretender,' he was recognised abroad as James III and will be referred to as such.

The Jacobites believed in the Divine Right of Kings, and were planning for their rightful return. Burlington believed in this manifest destiny so deeply that he had already built a structure to stage the coronation. It would take place at Chiswick.

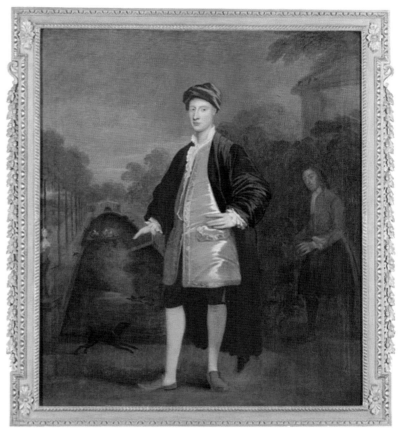

Figure 4.8: '**Man, probably Burlington. Attributed to William Aikman,**' from a Christie's Catalogue.

BURLINGTON'S GRAND PLAN

While many historians now acknowledge that Burlington built his villa as a Masonic Lodge, I will show that it was, in fact, part of a grand theatre that would dramatise the coronation within a Masonic theme.

Three pieces of evidence to support this. The first is this portrait of Burlington in his bright red coat *(Figure 4.7 painted c.1717 by Jonathan Richardson, 1667–1745)*. He stands proudly in front of his vision of the Temple he was planning for the coronation. The compasses signify that he is Master of the Lodge. Although the final structure was not as grand, it does show the man had a vision early on.

Burlington incorporated the biblical account of Joshua's seventy-year exile by building his Villa to be a 'cube square' of exactly seventy feet. *'For thus saith the Lord, That after seventy years be accomplished at Babylon I will visit you, and perform my good word toward you, in causing you to return to this place.' —Jeremiah 29:10.*

As Solomon's Temple was made from *the tall cedars of Lebanon*, so Burlington planted these trees around his Villa. Chiswick is famous today for its tall cedar trees. (There is a pseudo-masonic organization known as the *'Tall Cedars of Lebanon'*). A line of cedars can be seen in this second portrait in which Burlington stands at a square with his fingers showing a compass *(Figure 4.8)*. I was so fortunate to have found this on a Christie's auction website (attributed to William Aikman' *(1683–1731)*). It

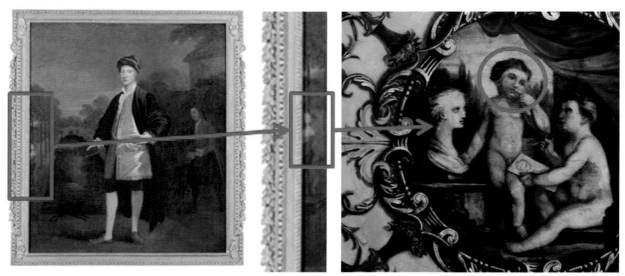

Figure 4.9: **Right, detail of Putti at Chiswick Villa.**

gives a wonderful glimpse as to what Burlington was planning.

Burlington holds a slender book which we can take as the Old Testament, or maybe the Book of Joshua, as that is the persona that James would take.

Follow Burlington's hand and you can just make out a statue of a woman on the other side of the canal *(Figure 4.9, close-up detail in central illustration).* I believe this is James III's wife, Maria Clementina Sobieska (1702–1735). The fact that the bust in the painting is half hidden adds to the subversive nature and so potentially to the veracity of this claim.

In her ground-breaking research, Jane Clark exposed much new evidence in her chapter entitled 'Lord Burlington is Here' (*Lord Burlington: Art, Architecture and Life, edited by Toby Barnard, Jane Clark. London, The Hambledon Press, 1995.)*

Clark tells us that Burlington and Kent brought a bust of the Queen back with them from Paris so that they could copy her likeness. They incorporated it into the painting above which adorns a ceiling in Chiswick (third of the three illustrations above). You can see the young Princes, Charles Edward Stuart ('Bonnie Prince Charlie') and his brother Benedict, who is making a hush sign next to their mother's bust *(Figure 4.9, on right with red circle).* I

identify this finger sign as Masonic in my notes to Chapter 2.

Burlington seems to be gesturing to the canal, which he constructed next to the temple. This would also have some significance, as James was often referred to as 'the King over the water' (meaning that James had been exiled across the English Channel).

Jacobites would pass their wine glasses over a water glass to symbolise this phrase. For some time 'finger bowls' of water were banned from dining tables to prevent this treasonous act. The 3rd Earl of Burlington used this phrase 'over the water' as a code for James (Clark). You can see the 2nd Earl of Burlington demonstrating such a subversive action in a portrait at the end of this chapter where he poses holding his ring above a glass *(Figure 4.13). Our Earl planned to outdo his father's symbolic action by creating a dramatic piece of outdoor theatre.*

Burlington had his architect, William Kent, design a double cascade of water on either side of the approach road to his house *(Figure 4.10).* At that auspicious moment, when James III drove his carriage through the gates at Chiswick, the water would flow. To those that gathered to witness the spectacle, it would appear that the King had been transported back 'over the water.'

Figure 4.10: Cascade at Chiswick, England. Photo Credit, Ricky Pound from Pallas Tours.

In his biography on Kent, Timothy Mowl mistakenly criticises the architect for this. While he points out that although Kent *'drew more sketches for this than for any other single feature at Chiswick, his cascade was and remains a mistake. The actual idea of running a carriage drive on a shelf between two waterfalls was dramatic and inspired [but] it only produced a flow lasting for a minute or two.'*

—*William Kent—Architect, Designer, Opportunist. T. Mowl, (Pimlico 2007).*

Mowl had failed to see this cascade as a magnificent piece of theatre, which only needed to flow as the carriage carrying *'the King over the water'* arrived. It was never supposed to be a permanent feature with a continuous flow. Locals of Chiswick town recently installed an electric pump in an attempt to keep the water flowing, but even modern technology failed where classical imagination had succeeded.

Mowl muses that *'It would have been interesting to have eavesdropped on the conversation between Burlington and Kent the first time the Cascade malfunctioned.'* What would have been interesting is two flamboyant men, trying to create a piece of theatre reminiscent of the French court. James I, had a fanfare when he arrived in London in 1604, as did his grandson in 1660. Perhaps having a ceremony on private grounds was planned for safety, as James' return would have started another civil war. I believe the plan was to announce the crowning as a fait accompli, in the hopes of avoiding any unrest.

Burlington was certainly theatrical. He was manager of *The Opera of the Nobility* (with its anti-Hanoverian slant). We get an idea of the spectacle that Burlington was dreaming up as the royal carriage entered the grounds. Those in the inner circle would first attend a private ceremony in the small reconstruction of Solomon's Temple in the garden. A larger reception might have been planned in the main villa. This is only accessible from a spiral staircase of fifteen steps, a curious architectural

Figure 4.11: Tribunal Salon, Chiswick House, London. Photo Credit Ricky Pound from Pallas Tours.

detail, taken directly from biblical descriptions of King Solomon's Temple. All the Royalists would pass through Green, Blue and Red rooms until they came to the main reception hall—the 'inner sanctum.'

James might notice the Scottish thistles, and several Masonic decorations which Kent had designed throughout the villa. These have been covered in other publications too numerous to mention. There has been much research done to demonstrate that the ceiling paintings show the first depiction of elements of a Masonic ritual. *(Figure 4.12 from Chiswick ceiling showing putti holding masonic tools).* I do hope the historians of Chiswick are able to use Hogarth's exposé of Burlington to discover more connections that further their case.

In the centre of the main Tribunal Salon, there is a huge star *(Figure 4.11),* the emblem of James' Order of the Thistle, which has Masonic connotations that have also been covered in length elsewhere.

James III would stand in the centre of this star and look up at a portrait of his grandfather Charles I. The frame was surrounded by grapes—a known symbol for the Divine Right of Kings.

Burlington had hung other paintings in the hall to prove that his ancestors had stayed loyal to the cause. They still hang at Chiswick. Opposite the portrait of Charles I, is a painting of the 2nd Earl of Burlington, making a classic Jacobite sign by running his ring around his glass *(Figure 4.13 detail from the painting of Charles Boyle, 2nd Earl of Burlington, 1660–1704 by Sir Godfrey Kneller, 1646–1723).*

There is another family portrait showing the young 3rd Earl standing with the greyhound of loyalty and a pug—a known symbol of secrecy.

Burlington had planned this all out. In his dream scenario, the freshly anointed King would pull out his cheque book and repay his debts (8% interest was promised for larger sums). *'His*

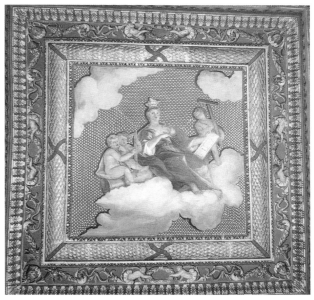

Figure 4.12: Ceiling from Blue Velvet Room, Chiswick House, attributed to William Kent.

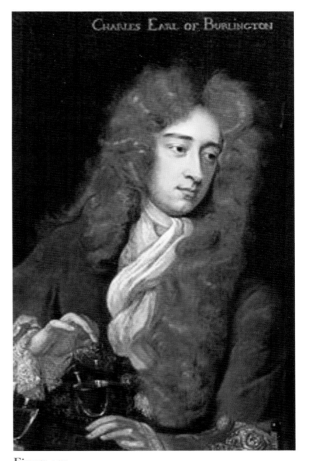

Figure 4.13

Majesty will in his own hand give receipts for such money payable at his Restoration with interest at 5 per cent. 8 % for any considerable sum of money that shalle be advanced to him.' (Clark)

'... Burlington may therefore have been a covert Jacobite. It is not unlikely that this was so, for, after all, the Boyles owed their meteoric rise to the Stuarts, and Burlington would not have been alone in hedging his bets.' —James Stevens Curl, Georgian Architecture in the British Isles 1714–1830, (Swindon, EHBooks, 2011 p.22).

Figure 4.14

Burlington had borrowed more money than was necessary to build his Villa at Chiswick. He directed the surplus funds into the Jacobite coffers. He also had fundraisers in London, and used operatic performances as a cover-up to collect donations. Maybe we should re-examine the popularity of opera with this in mind!

THE FUNDRAISING RAKE

Let us return to Hogarth's Rake for some obvious (but as yet unnoticed) links to Burlington's clandestine fundraising activities. The accusation of money laundering lies before the Rake at his levée scene *(Figure 3.1 ii)*. The scroll lists huge amounts of cash given 'for one night's performance.'

Hogarth includes a very serious accusation of treason in the title of the opera *Artaxerxes* that is written on the scroll *(Figure 4.14)*. The storyline of *Artaxerxes* featured the overthrow of a king. It comes from the Book of Ezra which also inspired the 'red Degrees.' The opera was first performed in 1730 in Rome by an all male cast with castrati. *Artaxerxes* was dedicated to James III (and his Queen). This was Hogarth's accusation of treason, thrown down like a gauntlet at Burlington's feet!

These societies were inextricably linked to the Stuart cause and in the post–Restoration period a new higher degree of membership emerged ... to which it seems Burlington belonged. By the mid 1720s Jacobite freemasonry went underground, adding to the mystery. —Roy Strong, The Spirit of England: A Narrative History of the Arts, (Pimlico, 2000, p248).

The government was well aware of this threat and became alerted to Burlington's involvement. England's first prime minister, Robert Walpole, was quoted as saying of secret Jacobites—*'these are the men we have most reason to be afraid of.' (Clark)*

The Prime Minster was known to have a huge spy network, and Burlington was on their radar. Two lists of suspected Jacobites include his codename 'Mr. Buck.' The Jacobite threat in 1731 was at a 'red alert,' as there was an escalation in plotting. This was the same year that Walpole started opening Burlington's letters, which could only be done if there was 'suspected treasonable correspondence.' (Clark)

It was time to order an assassination. Guess who they called in to do the dirty work?

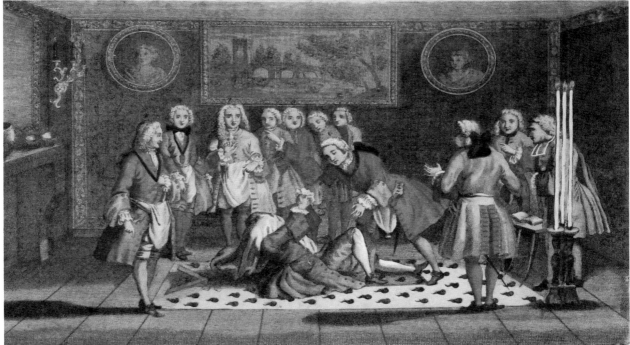

Another two prints from the same series (page 49), showing the ritual of the Master Mason. Note the top print shows a 'circle of swords' that is apparently still practised in some lodges in Bristol. Masons will note that the sheet covering the candidate becomes his blindfold, as he is raised to the Third Degree.
—*Assemblée de Francs-Maçons pour la réception des Apprentifs. Léonard Gabanon, 1740.*

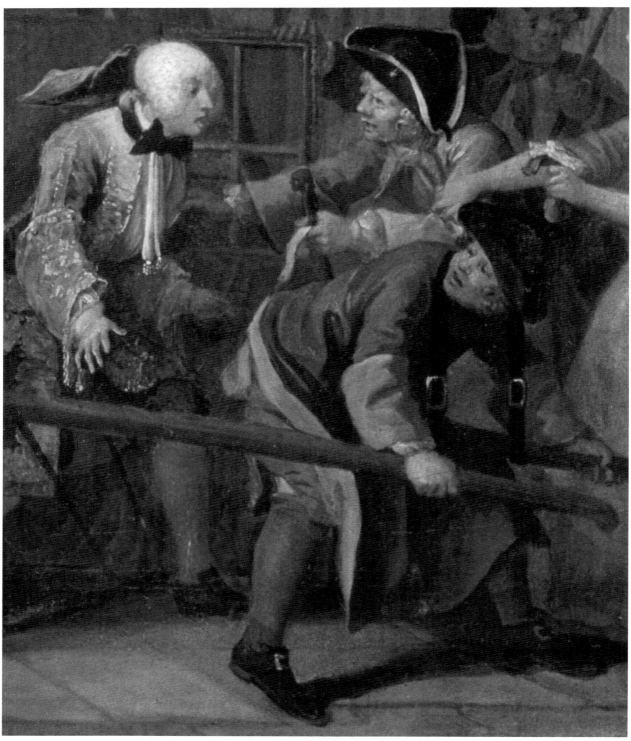

Figure 5.1

Chapter V

Sodomy

Robert Walpole became Britain's first Prime Minister in 1721. His son, Horace was an art critic who scribbled this note into the margin of his journal: *'After Hogarth published A Harlot's Progress, the Opposition offered him a large Subscription, if He would paint the Progress of a Minister. He refused.'* —Horace Walpole, 'Anecdotes of painting in England' (1762–71), (Murray, 1887).

I believe that the 'minister' was Robert Walpole, who was continuously mocked by Hogarth's fellow satirists, who all had cast Walpole as a shady character in their works.

John Gay's smash hit *The Beggar's Opera (1728)* ridiculed Walpole's known corruption by using his nickname 'Bob Booty' as one of the thieving characters. Gay's sequel, 'Polly,' was banned by Walpole because it slandered him so directly. Fielding too, mocked another of Walpole's nicknames in his title *Tom Thumb The Great (1730)*, as did Swift in *Gulliver's Travels (1726)* with the corrupt character of 'Flimnap the Treasurer.' Finally, Pope mocked Walpole as 'The Wizard' with his 'cup of forgetfulness' in *Dunciad (1728)*.

Having Walpole cast as the central character in Hogarth's Rake would have been perfect for the opposition's ceaseless ridicule. Something must have stopped Hogarth from joining his friends and fellow satirists on this bandwagon.

After 1724, Hogarth was most definitely behind Walpole's Party, (the Whigs) and stayed loyal for the rest of his life. I will show that this was due to his relationship with Thornhill. Hogarth had just been reunited with the family and he was not going to be cast out again.

Hogarth had supported Sir James Thornhill as a Grand Lodge Officer when he first attacked Burlington with *The Bad Taste of Town* and the *Gormogons*. I believe that this next round of Burlington-bashing was also influenced by his father-in-law. This time it was from Thornhill's position as a pro-Walpole Member of Parliament.

(Sir James was MP for Melcombe Regis 1722 to 1734). It is no coincidence that in the years in which Hogarth painted *A Rake's Progress*, he was living in the Thornhill's house in Covent Garden, (having moved there in 1731).

The Thornhills were proud of their ancestors who fought with Cromwell. Hogarth had married into a family of anti-Jacobites.

This chapter will show how Hogarth was supplied with incriminating details that enabled him to assassinate Burlington's character. Hogarth was such a sharp shooter that you did not notice that he had already fired an accurate volley.

Hogarth had to lure his victim outside so he could get a good shot at him. He waited until he could paint the Rake in the street, which occurred in Scene 3. As the Rake fell out of his sedan chair, Hogarth made the accusation that Burlington was a homosexual.

You can plainly see that in the action of falling forward, both of the Rake's hands are outstretched, ready to grasp the buttocks of the man bending down in front of him *(Figure 5.1)*. There is no other reason for the chairman's breeches to be undone at the knee, exposing the flesh of his leg. His coat is pulled up his back and the tails are pulled forward and to the side, clearly exposing his behind. His right heel is raised, as if presenting his rear, and he has a somewhat expectant look on his face. Burlington's expression is first viewed as that of surprise, but in the light of this reading, it could also be construed as one of ecstasy.

There are other sexual hints. The two men close to the Rake are grasping phallic canes *(Figure 5.2 red circles)*. The debt collector presents the Rake with a thin white receipt for payment which, when read in this sexual light can be a representation of ejaculation as it is perfectly positioned with the cane for this lurid effect. The cane has a human head carved into the top which completes this male-on-male suggestion.

Some commentators have been confused by what they have referred to as the '*clumsy lamplighter anointing the innocent rake.*' I believe the oil is being poured between the two men below as a lubricant for this suggestion of sodomy *(Figure 5.3)*.

There is a horse behind the lamplighter, advertising a saddle shop that has never been identified as ever being in that street *(Figure 5.3 red box)*. I believe there is a sexual connotation made by the position of this rather errant detail directly above the couple in question. If you were to follow the image down, it would fit between the two men in the suggested act of sodomy. It would then imply the word 'ride,' a common sexual slang.

I also believe the artist adorned the men's hats with leeks as a suggestion of their excited state. It has always been interpreted as a celebration of Queen Caroline's birthday (which fell on St David's Day with its tradition of wearing this Welsh national emblem). Every commentary starts with this birthday explanation instead of considering Hogarth's phallic joke.

We might notice the sneer on the face of the figure who stands separate from the group *(Figure 5.4)*. Hogarth insinuates he is not homosexual by giving him a muff as a euphemism for his heterosexuality (muff has been used as slang word for pudenda since 1690s). In 1807, the commentator George Smith mentioned that it was '*a somewhat strange ornament for a gentleman.*'

There is an inexplicable bolt of lightning that hangs over Burlington, which Hogarth added to the print at a later date (not shown here). I believe this is a storm of damnation to show Hogarth's scorn on this homosexual relationship.

This was a dangerous exposure for the Earl in an age when homosexuality was a capital crime. In 1726, a well documented raid at 'Mother Clap's Molly House' in London, had forty men arrested for being homosexual. Three were subsequently hanged at Tyburn.

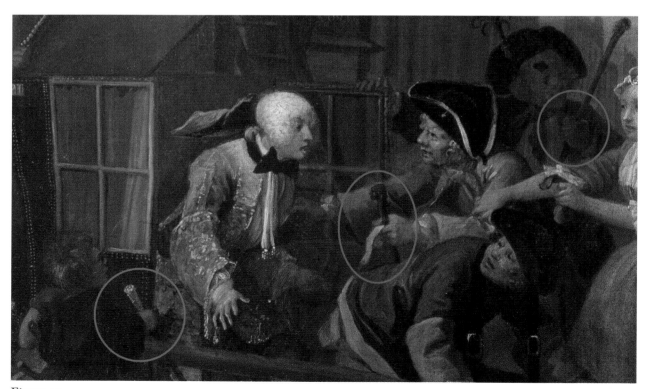

Figure 5.2

Hogarth was making a serious accusation indeed, and if challenged, this would have necessitated a duel over the slander. I believe that Hogarth knew he was being a little 'close to the edge' here. In the Rake's levée, Hogarth paints the dueling sword pointed directly at himself, the painter *(Figure 5.5)*. There is no other character in any of Hogarth's works that stares out at the artist in such a menacing manner.

The British Museum's Catalogue of Prints describes how Hogarth made more changes to this Arrest Scene than any in the series. The fact that the artist eventually obscured the reference to sodomy, with an unconnected group of beggar boys, is further evidence that Hogarth was aware that his accusation might have been a little too obvious *(Figure 5.6)*.

I believe that for this reason, Hogarth also painted over the face of the chairman to make him less recognizable. You can detect this alteration when you compare the colour of other faces in the painting. I believe the original version would have shown a likeness to Burlington's main lover—William Kent.

William Kent (1685–1748)

Kent never married, and lived in the Burlington household for 40 years. He is reported to have died in his master's arms, and was buried in the Burlington family vault. *'Their relationship was clearly something rather different from those ordinarily subsisting between a nobleman and his professional retainer. They became extremely fond of each other as the letters between them show.'* —Architecture in Britain, 1530 to 1830, John Summerson, p310.

'The close relationship was subject to much envy and speculation (... the relationship might have had its amorous dimension)' —William Kent: Designing Georgian Britain, (V&A, 2013).

Kent's biographer, Timothy Mowl calls him *'a high camp Yorkshire bachelor'* and insinuates he slept to the top with his other patrons: *'Judging from the implication of those effete silk stockings, a gift from Earl Shaftsbury described as 'a new boyfriend.'*

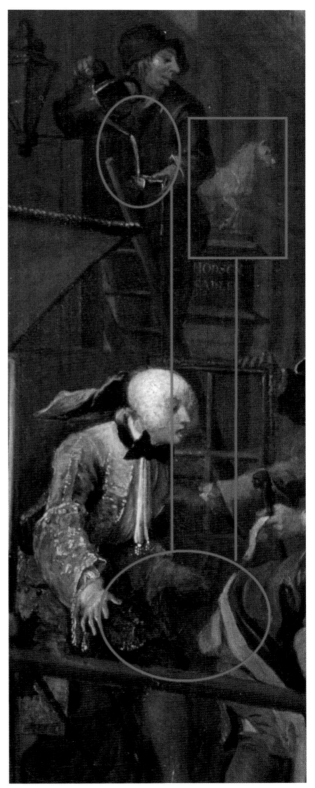

Figure 5.3

It seems likely that [Shaftsbury and Kent] did actually get together.' 'Kent was to prove himself consistently as a charmer, not of women, but of men,' '...constantly in need of a soft cushion to lay his soft Head and rest his tender Tail.' —William Kent: Architect, Designer, Opportunist. Timothy Mowl, (Pimlico, 2007).

ALEXANDER POPE (1688–1744)

Another of Burlington's lovers was the poet Alexander Pope, who, like Kent, lived with Burlington for some time. He described his stay to a female confidante: *'at my Lord Burlington's … where we are to walk, ride, ramble, dine, drink and lie together.' (Clark)*

Hogarth features Pope's relationship with Burlington by including him at his levée in Scene 2. He stands in a corner, rehearsing his *'Epistle to a Rakewell,'* the title of which is written on the script he holds *(Figure 5.7).*

Figure 5.4

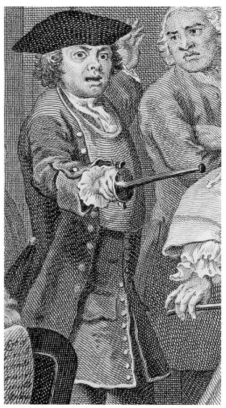

Figure 5.5

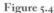

Pope wrote a famous sycophantic poem entitled *Epistle on Burlington (1731).* However, it was not widely known that Pope allowed Burlington to read a rough version of the poem before publishing it in order to gain his approval. Indeed, I believe that Pope brings a copy of the *Epistle,* which you can see hidden under his hat *(Figure 5.7 bottom left, red circle).*

Pope was mocked for being small in stature which is why Hogarth might have positioned a very tall man behind him here. Burlington called Kent 'Big Senior' and Pope 'Little Senior.'

Pope writes about a party at Burlington's house with the lines: *'And Burlington's delicious meal / For salads, tarts, and peas.'* These ingredients make for a curious meal until you realise that *'Salad, tarts, and peas'* are all homosexual slang terms.

GEORGE FREDERICK HANDEL (1685–1759)

Handel was another of Burlington's 'muses' who lived with the Earl for three years. *'Handel and Homosexuality: Burlington House and Cannons Revisited,'* McGeary, *(JRMA, 2011)* describes Burlington's homosexual relationship with the famous composer. *'It has been claimed that the homes of the Earl of Burlington and the Duke of Chandos were homosexual or homoerotic settings.'*

Another poem about a party at Burlington's house mentions Handel in homoerotic vocabulary of 'melting,' 'thrills' and 'vein' (slang for penis).

There Handel strikes the strings, the melting strain,
Transports the soul, and thrills through every vein
There oft I enter, but with cleaner shoes.
For Burlington's beloved by every muse.
— 'Trivia,' John Gay (1716).

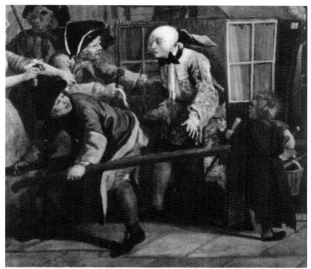 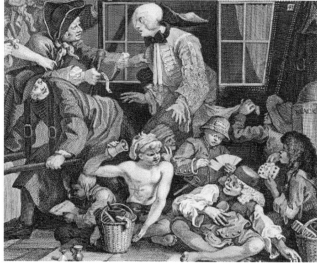

Figure 5.6

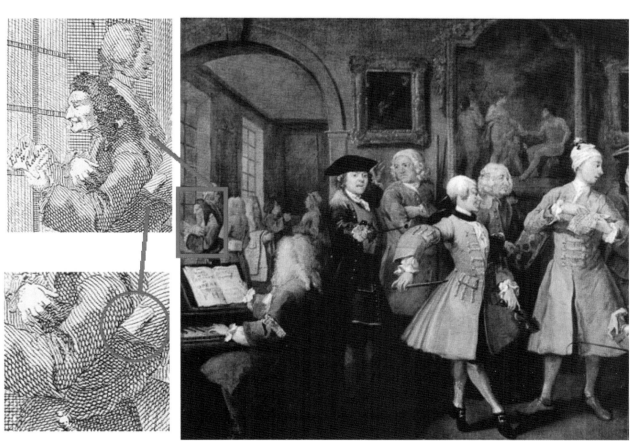

Figure 5.7

John Gay was the author of *The Beggar's Opera* also lived with Burlington. His biographer, David Nokes believes that Gay was *'at least a latent homosexual.'* I believe the only reason he is not slandered in the scene is that Gay died in the year of the painting.

CASTRATI

As manager of *'Opera of the Nobility,'* Burlington promoted and managed many castrati on the London stage. Hogarth cleverly includes them all into the scene by listing their names on the scroll that hangs from the pianist's chair and tumbles before Burlington.

The wording on the scroll *(Figure 5.8)*, lists the castrati in *'The Rape of the Sabines'* and is ambiguous in its eroticism. The *'Performers'* are described as 'ravishers' for *'one Night's Performance.'* They are described as *'condescended,'* which literally means 'to go down together.' The choice of *'Orpheus Charming ye Brutes'* might have meant Farinelli, as Orpheus withx his bewitching voice *charming ye Brutes* of Burlington and his gay English friends.

Hogarth mocks their Italian names by breaking up the syllables: *'Fari[nel]i, Sen[esi]no, and Car[esto]ne.'* This feminises Farinelli into 'Nel' and creates 'Carne' or 'meat' for the famously attractive Carestone.

Indeed, the scroll itself seems to add to the phallic nature of the scene. Its limp form might be alluding to the belief that castrati could not get erections *(Figure 5.8)*.

At the end of the scroll is a paper depicting Farinelli, with the famed sycophantic cry *'One God! One Farinelli.'* This wording, on a ribbon, is often cited. However, I believe the ribbon is only there to create the semblance of a penis. The circular shape drawn on the paper below the scroll adds a head to the member. It relies on this very detailed script to create this idea and so was not used in the painting. *(Figure 5.9)*.

Hogarth features Kent, Handel, Pope and the Italian castrati to imply that Burlington surrounded himself with a homosexual entourage at his levée (a French custom of entertaining in one's bedroom.) Hogarth goes further and insinuates that the young man is standing in his bedroom, surrounded by a circle of cocks!

The homosexual lord is flanked by two paintings of 'celebrated cocks' that crane their necks towards him and set the scene by hinting at the word 'cock.'

We read how Hogarth loved the street signs of London, especially those that used the rebus (where pictures represent words or parts of words). A popular example of this sign was to represent the last name 'Cox' with two cockerels. Hogarth might have recalled this sign when including the painting of fighting birds.

Each patron-seeker is depicted with some phallic object connected with their 'trade.' The fiddle, bow, sword and whip are all held from the groin area and pointed towards their patron. *(Figure 5.10 my red arrows)*. The effeminate dance master, with an oversized hair bow, holds his compact dancing master's violin as if it were his own undersized penis. In his other hand it looks as if he is grasping that of the French fencing master behind him.

The bodyguard makes the same suggestion when he grabs his sword so close to the horn player as to look like he is handling the man. The manner in which the horn's mouthpiece is drawn adds to this phallic theme, insinuating oral sex.

The jockey seems to be holding out his whip in a way that could suggest the presentation of his member to the Earl. The tip of his whip tantalizingly opens the Lord's coat. Interesting to note that in the preparatory sketch for this piece, the same jockey holds his whip under his arm as Hogarth was yet to create this analogy in that early version *(Figure 5.11)*.

Hogarth continues this slander in the wording of the letter from the bodyguard which suggestively reads 'his Sword may Serve you.' Moreover, 'Wm. Stab' (William) can be read as 'Will Stab' with its overt sexual connotation. This adds another example of a character name having a clever

Figure 5.8

Figure 5.9

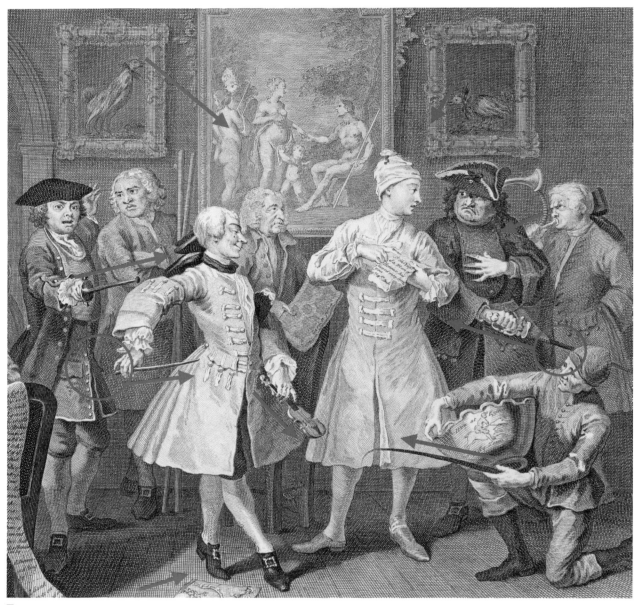

Figure 5.10

double meaning. We can add it to Tom 'Rakewell' and Sarah 'Young' from this series. Even the title of this print has a double meaning. 'Levée' (to rise) describes an *erect* circle with the setting of the Lord's bedchamber.

Notice how the gay references are not made by the casual additions of peripheral details. The vehicle for the slander is the main action of the narrative and takes centre position in the scene.

Hogarth chose this particular scenario of a levée because it allowed him to feature a circle of men, and insinuate a gay orgy.

The same can be said about the arrest scene which centers on the rake falling out of his sedan chair—a perfect vehicle to portray a sexual act.

Figure 5.11

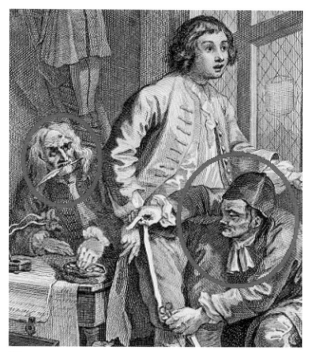

Figure 5.12

HOMOSEXUALITY THROUGHOUT
A RAKE'S PROGRESS

When we look back to Scene 1, we find more evidence that Hogarth had set up this homosexual slander from the start. Observe the tailor who stares at the young man's groin *(Figure 5.12)*. The end of his tape-measure adds a phallic hint to what is on the tailor's mind. My editor, Larry Young, pointed out that the *'tailor's measure'* is a euphemism for a male member. He also noticed that the blades and handles of the shears in the tailor's fist resembled a shaft and testicles *(Figure 5.13)*. Tailors were often accused of being homosexual.

However, the smoking gun that pulls all these hints together, is the most definite outline of an erection that is shown within the folds of the young man's breeches. It is clearly pointed towards the tailor's mouth *(Figure 5.14)*.

The lawyer directly behind the pair has a quill in *his* mouth. In the light of the other two more overt sexual scenes, this subtle suggestion of oral sex does fit the theme.

You could not draw a more realistic penis on young Lord Burlington's breeches *(Figure 5.14 left)*. The same suggestive trouser-crease can also be

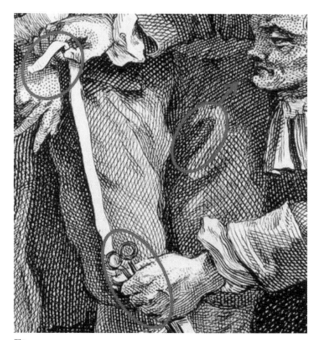

Figure 5.13

71

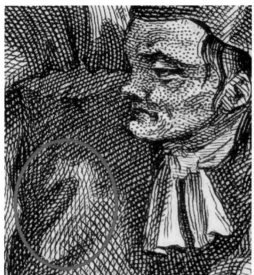

Figure 5.14

seen in the original painting *(Figure 3.11)*. Hogarth hides a similar phallic shape within the folds of a loincloth, held by a satyr in his frontispiece for Samuel Butler's *Hudibras (1725) (Figure 5.14 right)*.

I believe that Hogarth had the idea of featuring a tailor on his knees first, and *then* created the scenario around that central theme. This was Hogarth's way of starting with an obvious innuendo, and then disguising it as something else. The levée and arrest scenes also start with the sexual slander as the central action and then introduce details that obfuscate the intended message.

To add to his disdain of Burlington's gay circle of Jacobite supporters, Hogarth adds another message of contempt in this first print. Return to the first image *(Figure 3.2)* and see if you can find the clever work riddle which I believe has been hidden within the depiction of the Bible. By cutting out a replacement sole from the book's cover, Hogarth created the word 'Horible' from 'Holy Bible' *(Figure 5.15)*.

This brilliant piece of 'biblical' word-play, links into the Arrest Scene (print not shown), to which Hogarth added ominously dark clouds and a lightening bolt over the scene of suggested sodomy. This was a second indicatation of God's wrath against homosexuality.

Figure 5.15

GOVERNMENT SANCTIONED SLANDER

I believe I can show that this whole slander of Burlington was orchestrated by the Walpole administration. The government wanted to dissuade other powerful members of the gentry from joining Burlington's Jacobite group by claiming it was a circle of homosexuals.

Walpole had recently found out that Burlington was the main agent, working for James III. The Prime Minister had personally broken up the latest Jacobite attempted coup, known as the Atterbury Plot of 1722. Walpole had been criticised for holding the conspirators illegally without bail or trial. He eventually had one of the ring leaders (Christopher Layer) sentenced to death, but the execution was delayed by six months as the government tried to find more information as to who else was involved.

Those arrested would have been tortured, and Burlington's name could have come up several times. Another of the key conspirators locked up in the tower for six months was Burlington's own cousin, Charles Boyle (4th Earl of Orrery). Jane Clark's article in *Lord Burlington—the Man and his Politics: Questions of Loyalty* gives much evidence to suggest this. Burlington's chaplain had christened Layer's daughter Clementina (after the Queen), in Burlington House and in the presence of a proxy for James III, the child's Godfather.

It is no coincidence that Hogarth was working on his anti-Jacobite prints (*Gormogons, Burlington Gate, Kent's Burlesque (detailed in Notes to Chapter 6)),* all in the years that followed Walpole's investigations of 1722.

We read that the next big threat of Jacobite plotting returned in 1731, which was exactly when Walpole started opening Burlington's letters. This could only be done if there was 'suspected treasonable correspondence.' [Clark] This was the date of Hogarth's *The Man of Taste (coverend in Notes to Chapter 7),* which exposed Burlington for his connection to James III.

Once again, a link between the timing of Jacobite activity and the time when Hogarth produces his work raises suspicions of government involvement.

James Bramston's *Man of Taste (1733)*

Another reason to suspect the coincidence of Hogarth's work is that in the very same year that *A Rake's Progress* was painted, James Bramston

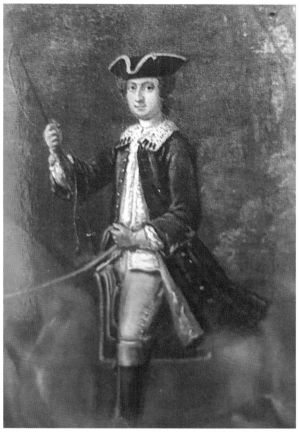

Figure 5.16

dedicated a poem to Lord Burlington which also exposed the Lord's politics and homosexuality. Its title, *'Man Of Taste,'* had been inspired by Hogarth's previous print (*'The Man of Taste' 1731*) which, as we will see in Chapter 7, also slandered Burlington. I believe the following lines, taken from the poem are meant to expose Burlington's sexuality.

– 'Not to writings I confine my pen,
 I have a taste for buildings, musick, men.'
– 'I'd try if any pleasure could be found,
 In tossing-up for twenty thousand pound.'
– 'I'm English born, and love a grumbling noise.'
– 'I love young colly-flow'rs if stew'd in cheese,
 And give ten guineas for a pint of peas.'
 (pea is slang for penis as they are the same word in Latin)

Bramston also slandered William Kent, with a damning reference which described the casual nature with which Burlington recruited him: *'From out my honest workmen, I'll select, A Bricklay'r, and proclaim him architect.'*

Bramston's poem seems to be in line with *A Rake's Progress* as it mentions the same characters in the levée lineup: both feature 'Figg the Prize-fighter,' the gardener Bridgeman, and a fox hunter. There is a subtle reference to sodomy when mentioning the jockey (also present in Hogarth's levée): *'I would with Jockeys from Newmarket dine, And to Rough-riders give my choicest wine.'* Although much of this is speculative, it cannot be ignored when read with all the other homosexual references.

Senesino, the celebrated castrato, is also featured in both print and poem with the accompanying hint at fellatio: *'The Stage should yield the solemn Organ's note, And Scripture tremble in the Eunuch's throat. Let Senesino sing ...'*

Bramston was well versed in the ways of the political world. Indeed, his previous poem was entitled *The Art of Politics*! I believe he makes a reference to Burlington's Jacobitism in the very first line of the poem: *'Those who of courtly France have made the tour.'* This calls out the Lord for covering his visits to the French court while claiming he was on the Grand Tour. (There is much evidence of this in the notes).

I believe that the poem alludes to the Stuart's Scottish blood with a reference to the bagpipes, adding 'lofty' for royal, along with the word 'secret:' *'My soul has oft a secret pleasure found, In the harmonious Bagpipe's lofty sound.'*

Later in the poem, there is mention of Kent helping to build Chiswick: *'First bid him build me a stupendous Dome, Which having finish'd, we set out for Rome.'*

This also accused Burlington of going to Rome, possibly in order to inform James that Chiswick was ready for him. *'Building so happily I understand, That for one house I'd mortgage all my land.'* By building Chiswick ('that one house'), Burlington was planning to give up 'all the land' (of Britain) to the Stuarts.

A final line from Bramston addresses Burlington: *'I would caress some Stableman of note, And imitate his language and his coat.'* I believe this refers to the 1st Duke

Figure 5.17

of Richmond, who loved horse riding and was certainly a *'Stableman of note.'* He was the illegitimate son of King Charles II, and his mistress Louise de Kérouaille. As to *'imitate his language,'* Richmond's French mother meant he spoke fluent French. Richmond was well acquainted with Burlington and the Jacobite cause.

> *'By 1714 against this backdrop of fox hunting the 1ʳᵈ Duke of Richmond (Charles Lennox) had become firm friends with Richard Boyle, the 3ʳᵈ Earl of Burlington who was well known in inner circles for his Jacobitism. The regular foreign trips undertaken by the architecture-loving Earl were more probably a cover for clandestine meetings. Whenever he went hunting between 1714 and 1722 Lord Burlington may well have been meeting men who had travelled from France, landing just five or six miles away at Chichester or a little more remotely at Itchenor. '*
> —The Hunting Dukes,
> Thehistoryguide.co.uk taken at 2016.

'I would caress some Stableman of note, And imitate his language and his coat.' Along with the possible homosexual reference with the word 'caress,' the 'coat' must be referring to the blue jackets which became the uniform of these Jacobite foxhunters. The Blue Coat Hunt in Staffordshire seemed obsessed with this colour code and once dressed a fox in red and clothed the hounds in tartan!

BLUE COATS

The idea of wearing a blue coat to support the Jacobites was commented on by Walpole's son Horace.

In his letter to George Montagu (19 July 1760), Walpole noticed this same blue colour in the *'portraits of the Litchfield hunt in true blue frocks, with ermine capes.'* He called this a *'loyal pun.'* The Jacobite Earl of Litchfield (another of Charles II's illegitimate grandsons), was a member of *'The True Blue Jacobite Beaufort Hunt.'* Detail of the

Figure 5.18: Walpole Salver, Victoria & Albert Museum, London.

anonymous painting, *Earl of Litchfield, and his Uncle Shooting in 'True Blue' Frock Coats* shows his ermine cape clearly *(Figure 5.16).*

Walpole's son was a Member of Parliament (1741–68) and would have been privy to this information. Hogarth was a lowly painter and must have been supplied such political intrigue, and then encouraged to include them in his work. This would explain Burlington's blue coat in the Wanstead gathering mentioned before *(Figure 5.17)*. We talked about the Masonic significance of the red and green dresses in Chapter 4. Now we can add the blue coat as another example of Hogarth using his art to make a subversive statement.

There seem to be so many overlaps between Bramston's poem and Hogarth's prints. For these to have been produced in the same year, (that saw an increase in Jacobite activity) is strong evidence that both artists had been given classified information about the enemy.

> *The House of Stuart were not unwilling to accept the influence of the Masonic Institution, as one of the most powerful instruments*

whereby to effect their purpose … it was in the fabrication of the high degrees that the partisans of the Stuarts made the most use of Freemasonry as a political instrument.
—Albert Mackey, *The History of Freemasonry*, Ch. 30) 1910. (Republished, Dover Publications (2008)).

A REWARD FOR GOVERNMENT WORK

There is evidence of a possible reward that Hogarth might have received from Walpole. In the same year (1728) that Hogarth started his Wanstead painting (exposing Burlington and Kent), Walpole gave Hogarth a prestigious commission. He was to design the plate that George II presented to the Prime Minister *(Figure 5.18)*. Hogarth would also eventually be made Sergeant Painter to the King. Walpole was known (and despised) for handing out such royal positions for political gain. Hogarth was known for delighting in any connection to royalty.

A government reward also followed *A Rake's Progress*. It was in that year of publishing that Walpole passed the copyright law to prevent other printers from stealing Hogarth's work. Known today as *Hogarth's Act*, this might have been compensation for his work in slandering the Jacobites.

There were two members of Walpole's family on the committee. Sir Robert Walpole might have helped to get this bill pushed through so that Hogarth's slander could be published.

Whatever Walpole's other tactics were, they worked. Burlington stopped attending the House of Lords—a move that has never been fully explained. He might have left politics to focus on the next uprising of 1745.

A new layer of intrigue is added to these paintings when you realize that the Sergeant Painter was a politician, who was housing a very clever young engraver. And that the government had commissioned this artist to slander an enemy of the State with a link to Freemasonry.

'[The Premier Grand Lodge] was a Liberal-Protestant and Hanoverian Masonry, founded with the express purpose of countering the Jacobite-Catholic Masonry. Desaguliers, with the approbation of the British Government, utilized the old decadent Masonry to establish a corporation to counter the influence of the Stuarts.'
—*Who were the Freemasons? The Tablet*, (International Catholic News), A. Gordon Smith, 5th November 1950.

It certainly helps to explain a character trait of Hogarth's upon which everyone comments—his pugnacious attitude. Hogarth had an unbridled confidence to take fearless jibes at his enemies. I was amazed to find that he was never challenged to a duel. We might now assume that our protagonist was assured some protection from the Government and was therefore beyond reproach.

Hogarth lived in Thornhill's house while he painted *A Rake's Progress*. Sir James Thornhill could have been at his shoulder to encourage the slanders, and maybe even suggest some. In turn, Thornhill was in close connection with his parliamentary leader and able to give assurance to Hogarth that the Government would protect him if he were challenged.

Hogarth might have felt he was untouchable as he was now acting as an agent of the crown, fighting for King and country. This would certainly help to explain his vicious attacks on Burlington's lover and Hogarth's rival—William "Knt".

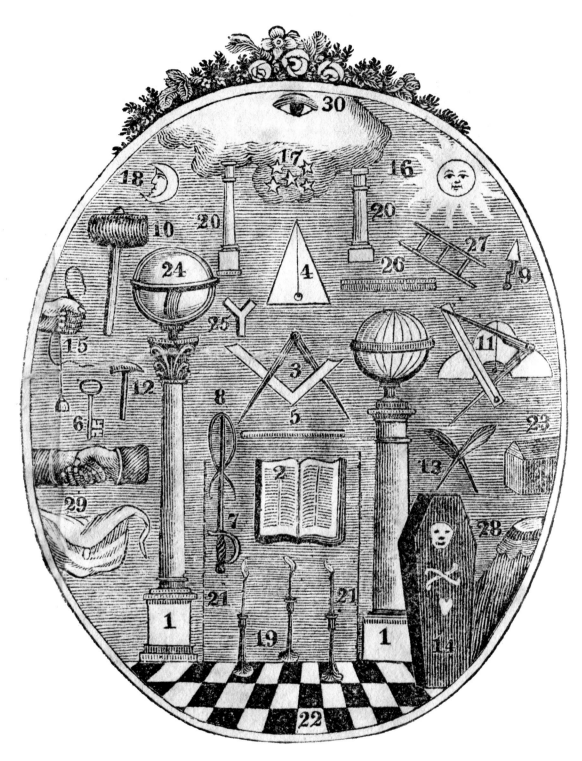

This frontispiece to a Masonic monitor shows the large number of symbols from which Hogarth could have chosen to hide within his work.

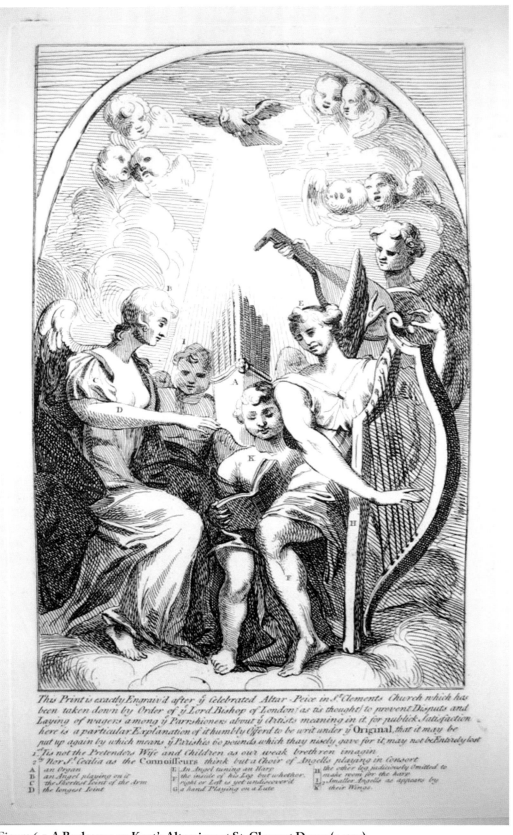

Figure 6.1 **A Burlesque on Kent's Altarpiece at St. Clement Danes (c.1725).**

Chapter VI
William KNT

Figure 6.2: Details from various drawings by William Kent.

Hogarth is well known for his mockery of Kent's work in *A Burlesque on Kent's Altarpiece at St. Clement Danes (1725) (Figure 6.1)*. This print ridiculed Kent's inability to draw appendages. Take a look at the jumble of legs and an awkwardly long neck.

This well documented derision of Kent's lack of perspective is seldom shown alongside a few of the actual inaccuracies that were universally ridiculed. Notice the clumsy position of the legs in these details from Kent's work. *(Figure 6.2)*.

Horace Walpole had some harsh words: '... ill executed, the wretchedness of drawing, the total ignorance of perspective, the want of variety, the disproportion of the buildings, and the awkwardness of the attitudes.'

Historians have struggled to explain how this talentless artist managed his rapid rise to royal patronage. The Victoria and Albert Museum recently had a huge exhibition on the long lasting effects of Kent's influence: *'Kent—Designing Georgian Britain.'* It touted him as 'the most influential artist of his time.' There is no explanation as to why Kent received some damning reviews that are listed in the exhibition catalogue:

- 'A terrible artist whose paintings were below mediocrity' and whose portraits 'bore little resemblance' to the sitter.
- 'a great waste of fine marble,' 'often third-rate or disastrous,'
- 'creator of 'preposterous' designs,' 'terrible glaring' interiors and 'clumsy features.'

Even when Kent became *Principal Painter to George II*, the King sensibly declared that he would never sit for a portrait by him. Kent's lack of talent was well known.

Horace Walpole had negative comments for Kent's interiors also, notably at Wanstead House, which he called *"proof of (Kent's) incapacity"* as an artist. You will remember that Wanstead was where Hogarth gave us a glimpse of Burlington's Jacobite

Figure 6.4

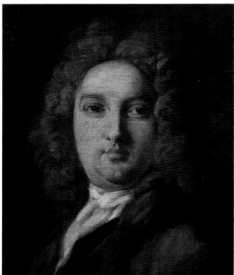

Figure 6.5: **Portrait of William Kent (1718)**
Benedetto Luti (1660–1724).

Figure 6.3: **Detail from Wanstead Assembly.**

colours *(Figure 4.4)*. Hogarth also used this family portrait to make two attacks on William Kent.

Hogarth conveys how Kent was inferior to him in technical skill with a clever inclusion that has never been detected before. To use a phrase from the painter's world, Kent could 'not hold a candle' to Hogarth. This means that Kent was a mere assistant, who was only allowed to help his master with the lighting. Hogarth includes Kent in this portrait doing just that—lighting a candle to help the true master (William Hogarth) at his work. I have enlarged the figure just visible behind Lord and Lady Burlington *(Figure 6.3 and 6.4)*.

Everyone had assumed this was just a servant lighting candles of a chandelier. However when one compares this tiny detail to Kent's

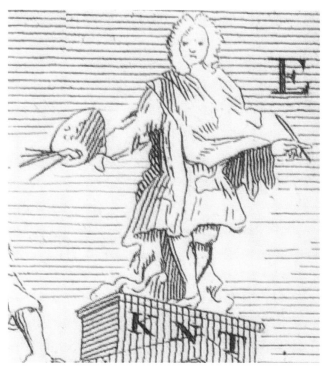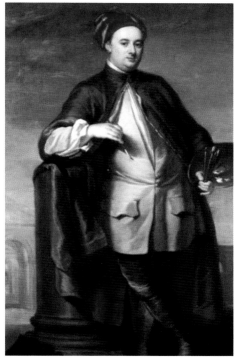

Figure 6.6: Painting on right, William Kent (1723) by William Aikman (1683–1731).

formal portrait *(Figure 6.5 by Benedetto Luti, 1718)* one can see a facial similarity, as well as the same colouring of his wig. I am sure it is no accident that Kent would appear directly above his lover, Lord Burlington.

The figure holds his toga/cape in the same way that Hogarth depicted Kent when he mocked him as a statue in *The Man of Taste (1731)(Figure 6.6 left)* and *The Bad Taste of the Town (1724)(Figure 1.15)*. I believe Hogarth is showing him in the same painting smock as the one that Kent is wearing in his full portrait by William Aikman *(Figure 6.6 right)*. We have seen this portrait of Kent in his red slippers before. It was commissioned by Viscount Castlemaine and hung in the hall of this house at Wanstead.

'William Aikman was commissioned to paint a full-length portrait of Kent, palette in hand to hang over the fireplace in Wanstead's entrance hall. Such a prominent

tribute was without precedent in English culture. Not even Lord Burlington was prepared to go this far. So Kent's work at Wanstead must have been highly valued.'
—*'Kent the Painter' V&A catalogue, p117.*

You can imagine Hogarth's affront. They had been classmates together at drawing school, and Kent was now enjoying lucrative commissions, painting frescos in a country mansion. Meanwhile, poor Hogarth was still painting boring family portraits which he derided as 'phismongering.'

'Kent's jealous fellow artists resented his rapid rise to royal and aristocratic patronage through Burlington's influence.' 'This 'over-rated sycophant,' hid his lack of talent behind 'civil and obliging behaviour.'
—Vertue quoted in Mowl's biography.

Homophobic Hogarth believed that Kent was receiving generous patronage by bestowing sexual

Figure 6.7

Figure 6.8

favours on the Lord. He decided to add a hint of this homosexual relationship between artist and patron in the Wanstead Assembly.

Part of this slander was picked up by the historian Arthur S. Marks, who noticed a depiction of Kent's face in the carved figure of the heavy mantelpiece. In his review of this painting, Marks thought that featuring Kent as a stone statue indicated that his taste had 'petrified.' Let me introduce a far more salacious reading of this same detail.

WILLIAM KENT AS A HERM

Kent had adorned Burlington's Chiswick garden with many Romanesque statues known as 'herms.' This ancient form curiously shows male genitalia on a smooth body *(Figure 6.7).*

Hogarth would have seen Kent's obsession with these homoerotic forms as something he could mock. Hermaphrodites had long been a symbol of androgyny or effeminacy and sometimes portrayed in Greco-Roman art as a female figure with male genitals.

Observe one of the herms in Chiswick garden *(Figure 6.8, first illustration).* Kent also featured them on either side of a mantelpiece in the Villa *(Figure 6.8, second illustration).* Hogarth simply continued this trend by depicting Kent as a herm, which he added in his painting as a support for

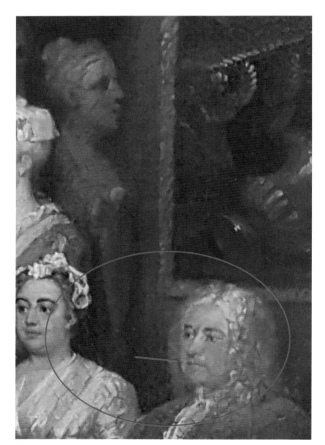

Figure 6.9

the mantelpiece next to Castlemaine *(Figure 6.8, third illustration)*.

Notice that the statue is androgynous looking. It has a wreath at the neckline that almost resembles cleavage. This corner of the painting has been carefully spaced so that you can see the base of the statue and therefore its male appendage.

Now comes a further more serious slander— Kent's groin is lined up with Castlemaine's mouth *(Figure 6.9)*. Before you react with incredulity, note that Hogarth has added another detail to back this idea up.

Observe the man standing on the left of the group *(Figure 6.10)*. At first you think that the man's hand is behind the woman head. However, you can just see the material of his breeches, which means that the man's hand is actually inside his pocket fondling himself *(Figure 6.10 red circle)*.

He seems to be making an advance at the blonde woman (suggested by his blush). She has a defined cleavage, and is fingering a snuff box *(Figure 6.10 red box and circle respectively)*. All these elements combine to create something of a sexual nature. Hogarth wants you to imagine that the man has an erection, because you can then visually connect it to the herm's appendage.

Follow my red line *(Figure 6.11)* that runs from this man's erection, (and flows in the direction of the stare of the young woman in blue). It visually connects to the herm's appendage, which is directed at Castlemaine's mouth.

I believe that Hogarth added the fan above the Lord's lap to signify *his* erection and his homosexuality *(Figure 6.11 vertical red line)*.

If this were the only mockery in the painting, it might have been passed over, but when you see a second attempt to mock Kent (along with lighting candles), they both become more plausible. Hogarth was known to have been an aggressive and jealous man. He felt that the only way that Kent was able to have a painting of himself hung in Castlemaine's front hall, was if Kent was sleeping with his patron.

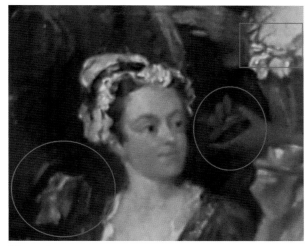

Figure 6.10

To repeat his biographer's words: '*This over-rated sycophant who hid his lack of talent behind civil and obliging behaviour.*' *(Vertue quoted in Mowl)*

Wanstead Assembly remained in Hogarth's studio for three years before being delivered. I wonder if Hogarth enjoyed showing his friends these vulgar additions? He certainly had lots of time to come up with this complicated scenario.

KENTIAN FURNITURE

In the notes to Wanstead Assembly, Marks also explains how Hogarth further mocked the heavy furniture for which Kent was famous. Indeed the term 'Kentian' has actually become a descriptor for furniture that is heavy and overly gilded. It is especially apt when describing elaborately carved picture frames.

Hogarth's comment for this gaudy, foreign approach to interior design was 'All gilt and beshit!' He preferred a more refined and less opulent British taste in everything, even down to the basic frame he used to show his work. This understated frame is still known today as a 'Hogarth Frame.'

It is peculiar that both Hogarth and Kent had frames named after them, however, their two styles are on different ends of the design spectrum. It helps to explain the artists' mutual dislike of one another.

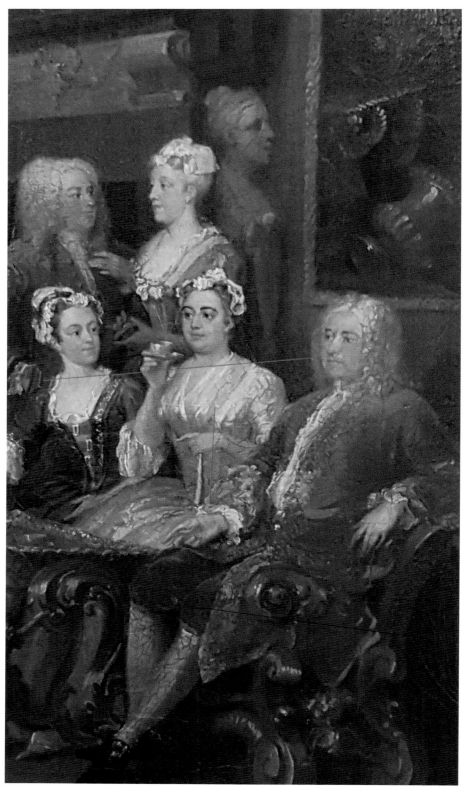

Figure 6.11: **Detail from Wanstead Assembly.**

Figure 6.12: Detail from Hogarth's Marriage a la Mode (1743–45).

I found a example of Hogarth comparing his taste in framing, in contrast to that of his rival's in a scene from '*Marriage a la Mode*' *(Figure 6.12)*. On both walls in the room you can see several of Hogarth's basic frames compared to the more elaborate 'Kentian frames.' On the right, the grotesque Medusa is actually a copy of one that Kent used to decorate the Kensington apartment *(Figure 6.13)*. The Medusa was also a symbol used by the Jacobites. It is carved into a marble mantelpiece in the Palace's drawing room, and is surrounded by a wreath of acorns, another Jacobite symbol that the current residents might not appreciate! Featuring it in a Hanoverian palace would have been quite an affront, not to mention treasonous, had it been detected as such.

The entwining candle-holders below the Medusa in his painting are also a design of Kent's. How clever of Hogarth to mock them both together like this in a room that also features large and garish 'Kentian furniture' (not shown).

KENTIAN FRAMES IN BURLINGTON'S BEDROOM

Hogarth also includes a Kentian frame in *A Rake's Progress*. It is directly between the 'celebrated

Figure 6.13: Kensington Palace, drawing room.

cocks.' The painting is 'The *Judgment of Paris*' *(Figure 6.14)* which still hangs in Burlington's Villa at Chiswick. This following description in the brochure ends with a telling line:

> '*The Judgment of Paris.' Artist Seiter, Daniel. Date c. 1680. (Austrian painter and draftsman, 1649–1705, active in Italy), Burlington Collection, probably at Chiswick House by about 1729. The painting was cut down to fit the frame designed by William Kent.'*

Hogarth must have been shocked that Kent would cut down a painting to fit one of his gaudy

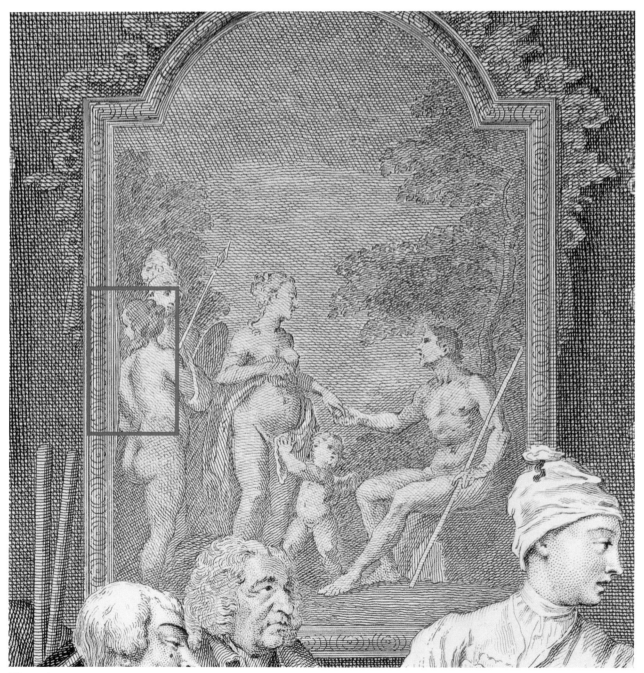

Figure 6.14

frames, and so included it in the levée scene, (which we now read as Burlington's bedroom). This is further evidence to identify Burlington as the Rake, and Chiswick as the home.

'*The Judgment of Paris*' may have been acquired for its connection with James Stuart, who was being <u>judged</u> while staying in Paris.

Hogarth criticises Kent for cutting the painting down, by insinuating that it was done badly and that Kent has trimmed a little too much from the goddess' back *(Figure 6.14 red box)*. The frame seems to have been purposefully altered here to give this impression. The goddess appears to be talking to someone over her shoulder. The end of Paris' staff also seems to have been cut a little short.

Hogarth's Final Insult

Many people mocked Burlington's Villa for its size and design. However, it is Mr. Hogarth who leaves us with the cleverest slight of all.

Due to his famed artistic skill of rendering figures, Hogarth was often asked by other artists to add a few human details into their landscapes. You can imagine his delight when he was asked by George Lambert (1700–1765) to add some figures to Lambert's painting of Chiswick Villa. (It is regarded by art historians as the first painting to depict the English landscape garden.)

Chiswick was Kent's masterpiece and Burlington's home *(Figure 6.15)*. Hogarth adds a subtle criticism by including a couple in front of the building, looking in a completely different direction!

Figure 6.15

*
* *

Hogarth is oft quoted as saying *"Neither England nor Italy ever produced a more contemptible dauber than the late Mr. Kent."* However, it should be noted that Hogarth waited until Kent had died before saying it. Curiously, when Burlington had died, Hogarth moved to a small house on the boundary of Chiswick Villa.

Did he want to show the world that he had outlived them? Or did he want to ensure that he was buried in the same churchyard?

As if to follow them to the grave, Hogarth is buried next to the Burlington vault. Burlington and Kent are interred together, just a stone's throw from Hogarth's tomb. Apparently nobody is 'resting in peace.'

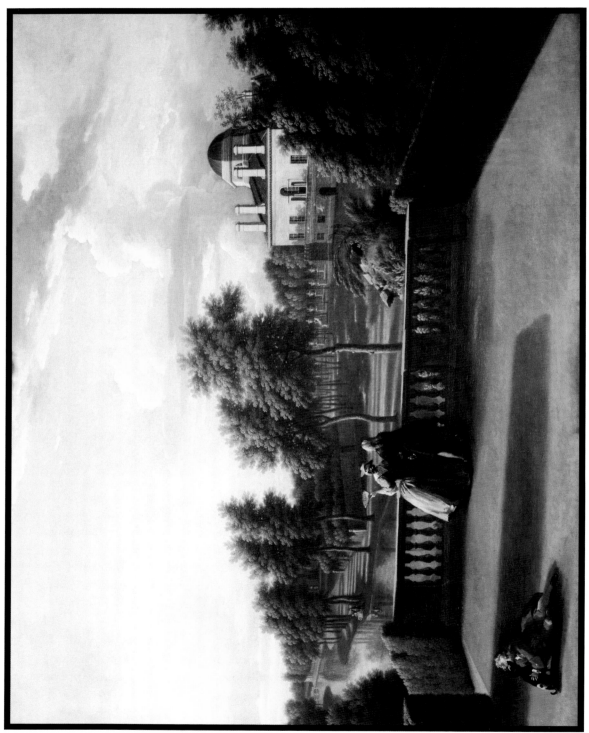

Figure 6.16: George Lambert (and William Hogarth): *View from Cascade Terrace, Chiswick Villa* (1741).

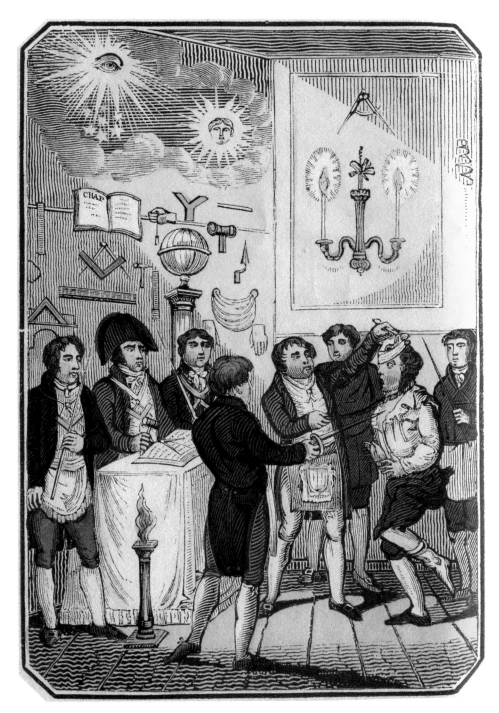

In this colourful frontispiece to an exposé of 1800s, we see a candidate at the point of a sword, just as when Moll arrives in London (Figures 2.2 and 2.4). The man's bare leg was featured twice by Hogarth (see Figure 3.6). The gloves and apron hanging on the wall resemble the washing in the Harlot's bedchamber (Figure 2.1 v).

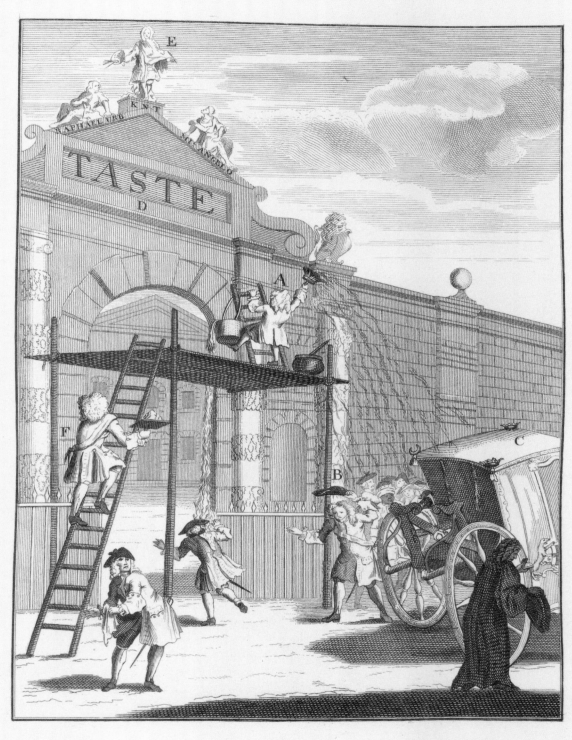

Figure 7.1: **The Man of Taste or Burlington Gates (1731).**

Chapter VII
Fart Catcher

Figure 7.2

Figure 7.3

Figure 7.4

In *The Man of Taste, or Burlington Gates (1731). (Figure 7.1)*, Hogarth makes a second joke at Kent's expense concerning the spelling of his name. As in *The Bad Taste of the Town(1724)(Figure 1.15)*, Hogarth has removed the letter 'E' from underneath the figure of Kent, who crowns the summit of the structure. It thus mocks him with the vulgar 'KNT' *(Figure 7.2)*. Hogarth makes it look like the missing letter 'E' from his name is part of the identifying letter code.

The letter 'F' identifies Lord Burlington. He is shown with a compass shape formed from the Masonic sash *(Figure 7.3 red circle)*. Hogarth therefore, labels him 'F' for Freemason, placing the letter next to that identifying detail.

The other letters used in this code are not distributed in any logical order. The letter 'B' (which identifies the Duke of Chandos) is printed on the column behind him *(Figure 7.4)*. As you will recall from Chapter 1, Freemasons mark their columns with the letters 'J' and 'B.' Hogarth has cleverly labelled the column behind the Duke with the letter 'B,' hinting at this Masonic procedure.

The print contains a Jacobite reference that is examined fully in the notes. This chapter, however, uses this print to show a criticism of the man standing in the shadows behind the carriage that is marked 'C' *(Figure 7.1)*.

I believe this is Dr. Desaguliers, the 'Father of Freemasonry' *(Figure 7.5)*. I have highlighted the same facial wart that Hogarth gave him in the *Sleeping Congregation* print and the Harlot's funeral scene, where it is covered with a plaster. (See Notes to this Chapter *(Figure N7.14)*).

Reverend Desaguliers was chaplain to the Duke of Chandos, and letters show that the Duke tyrannized him. Hogarth hints at this in the following clever picture-riddle.

Originally, the servant who ran alongside a carriage was called a 'fart catcher.' It became a slang term for any footman or sycophant. Hogarth features Desaguliers behind the carriage where he is holding a vinaigrette (a small silver box that held smelling salts *(Figure 7.6)*).

Hogarth positions the vinaigrette at the tail of the animal that is part of the heraldic shield on the carriage. This creates the impression that Desaguliers is catching a fart from this animal, and then smelling it in his vinaigrette. This rather obscure detail has never been properly explained before.

It was Desaguliers' constant intimacy with the gentry that secured the Duke of Montagu as Grand Master. He was the 'noble brother' that the Premier Grand Lodge had been seeking since its formation in 1717. Montagu's appointment in 1721 bestowed the Lodge with an air of nobility it needed to attract more gentry to the Fraternity.

THE INDIAN EMPEROR (1731/2)

In *The Indian Emperor, or The Conquest of Mexico* we see Desaguliers rubbing shoulders with the Duke of Montagu and other high ranking Freemasons at a high society party in Hanover Square, London *(Figure 7.7)*.

Non-Masons would see a group of parents watching their children perform a party piece. However, members of Grand Lodge would find a joke that was meant for their eyes only. That was the point of these 'conversational pieces'—only a few people were privy to the hidden jest. Hogarth was in great demand for his uncanny skill to insert entertaining details into each of his commissions.

In the background you can just make out the tiny figure of Desaguliers, peering down through his spectacles as he prompts the child actors through their performance *(Figure 7.8)*. Hogarth had originally ridiculed the Grand Master by having the candle dripping wax on his head, however it was painted over to cover up this mockery. Three centuries later we see the original insult 'ghosting' through the correction.

Desaguliers had recently introduced the Third Degree into the traditional Masonic ceremony that had previously been comprised of only two parts. This Third Degree ritual is still acted out by all lodges today, and any Freemasons will tell you how difficult it is to learn the long passages of Desaguliers' script which must be recited from memory. They might also admit how much prompting goes on when a brother fails to remember his part. There is always someone reading along who can help those who forget the complicated and sometimes archaic wording.

Figure 7.5

Figure 7.6

Desaguliers is that prompter in the painting. As its author, he was keen for the ritual to be performed correctly. The other men in the painting have all been identified as prominent Freemasons. They are laughing at Desaguliers because the doctor just cannot stop prompting, even when it is only children acting out a play.

There is another hidden joke here. You will notice that there is no painting above the fireplace.

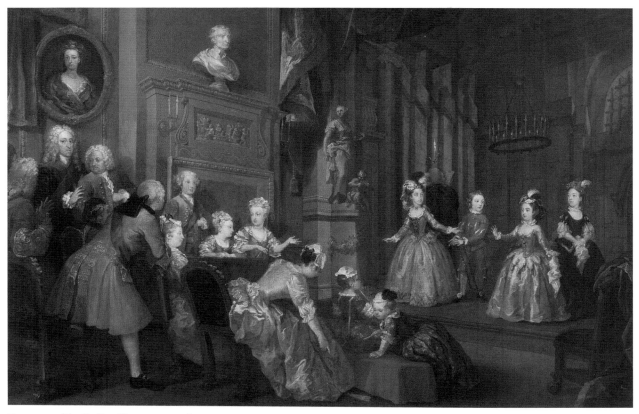

Figure 7.7: **The Indian Emperor 1731/2.**

The space on the wall is the exact dimensions for this very painting. Hogarth was showing his patron where he wanted *The Indian Emperor* to hang!

Presently, the bust of Sir Isaac Newton stands alone on the mantelpiece *(Figure 7.9)*. The great scientist presides over the audience. A little girl has misplaced her fan, which her mother points out has fallen to the ground *(Figure 7.10)*. This demonstrates *Newton's Law of Gravity*. It would be yet another funny detail to point out to anyone seeing the painting for the first time.

Hogarth has included a bust of the great scientist next to this scene of Desaguliers prompting the Third Degree, because Newton was instrumental in its creation.

Figure 7.9

Figure 7.8

In *The Genesis of Freemasonry (Harrison, 2009)*, I was amazed to learn that Sir Isaac Newton spent more time researching the Bible than he did science. He was preoccupied with the study of the

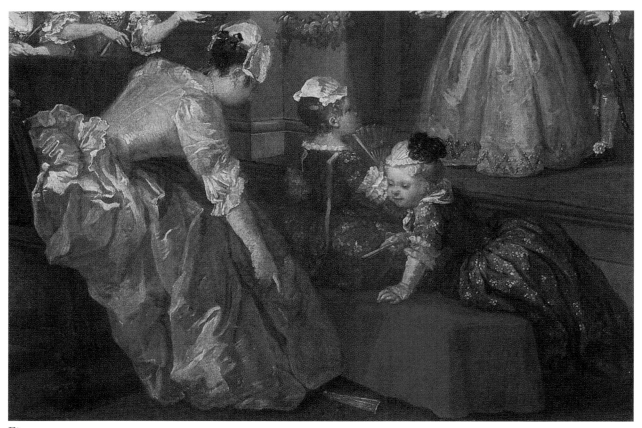

Figure 7.10

'heavenly geometry,' gleaned from the biblical account of the building of Solomon's Temple.

> *'Newton determined the measurement of the sacred cubit ... enabling him to unlock the mathematical secret of God and the Universe'* and *'interpret Biblical prophecy (by) unraveling God's code within the measurements of Solomon's Temple.'* —David Harrison, The Genesis of Freemasonry, (Lewis 2009).

Much has been written about Newton's obsession with Solomon's Temple and how Desaguliers used it to form a basis for his ritual, which he introduced to the Premier Grand Lodge in 1725. In that same year, Desaguliers was Master of a French lodge called 'Solomon's Lodge.' Desaguliers imbued the ancient ceremony with this biblical story.

It can be argued that Newton was the initial reason for the influx of the scientific community that helped form the Premier Grand Lodge. *The Foundations of Modern Freemasonry, Ric Berman, (Sussex, 2013)*, charts the importance of the Royal Society (of Sciences) to the development of the Premier Grand Lodge. Berman lists twelve Grand Masters who were also 'Fellows' of the Royal Society' (F.R.S.) and quotes a source that estimated 50% of members were Freemasons.

Berman shows how this scientific organization turned the aristocratic Masonic Lodge into a science club where members socialized over dinner, and indulged their fascination of the Newtonian world with lectures and debates.

When Newton was President of the F.R.S., he recognized the talents of Desaguliers and invited him to join the Royal Society, waiving his entrance fee. Desaguliers became the demonstrator at the weekly meetings, and served as its curator for the next twenty years. Desaguliers actually helped

Newton with his work, and wrote a sycophantic poem: *The Newtonian System of the World the Best Model of Government (1728).* Newton was Godfather to one of Desaguliers' sons.

When Desaguliers revamped the ancient Masonic ceremony with a legend of Solomon's architect Hiram Abif, he got his inspiration from Newton's earlier research on the subject.

Desaguliers also inserted *'Newton's observations of the rising and setting sun'* into the general lodge ritual. A line of Newtonian thought concerning *'the earth's meridians'* is now repeated at the opening and closing of every Masonic lodge worldwide.

Another manifestation of Newton's study that still exists within the Freemasons lexicon, is the rather bizarre system of writing a date by adding 4,000 years. This was first seen so prominently on the frontispiece of the Constitutions of 1723, which was printed 'In the Year of Masonry—5723.'

By this inclusion, Desaguliers was again paying homage to his mentor. Sir Isaac Newton calculated the date of creation as 3988 BC in his book *The Chronology of Ancient Kingdoms (1728).* This started a Masonic tradition which has been used right up to the present year of 6017 (to use this illogical Newtonian law!)

In *The Indian Emperor,* Hogarth somehow managed to encapsulate this whole curious situation. On one side, he has positioned a group of gentlemen scientists, proud of their connection to the celebrated genius of Newton. On the other side, we find a clergyman who has ritualised Newton's fascination with the Bible into a new ritual for the Fraternity.

Newton's dichotomy of science and biblical studies is being played out by children. One child drops a fan in a lighthearted demonstration of gravity. The other children perform a play which has synthesised Newton's obsession with King Solomon's Temple. This shows Hogarth's imagination at its finest.

Although most Freemasons are unaware of this origin of the Third Degree ritual, they are proud when they are able to perform their parts without prompting, and there is some competition among

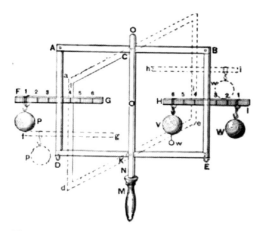

Figure 7.11

the lodges. The rehearsals and final production bring solidarity and camaraderie to the lodge officers. I would like the brethren to imagine what it would have been like to have lived through the first years of Grand Lodge, when a self appointed Grand Master suddenly tells you to learn and perform a long play that he has just written. The first officers might have found this rather cumbersome and long winded, and many would have found it difficult to memorize and perform. It would only have taken one person to complain to Hogarth that acting out this new ritual was like performing a party piece, for the artist to come up with the idea of children doing a play.

Once again, Hogarth had used Desaguliers as the butt of this joke while creating a very clever multi-levelled discourse on the development of the Premier Grand Lodge.

Hogarth mocked Desaguliers more than any other individual. In the Harlot's funeral scene, he was disguised as an old crying woman. You will recall how Hogarth featured Desaguliers, tipping back on his chair—a joke concerning his famous scientific experiments on balance. The apparatus he used is still called the *'Desaguliers' Balance' (Figure 7.11).*

LORD HERVEY AND HIS FRIENDS (1738–40)

Hogarth uses this same mockery in another painting called *Lord Hervey and his Friends (1738–40) (Figure 7.12).* Once again we see Desaguliers,

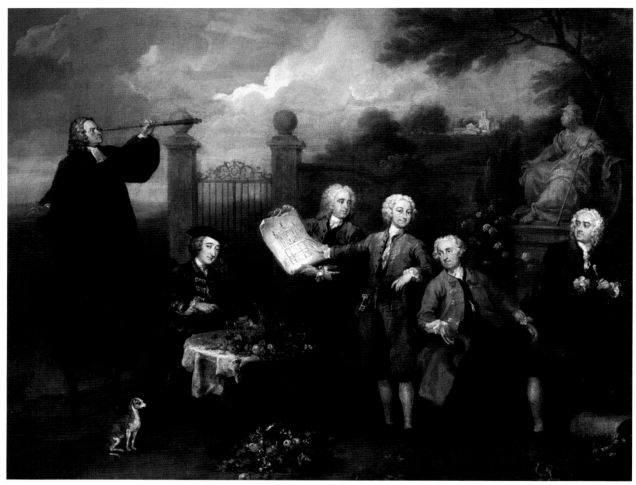

Figure 7.12: The Hervey Conversation Piece, c.1740.

identified by Horace Walpole (who knew him well). He is tipping back on his chair, which is being pushed by the man in front of him. The viewer is held in suspense as Desaguliers begins to tumble backwards into the water, which might have been added as a jest on baptising the minister.

> *'The protagonists in this lively picture all*
> *seem to be enjoying a private joke.'*
> *—National Trust Collections*

All the men in the rest of the painting were prominent Masons, and you can imagine them wanting Hogarth to include a clever Masonic reference like the one that they had enjoyed in *A Harlot's Progress*. Hogarth therefore works a Masonic phrase into the painting by featuring a 'leveller' in the scene. This garden tool that we now know as a 'lawn roller' catches your attention because one of the gentlemen is resting his foot upon it *(Figure 7.13)*. Masons would recognize the phrase that these men are all *'on the level,'* which meant that they were all brothers of the same rank. Note this man has his hand at his heart—a recurring Masonic gesture within Hogarth's work.

By placing Desaguliers on a chair, Hogarth insinuates that this Past Grand Master believes he is above them. Indeed, Desaguliers had introduced a hierarchy into his Premier Grand Lodge—described in the first entry of the history of Freemasons first printed in Anderson's Constitutions:

Figure 7.13

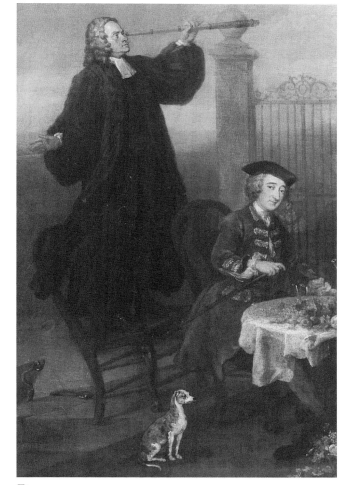

Figure 7.14

Grand Lodge resolved to hold the annual assembly and feast, and then to choose a Grand Master from among themselves, till they should have the honour of a noble brother at their head. —Anderson's Constitutions

Desaguliers would wait five years until the Duke of Montagu agreed to be the first *noble* Grand Master. He managed to create a precedent—the Grand Lodge has always had a member of the aristocracy at its head. The current Grand Master of the United Grand Lodge of England is HRH the Duke of Kent, who has held this position since 1967.

Desaguliers had set out to create a hierarchy within the Masons by creating a Grand Lodge that held dominion over all regular lodges. The Masters of these lodges were outranked by any Grand Lodge officer, who in turn was subservient to the Grand Master. All of this went against the previous egalitarian structure of Freemasonry, in which all Masons were equal, or *'on the level.'*

The Modern Grand Lodge became top-heavy with aristocracy ... exclusive and snobbish ... in violation of the Landmark of 'meeting upon the level.' —Mackey, Encyclopedia of Freemasonry (1894).

Desaguliers had placed himself within this elevated group. As a Past Grand Master, he acted as if he were on the same social standing as the gentry.

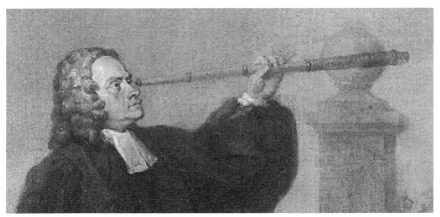

Figure 7.15

By all accounts, he was an ingratiating toady, desperate to surround himself with the higher echelons of society. *'Desaguliers, (a jobbing engineer and mere servant of the Royal Society) used Freemasonry as a vehicle to promote and support his own social advance and financial well being.'* —Berman.

Hogarth captures this development within *Lord Hervey and his Friends* by placing Desaguliers in a prominent position on top of the table. However, Hogarth then tells us that Desaguliers has reached too high above his station by showing him unbalanced in a precarious position *(Figure 7.14)*. This lowly individual had climbed too high, too quickly and was about to fall. Indeed, at the time of the painting saw Desaguliers' decline within the Fraternity.

Hogarth's addition of the telescope is also multi-layered. First of all, it refers to Desaguliers' famed lectures on optics. Then it reminds us that he is a clergyman, peering at the distant church. However, since he has become unbalanced, Desaguliers is now pointing his telescope a little higher up, and is now looking above the Church—another gibe at his rising above his station.

The way in which the telescope bisects the orb on the gate post behind is not by chance. I believe Hogarth is referencing the celestial globes on the columns of Solomon's Temple—a scientific embellishment introduced by Desaguliers *(Figure 7.15)*.

Devising such an impressive addition to a biblical landmark would have been seen as rather presumptuous and worthy of Hogarth's comment. The original columns did not have globes, because at that time, the world was flat! However, this is another detail which really shows Hogarth's genius in combining symbols. The telescope creates the semblance of a meridian, as seen in this early diagram of the Moderns' addition of globes. The illustration *(Figure 7.15 right)* is from *Jachin and Boaz*, an exposé from the time.

One critic derided the introduction of these globes as another invention of the Moderns to teach geometry. Lawrence Dermott (of whom we will hear more in the next chapter) sneered at how: *'the globes might be taught and explained as clearly and briefly upon two bottles.'* He also complained that many Freemasons were barred entrance to Grand Lodge meetings because of their lower status. Notice that the gate is shut between the columns, blocking the entrance to any outsiders. The position of the gate so close to the water seems incongruous, which makes you believe Hogarth positioned it there for this purpose.

THE SLEEPING CONGREGATION (1736)

Hogarth continues his insightful commentary of the development of Freemasonry with his most famous and vindictive portrayal of Desaguliers in *Sleeping Congregation (1736)(Figure 7.16)*.

We have already seen details from the painting of the same name in Chapter 1. We discussed

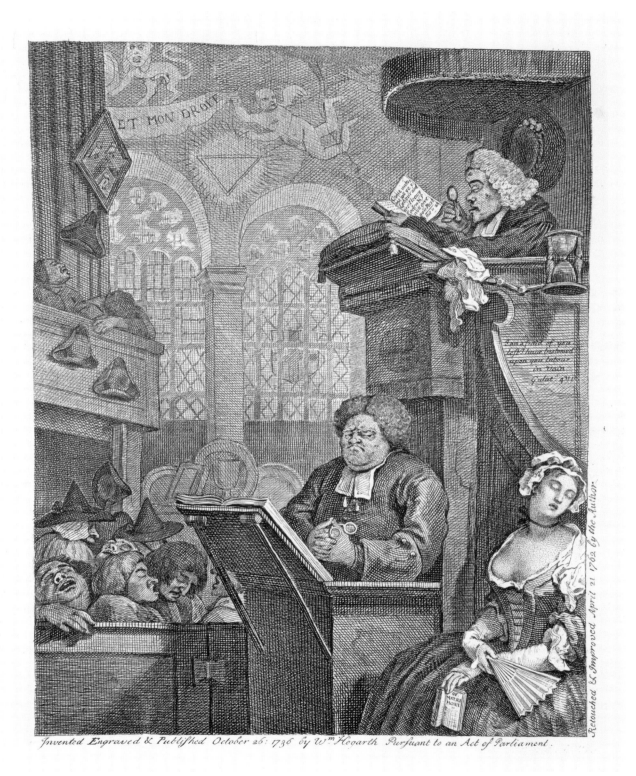

Figure 7.16: The Sleeping Congregation (1736).

WILLIAM HOGARTH: THE FREEMASON'S HARLOT

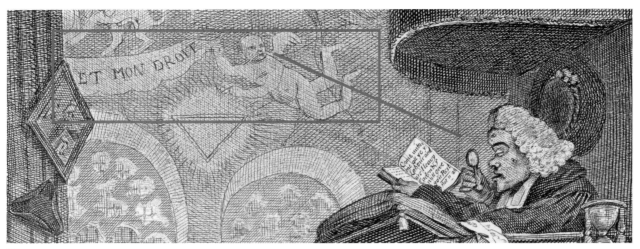

Figure 7.17

Desaguliers' obsession with the letter 'G' (which appears above him hidden within the pulpit *(Figure 1.7)*. Now we understand how Newtonian science was behind the scientific symbolism of the letter referring to 'The Grand Architect of the Universe.'

Notice how the banner on the church wall is missing the word 'God.' What would have *read 'Dieu et mon droit' ('God and my right')* now just reads *'et mon droit' (Figure 7.17 red box)*. Desagulier has taken 'God' out of the lodge room.

The changes that the Premier Grand Lodge made to the traditional ritual are well documented, as is the negative reaction which many traditional Masons experienced to this rewrite of their ancient procedures. *'This serious alteration in our creed (substituting God for 'Grand Architect') virtually deChristianized the tenets of Freemasonry. This startling innovation became a serious stumbling block to many of the old fashioned Operatives.' —The Moderns and the Antients, Arthur Heiron.*

Desaguliers had populated the Grand Lodge with aristocrats who were all fascinated with Newton's study of 'sacred geometry.' It had been noted by the Freemasons in York, who mocked the Premier Grand Lodge in a newspaper column:

'I am credibly inform'd, that in most Lodges in London a Lecture on some Point of Geometry or Architecture is given at every Meeting. The Grand Lodge of London …

expects that every Gentleman, who is called a Free-Mason, shou'd not be startled at a Problem in Geometry, a Proposition in Euclid.' —Grand Lodge of York, 1736.

Hogarth represents the Grand Lodge's obsession with geometry by featuring a geometric symbol on the wall of the church. It is held by an angel who stares down at Desaguliers accusingly, as if showing us who is to blame *(Figure 7.17 red line)*. The angle also holds a banner, whose words 'et mon droit' ('and my right'), seem to make Desaguliers declare that it was his right to change the ancient ritual. This was seen as a rather presumptuous move by the self-appointed leader of the self-styled Premier Grand Lodge.

Hogarth shows a church full of regular Masons who are bored by these lectures. We know that these men are not scientific fellows from the Grand Lodge because they are not wearing wigs, as members of the gentry would have done. This is a representation of the regular working class Freemasons, who are not interested in a lecture in geometry. This is why they are falling asleep. The following poem accompanied the reprint:

When Dulness mounts the Sacred Rostrum
And deals about his sleepy Nostrum
Is there an eye awake can keep?
No.—All submissive nod to sleep.

100

In *Sleeping Congregation (1736),* Hogarth features Desaguliers peering over the Bible with a magnifying glass. This does not give any confidence in his public speaking ability. He shows the same myopia in his figure in the *Emperor.* Desaguliers made his living from giving scientific lectures. These very public negative images of him cannot have done his business any good. It cannot have helped the Fraternity as a whole to have its leader slandered like this.

Desaguliers died in 1744. The passing of the 'Father of Freemasonry' was not even reported in the Grand Lodge minutes. One wonders if Hogarth's continuous slander of this man contributed to Desaguliers' fall in popularity. Here is a section of his epitaph, written by the poet James Cawthorn in 1749. Although it is known to be exaggerated, it also paints Desaguliers in a bad light.

> *How poor neglected Desaguliers fell!*
> *How he who taught two gracious kings to view*
> *All Boyle ennobled, and all Bacon knew,*
> *Died in a cell, without a friend to save,*
> *Without a guinea, and without a grave.*

Hogarth mocked Desaguliers as a bore in *Sleeping Congregation;* an old woman in the Harlot's funeral; a fart catcher in *The Man of Taste;* a myopic prompter in *Indian Emperor* (complete with dripping wax)*;* and an unbalanced star-gazer in *Hervey and Friends.* These combined works provide a critical portrayal of the founder of Modern Freemasonry. They also present a fascinating visual history of the development of English Freemasonry.

SUMMARY OF HOGARTH'S WORK SHOWING DEVELOPMENT OF PREMIER GRAND LODGE

Sleeping Congregation (1728):
– lectures on geometry (letter 'G;' pyramid of men with hats; Euclid triangle on wall)
– history of the Craft (Inigo Jones)
– New symbolism (hourglass)
– New procedures moving from 'work to rest' (biblical quotations)
– New props (Deacon's 'column')

– Drinking in the Lodge (wine jug on Bible, see Chapter 9)
– New ceremonial introduction of tri-gradal system (hinted at with 3 steps, 3 banisters)

A Harlot's Progress (1732):
– All the signs and passwords of the three 'Craft Degrees'
– Introduction of Deacons
– Sign and pass of the Mark Mason Degree
– 'Father Time and the Virgin'
– Tradition of giving gloves
– Globes on columns (chamber pots)
– Importance of Solomon's Temple (pillars in scene 1 and 4)

The Indian Emperor (1731/2):
– Successful recruitment of gentry
– New procedure of Hiramic play (children's play)
– Mocking Grand Master (candle wax, prompting)
– Importance of Sir Isaac Newton
– Influence of Solomon's Temple

Lord Hervey and his Friends (1738/40):
– Successful recruitment of gentry
– Desaguliers losing his popularity (falling)
– Masons meeting 'on the level' amidst hierarchy of Grand Lodge
– Preventing access to Antients (locked gate)
– Criticism of globes on columns

There is one other painting that belongs in this list. Its apparent anti-Masonic theme made many assume Hogarth was against the Fraternity. It has been a source of embarrassment to Freemasons for nearly three centuries for at first sight it looks like Hogarth insulted the Fraternity. However, I can show that the painting *Night* fits into the theme of the list above because Hogarth produced it in order to show us the most important development in the history of the Craft. In his inimitable fashion, he managed to encapsulate a very complex situation into a single work of art and it involves a chamber pot.

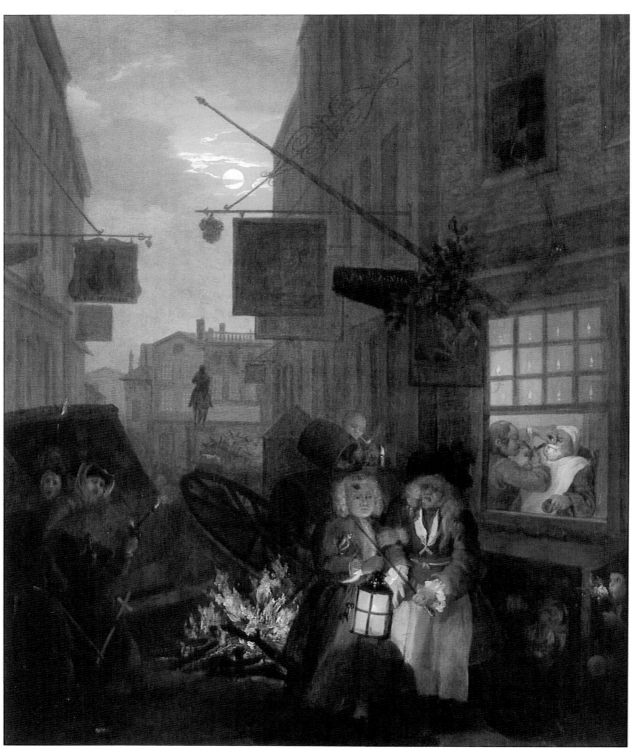

Figure 8.1: **Night, from The Four Times of the Day (1736).**

Chapter VIII
Chamber Pot

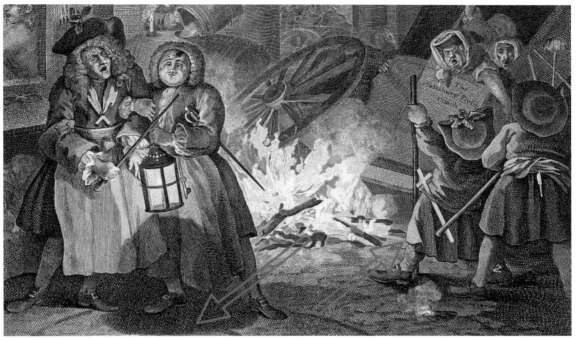

Figure 8.2

We now address the most Masonic of Hogarth's work—*Night (Figure 8.1)*. Hogarth painted a woman pouring a chamber pot of urine over two Freemasons which made historians think that the artist was anti-Masonic.

However, *Night* is similar to *Indian Emperor* and *Hervey and Friends* in that it gives us another glimpse into the history of the Premier Grand Lodge.

Hogarth records and conveys the division that was occurring within the Fraternity in the late 1730s, by featuring the two distinct branches of Freemasonry that were breaking away from each other. These two groups would eventually be known as the 'Moderns' (Premier Grand Lodge) and the 'Antients' (more traditional Freemasons).

These opposing factions are featured have just just come to blows in a crowded London street. The man on the far left of the print *(Figure 8.2)* has been hit and his head is bloodied. He grips his cane, wanting to continue the fight. His friend has confiscated his sword to prevent him from getting into more harm as he leads him to safety.

The recent confrontation has been disrupted by a carriage that has just crashed behind them. The group on the right has rushed over to help the accident victims, while the other two men walk on, oblivious to the calamity that has just occurred behind them. Hogarth captures the moment just as

the two groups are walking away from each other, as my red arrows suggest *(Figure 8.2)*. Hogarth was famous for cleverly portraying snapshots in time.

The two men, in obvious Masonic garb are well known London characters—Sir Thomas De Veil (1684–1746) and Andrew Montgomery—the first Grand Tyler. They are coming out of a Masonic meeting that has been held in the *Rummer and Grapes.*

Hogarth gives us the name of this famous drinking establishment by featuring the rebus of a bunch of grapes hanging next to the tavern sign showing a rummer glass *(Figure 8.3).*

> *The Rummer and Grapes was a different story, composed exclusively of Accepted Masons, all gentlemen, and a few nobles as well. Their discussion centered on the future of Freemasonry in England. They formed a Grand Lodge ... and Freemasonry split further from its Operative roots.*
> —Freemasonry: Rituals, Symbols & History, Mark Stavish (Llewellyn, 2007).

This is the tavern in which the Premier Grand Lodge devised the changes in their ritual and ceremony that would differentiate them from the more traditional Freemasons. While the first meeting of Grand Lodge was set in the *Goose and Gridiron Tavern*, it was the *Rummer and Grapes Tavern* in which the Premier Grand Lodge born.

Just to clarify, De Veil is wearing the insignia of a Master of a lodge, and is coming out of the tavern in which Grand Lodge met. He is not a Grand Lodge Officer. The Premier Grand Lodge was like an umbrella organisation which regulated all the lodges within its jurisdiction. De Veil is Master of one of these lodges that would then report to Grand Lodge, as they do today.

APRON AND MEDALS WORN GRAND LODGE STYLE

What is interesting is that De Veil wears his Master's insignia (a metal square) around his neck on plain white ribbon as directed in the minutes of Grand Lodge, 1731: *'All Masters and Wardens of Lodges may wear their respective Jewels with plain White ribbons but of no other Colour whatsoever.'* —Minutes of Grand Lodge, 1731.

At this time, the Moderns altered the design of their aprons—the most visually identifying part of the Mason's dress. Although the apron was supposed to symbolise the work of the stonemasons, the Moderns felt it was too 'working class' for them. They made it look less functional by cutting the bib shorter, and then letting it hang down as a flap.

In time, the apron was shortened and the bib cut at an angle. The waist-strings devolved into the broad ribbon ties that now dangle down either side of the flap ending with thin ornamental chains. These changes produced what we know as the modern apron.

Hogarth features De Veil wearing his apron in the recently prescribed fashion. *(Figure 8.4 red square).* Here is the negative reaction from the Antients:

> *There was another old custom that gave umbrage to the young architects, i.e. the wearing of aprons, which made the gentlemen look like so many mechanics, therefore it was proposed, that no brother for the future, should wear an apron. This proposal was rejected by the oldest members, who declared, that the aprons were all the signs of Masonry then remaining amongst them, and for that reason they would keep and wear them. It was then proposed, that, as they were resolved to wear aprons, they should be turned upside down, in order to avoid appearing mechanical. This proposal took place and answered the design, for that, which was formerly the lower part, was now fastened round the abdomen, and the bib and strings hung downwards, dangling in such manner as might convince the spectators, that there was not a working Mason among them.*
> —Antients' Constitution

Hogarth shows us De Veil's circular bib to his apron, which was the new fashion for Masters around this time.

In the 1730s, some masons were experimenting with fabrics other than leather for their aprons. The flap, when retained, was either cut to a triangular form or in a semi-circular line. The latter was increasingly adopted by Master Masons, presumably to mark their distinctive rank. There seems to have been a tendency amongst Master Masons to wear the flap down or to dispense with it altogether. This "subterfuge" was introduced between 1730 and 1740, but it was short-lived.
—F.R. Wort, Transactions of the Quatuor Coronatorum. UGLE.

Hogarth actually paints the traditional apron that buttoned at the neck in his painting of *An Election Entertainment (1755) (Figure 8.5)*. Hogarth shows the Mason giving a handshake and wearing his apron in the old style. The *British Museum Catalogue of Prints and Drawings* thought this apron was 'a shovel tied around the neck of a sweep!' My article concerning the Masonic significance of this painting was published in the *British Art Journal, Vol. 15, 2015*.

Figure 8.3

GRAND LODGE TYLER

The Masonic figure holding the lantern is a Tyler, whose job it was to guard the door to the lodge (which is why he has a sword under his arm). A candle snuffer hangs from his belt, cleverly drawn to confuse many who thought it was the Tyler's key *(Figure 8.6)*. It was not customary to carry such a dirty instrument against one's clothing (especially not against the Masonic aprons which both men are wearing). I believe it was to symbolise that he was locking the door to the Antients.

This armed guard was an invention of the Premier Grand Lodge, and first mentioned in

Figure 8.4

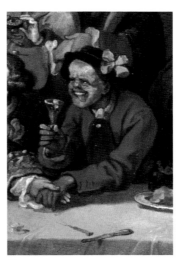

Figure 8.5

Figure 8.6

Figure 8.7

their minutes of 1732. Hogarth records this recent change in procedure.

This paid position was intended to bar the entrance of eavesdroppers. However, there are many documented rejections of Antient Masons because they were not from the same echelon of society.

> *The Modern Grand Lodge became top-heavy with aristocracy ... exclusive and snobbish .. The Antients .. could neither visit nor affiliate with London Lodges because they were 'mechanics' that is 'workers.'*
> —Mackey's Encyclopedia of Freemasonry (1894).

THE STEPS

In a further attempt to bar unwanted Masons from their meetings, the Moderns changed the prescribed steps that a visiting Mason would have to make when presenting himself for the first time at a lodge. Many exposés had been published in 1730s showing the secret signs, passwords and steps to gain access to a lodge. Premier Grand Lodge changed these modes of recognition to catch out any non-Masons.

However, this meant that Antients were unable to gain access to lodges under the jurisdiction of Grand Lodge. They mocked these new complicated steps describing them as: *'ingenious methods of walking up to*

a brother ... invented by a Man grievously afflicted with the Sciatica. The second by a Sailor, much accustomed to the rolling of a Ship. And the third by a man, who for recreation or through excess of strong liquors, was wont to dance the drunken Peasant." —Antients' Constitution

Hogarth tried to capture this curious movement in the steps that these two Moderns are making, while disguising it as the staggering of two drunks stumbling out of a pub *(Figure 8.7).*

MODERNS' DATE OF INITIATION

The Moderns changed many aspects concerning the induction of a new Master. However, the main modification was the date of the ceremony and the period of office that he would be 'in the chair.' The rules concerning this ceremony, known as 'Passing the Chair' became a sticking point between the two groups. Hogarth incorporates this phrase in a humorous way by painting a *'chair* passing' in a wagon. *(Figure 8.8).*

Figure 8.8

This has always been reported as a family changing lodgings at night to avoid paying rent.

We also see a ladder which symbolizes the antiquated ritual of 'Jacob's ladder.' It is part of a pile of 'furniture' that is being unceremoniously carted away. 'Furniture' was the derogatory term that the Moderns used for the Bible, Square and Compass which the Antients revered *(Figure 8.8 blue circle)*. The Antients naturally venerated these important icons of Freemasonry, which they called the Great Lights, and objected to the term 'furniture.'

Figure 8.9

This terminology is still contentious where lodges in America still identify 'the 3 lights' while English lodges call these items 'essential furniture.'

I believe Hogarth also added a Masonic 'mark,' *(Figure 8.8 blue circle just visible on the pedestal behind the cart)*. This was in reference to the ancient practice of receiving a *'Mason's Mark'*—a personal symbol chosen to represent each individual.

This part of the ceremony had been disregarded by the Moderns in their official simplified version and so was another detail that Hogarth could show the differences between the two groups. The password connected to this 'Mason's Mark Degree' begins with the letter 'J'. This letter is just visible in amongst the furniture in the later version of the print *(Figure 8.8 red circle on left)*. My insert has turned the letter upside down so you can see it is a letter 'J'. The full password is given in both Morgan's and Allyn's exposés.

THE ANTIENTS

Now that we have identified the Moderns, we will turn to the other side—the Antients. In general, this group perceived themselves as traditionalists who had maintained the time-honoured values of the Craft, even down to the archaic spelling of the word 'antient.'

Here is how they derided the creation of the Moderns: *'About the year 1717, some joyous companions who had passed the degree of a craft, though very rusty, resolved to form a lodge for themselves ... to substitute something new, which might for the future pass for masonry amongst themselves.'* —Antients' Constitution.

Although this criticism was written much later than the time of Hogarth's painting, Hogarth seemed to understand the Antients' dislike of the Moderns well before they actually formed their rival organization in 1751. Hogarth set down many distinguishing details of the two branches to show how different they had grown by 1736.

Indeed, to quote verbatim from the Antients' Constitution: *'And although a similarity of names, yet they differ exceedingly in making, ceremonies, knowledge, masonic language and installations; so much that they always have been and still continue to be two distinct societies totally independent of each other.'* —Antients' Constitution.

In *Night*, Hogarth shows members of the Antients, rushing to help those from the carriage accident. They are not so easily recognizable, and have long been misconstrued as a gang of youths. Commentators thought the smaller man was a *'street-urchin playing with fire'* or a *'youth with a wooden sword.'*

Take a closer look at this figure holding the staff with his back to us. Although he is furthest

away from the viewer, he has the largest feet of all *(Figure 8.9)*. His shoe has been darkened and detailed for a reason. His hands have been drawn fully-sized on purpose; it is only his torso that is shortened illustrating a classic case of skeletal dysplasia or dwarfism. He holds a substantial walking stick as an aid.

Some have deigned to criticize Hogarth for an error in proportion, however we know this artist was a stickler for correct form. Hogarth adds nothing by mistake. Everything is a clue—the answer lies at his feet.

Take a look at the diminutive figure's right foot, cleverly hidden by the leg of the man behind him *(Figure 8.9)*. My lines in red show how both feet are at an unnatural position, like the biblical reference to 'broken-footed.') Hogarth means this crippled man to represent the Antients because such a crippled person would never be allowed to join the elite Moderns.

THE 'MAIMED'

The Constitutions of Premier Grand Lodge (1723) stated that Masons must be *'a perfect youth, having no maim or defect in his body.'* The biblical origin of this law can be found in Leviticus: *'A man that is broken-footed … or a dwarf … shall not go in unto the veil, nor come nigh unto the altar, because he hath a blemish.'*

Hogarth uses his figure to show how Grand Lodge was strict in whom it was accepting as its members. This elite organisation would never accept anyone who was not physically perfect.

THE BUTCHER

The other man is a butcher, identified by his bright and prominent sharpening-steel that hangs from his belt *(Figure 8.10 red circle)*. I believe that

Figure 8.10

Hogarth makes this figure a tradesman to accentuate the highbrow nature of the Moderns who excluded such commoners from their honoured ranks. The Premier Grand Lodge was trying to disassociate itself from such labourers who actually required wearing their aprons for work, and not for ritual.

> *'There was another old custom that gave umbrage to the young architects, i.e. the wearing of aprons, which made the gentlemen look like so many mechanics [labourers].' —Antients' Constitution.*

There was a snob element here in that the Lodge was filled with gentry who did not want common

108

labourers joining their meetings. All this was totally against the tenants of brothers being 'on the level.'

MOP AND PAIL

Hogarth identifies the Antients with a Mop (that seems to be held by the butcher *(Figure 8.10 red box)*). This was used by the candidate to erase the symbols that were traditionally chalked out on the lodge room floor. Moderns had upset the Antients by replacing this old method with elaborately painted 'carpets' that were both elegant and portable. Hogarth uses this 'mop and bucket' motif in his Masonic *Gormogon's* print in 1724 where you see the monkey appear to hold them *(Figure 8.11)*.

> *... showing what innovations have lately been introduced by the Doctor (Desaguliers) and some other of the Moderns, with their Tape, Jacks, and Movable Letters, Blazing Stars, etc., to the great indignity of the Mop and Pail.* —Advertisement in London newspaper 1726, (Knoop, ibid.)

THE RODS

Next to the mop are the tops of two rods which were carried by Deacons as part of the Antient lodge ritual *(Figure 8.10 red box)*. The Moderns discontinued this office, and elected Stewards to help with the serving of food and drink (another of the Antients' criticisms). Hogarth became such a Grand Lodge Steward.

SWORDS

The Antients had always used swords in their ritual, and so one is included in their group *(Figure 8.12)*. Hogarth gives the crippled man a 'wooden sword,' which made many think he was a boy. The sword has a large handle which resembles the shape of a cross. I believe this refers to the Christian element of traditional Freemasonry. The Moderns omitted many of these elements in an attempt to soften the original religious ritual and make it more palatable to their aristocratic

Figure 8.11

Figure 8.12

audience. The Moderns wanted to seem more like a social club and less like a religious sect.

There was no place for swords in this peaceful, modern, science-based society. The only one allowed to carry a sword was the Tyler, who remained outside the Lodge door as a guard, and would stop any gentlemen taking weapons into the Lodge-room. This is still the custom today where the Tyler sits outside the door with a drawn sword, (sometimes affixed to the wall next to him).

SIMILAR SITUATION WITH BARBER SURGEONS

The Master is dribbling from his mouth *(Figure 8.13)*, rather like the barber in the window next to him. With this detail, Hogarth connects the Freemason's with the *The Company of Barber-Surgeons*. These two quite separate professions had shared the same guild since 1520 but the surgeons were separating from the barbers just at the time of Hogarth's print. I give detailed notes describing this battle.

The acrimonious nature of this schism was similar to what Hogarth was seeing within the Freemasons. Note the murderous look on the barber's face and the blood dribbling down his patient's neck, who we take to be a surgeon. Hogarth is alluding to the 'cutthroat' nature of this altercation, and warning the Freemasons not to let their situation get to this level.

The Company of Barber-Surgeons actually had Masters and Wardens, and many other similarities to the Masons. This is why I believe Hogarth drew the barber's hand position and razor to make a perfect square and compass *(Figure 8.14)*.

BARBER'S POLE AND EUCLID

There is another reason for Hogarth wanting to include a Barber's shop in the Masonic scene. By adding the barber's pole, Hogarth was able to include a classic rising diagonal line into the painting. It bisects the horizontal line to create a right-angled triangle *(Figure 8.15)*.

We know just how obsessed the Grand Lodge became with Geometry. Desaguliers used this right

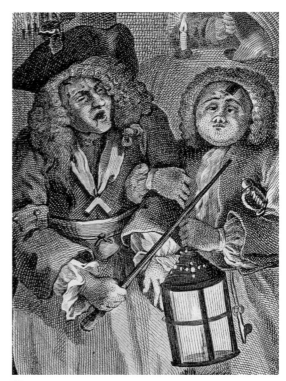

Figure 8.13

Figure 8.14

angled triangle that illustrated Pythagoras' famous theorem which allowed ancient builders to create a perfect right angle so important in their work. The Freemasons still use this concept as an analogy to 'square one's actions.'

Pythagoras' triangle is central to the frontispiece of the Constitutions of the Premier Grand Lodge designed by James Thornhill in 1723 *(Figure 8.16)*.

Hogarth hung this sign directly above our two Modern Masons. He also used the horizontal

Figure 8.15

line that supports the Rummer and Grapes sign to create the triangle. Furthermore, he made the Rummer sign into a perfect square, so that it conformed to the famous geometric equation (that all schoolchildren can recite): 'the square of the hypotenuse is equal to the sum of the squares of the other two sides' *(Figure 8.15).*

SQUARE AND COMPASS

As if this scene did not hold enough signs and symbols, Hogarth manages to make a prediction concerning this ongoing struggle, by hiding another badge of Freemasonry within the print.

On the Moderns' side, the Tyler's sword makes a right angle with De Veil's cane. On the Antients' side, the wooden sword creates a similar angle with the butcher's staff *(Figure 8.17).*

When you look at these two shapes together, you can see that there is a compass on the Moderns' side and a square on the Antients'. When you combine them, you create the classic insignia of the Freemasons—the Square and Compass (which I have superimposed between them).

However, what is actually being portrayed here is something more telling. Hogarth portends

Figure 8.16: **Detail from Anderson's Constitutions: Frontispiece (1723).**

Figure 8.17

the breakup between the two groups by showing the dismantling of the Square and Compass. The schism of the Moderns and Antients has been hidden in plain sight.

In the very first paragraph *Schism: The Battle that Forged the Freemasonry*, Ric Berman gives us a perfectly timed reason for Hogarth to show this dissent of Premier Grand Lodge in his painting of 1736.

> *'If one were to search for a single point of origin at which [Antients] began to veer away from the Original Grand Lodge of England it might be on 11 December 1735' ... The [Antients] were snubbed and their wish to be admitted 'could not be complied with ... alterations had been made [to Masonic ritual] which prevented intervisitation.'*

Berman gives a long and detailed account of this *'Rejection of an Irish deputation ... the principal 'casus belli' that instigated and sustained six decades of acrimony between the two organisations.'* The date is pertinent to our study because it happened at the end of 1735, and that was exactly when Hogarth planning his *Night* painting.

We must remember that Hogarth was from a very poor, working-class background. He had served an apprenticeship in the engraving business. By his good fortune, fortuitous marriage and commissions he had risen to an actual

Figure 8.18

112

officer in the Grand Lodge. He would have understood the angst of the treatment of these working class masons.

This rejection of the Irish deputation might have been the last straw for Hogarth. He predicted the future struggle and opted out of the Fraternity altogether as we will discover in the next chapter. *Night* might have been a visual record for his departure.

Beware the Sign

Hogarth had predicted a potential problem within the Freemasons and warned them not to let it become as vitriolic as the Barber-Surgeons. He gives his premonition in the Latin he knew so well from his scholarly father. Observe the lettering on the board above the barber's shop window. 'Ecce Signum'—Latin for 'take heed' or 'beware the sign' *(Figure 8.18)*.

Fortunately, the Modern/Antient split was not one that was powerful enough to rip the Fraternity apart forever. These two distinct branches would eventually be reconciled in 1813, almost 100 years after the Premier Grand Lodge had begun. This amalgamation created the 'United Grand Lodge of England' which continues to this very day. It is the same that celebrates its 300th anniversary.

For centuries, this painting of a drunk and bleeding Freemason has been a huge embarrassment to the Fraternity. Finally, we can appreciate that *Night* was not a criticism against the whole of Freemasonry, but rather a visual record of its development, and a friendly warning to its members.

<center>*
* *</center>

We have yet to address the most obvious humiliation—that of a chamber pot of urine being unceremoniously dumped down on the brethren.

It has made observers think the whole piece was against the craft and that Hogarth was anti-Masonic. However, even this repulsive insult has a much different meaning than is first interpreted. There is always another level of meaning that lies beneath Hogarth's obvious statements. This could not be more true in the instance of the chamber pot, the contents of which will be the subject of our next chapter.

Chapter IX
Empty Headed

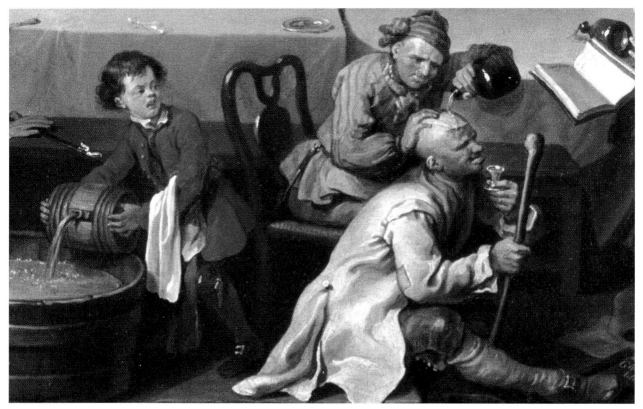

Figure 9.1: Detail from Hogarth's An Election Entertainment (1755).

In the forefront of Hogarth's *An Election Entertainment (Figure 9.1)*, a young waiter fills his punch tub with a cask of rum. He looks over as one belligerent administers brandy to anaesthetise his compatriot and treat a head wound. In his naiveté, the boy thinks the man is pouring brandy into his head, filling up an empty vessel!

Hogarth made the same jest in *Night*. He has positioned a man who is pouring beer into a barrel right behind the Freemason identified as the Tyler in the previous chapter. This makes it appear as if beer is being poured into the Tyler's somewhat rounded, barrel-shaped head *(Figure 9.2)*. This man's wig blends with the colour of the barrel and the beer seems to pour into a hole in his skull. I believe the artist was insinuating that the Tyler has an empty

head. This is not as clear in the print *(Figure 9.3)* until you know what to look for.

We have further proof that the Tyler was known to be simple. His name is Andrew Montgomery but he is referred to as 'Modest Montgomerie.' In a print entitled *Mock Masonry or the Grand Procession (1741)*, he is shown wearing a dunce's hat *(Figure 9.4)*.

The accompanying poem refers to the key he holds in *Night*: *"Who's he with Cap and Sword so stern-a? Modest Montgomery of Hibern-a, Who guard de Lodge and de Key who turn-a."*

Many have attributed the simple expression of Montgomery's face to an overconsumption of alcohol, even though he seems to be a sober influence on his Master. It seems probable that Hogarth chose Montgomery to accompany De Veil because of his lack of intellect, perfect for this particular mockery.

Figure 9.2

Figure 9.3

We find the very same joke is being made at De Veil's expense by featuring the chamber pot emptying onto his head *(Figure 8.18)*. It follows that the flow of urine insinuates the same jest for De Veil—that he has an empty head, mocking his lack of intellect.

> *In 1736, Hogarth found himself at loggerheads with one Sir Thomas de Veil, a justice of the peace and a member of the Lodge meeting at the Vine Tavern, Holborn which Hogarth also frequented.* —Yasha Beresiner. William Hogarth: The Man, The Artist and His Masonic Circle, Pietre-Stones Review of Freemasonry.

DENUNCIATION (C.1729)

Hogarth obviously disliked De Veil well before this altercation in 1736 because Hogarth featured this famous magistrate in one of his earliest paintings. Nichols identified De Veil in *Denunciation (1729)* which featured the magistrate's known leniency towards prostitutes in paternity cases *(Figure 9.5)*. The corrupt De Veil regularly gave out favourable sentences for sexual favours (see Notes).

The detail pertinent for this publication is that Denunciation was supposed to be twinned with another that also shows a similar glaring example of professional hypocrisy.

Figure 9.4

Orator Henley Christening a Child (c.1729) (Figure 9.6) shows a London clergyman gazing down the cleavage of a young woman, when he should be focusing on the blessing of a newborn child. A close-up from the sketch to this painting *(Figure 9.7)*, shows a different young woman, but the same lechery.

These two infamous London personalities (De Veil and Henley) are connected by exhibiting odious behaviour that runs counter to their profession. It is evidence that Hogarth was showing great inventiveness at an early stage. It is of double interest to this particular study because both men were prominent Freemasons.

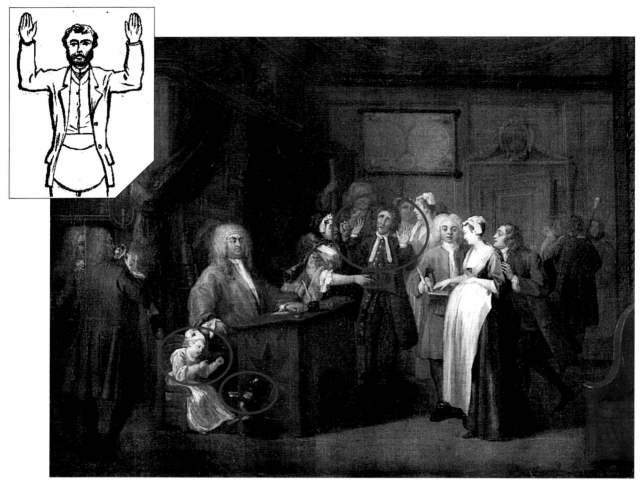

Figure 9.5: Hogarth's The Denunication (1729).

We know that De Veil was a Freemason, but so was Henley, as per this announcement in *Reed's weekly Journal, June 9 1733*: '*The Freemasons have made choice of Rev. Mr. Orator Henley as their Chaplain.*' Henley also lectured on many Masonic topics (given in notes to Chapter 7).

Christening was commissioned by a Freemason, and Hogarth then painted *Denunciation* to accompany it. In each, the artist has hidden a well known Masonic sign.

In *Denunciation*, the magistrate's ruling causes the accused man to make 'the Grand Hailing sign' as per the insert from *Duncan's Monitor (Figure 9.5 top left)*. The second and third parts of this sign is continued by the girl and her dog. Hogarth

concealed this same sign in Scene 7 of *Industry and Idleness (1747)* (not shown).

In Henley's scenario, the foppish man applying hair powder holds up his hand in a postition that resembles the sign of the Mark Master *(Figure 9.6 bottom right)*. Notice his hand is at his chest.

Again, I have inserted an illustration from *Duncan's Monitor*. Here is the description: '*right hand rapidly to the right ear, (thumb and first two fingers open) in a circular motion as though combing back your earlock.*'

The fop wears red heels in the French style. He is connected to the two foreign looking women behind him (identified by their unfamiliar headdress). This may also identify the Masonic sign as alien.

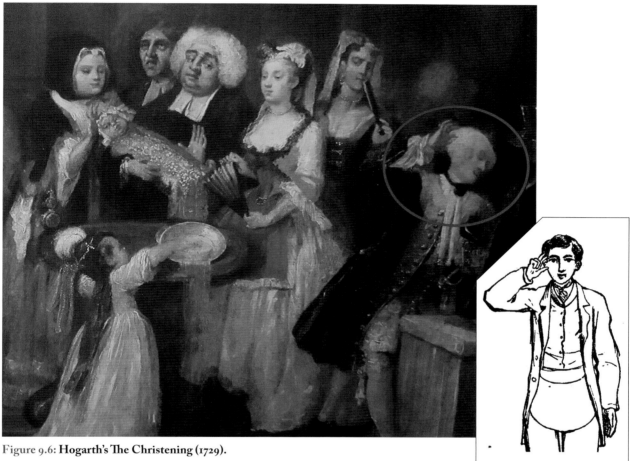

Figure 9.6: Hogarth's The Christening (1729).

Hogarth has exposed this same clergyman before, for the same professional transgression of lust. I believe I can now return to *A Sleeping Congregation (Figure 1.1)* and identify the horny Deacon as Orator Henley.

IT IS HENLEY IN THE CONGREGATION (1728)

Henley wears a white wig in *Christening*, and a black one in *Sleeping Congregation*. However, close inspection of the latter reveals the same white colour: *'Pentimenti under his black wig [in Sleeping Congregation] show that he originally wore a smaller white one.'* -Elizabeth Einberg, William Hogarth, A Complete Catalogue of Paintings, (Yale, 2017 p22).

The main reason for suspecting Henley in both *Christening* and *Sleeping Congregation* is that Hogarth made a similar joke in both *(Figure 9.8)*.

In *Sleeping Congregation*, the deacon was imagining the young couple in the act of foreplay, his erect thumb evidence of his excited state. In *Christening*, Henley's left hand is raised, imagining that it is touching the young woman's breast.

Now observe a curious detail in *Christening* in which a woman holds her fan suggestively. She is clearly fingering the tip in a suggestive manner, (which is what Henley imagines is happening).

Hogarth used a fan to suggest an erection in Wanstead Assembly *(Figure 6.11)*, painted in the same year.

Hogarth showed similar indecency in the original Christening sketch *(Figure 9.7)*. A different, and less interested young woman holds her fan lower down, pointing at Henley's groin. Note the fan and gown are the same colour.

This sexualised reading can now incorporate the bowl of baptismal water that is spilling also in front of Henley's groin. It is a suggestion of his ejaculation.

Hogarth has shown this very same idea in Harlot's funeral where another minster is exhibiting the same lechery and showing his excited state with a glass for his erection which spills its contents in a lewd suggestion of his ejaculate *(Figure 2.21)*.

All three examples (*Christening, Sleeping, Harlot*) show a lustful clergyman, with a depiction of an erection in terms of a fan, thumb and glass respectively. Two of the scenes include ejaculation (baptismal water and glass of liquor). One might interpret the random addition of the fop's white hair powder as a lurid representation of Henley's ejaculation.

The painting was delivered directly to a fellow Freemason (Hewer), and was never intended for public viewing. This reading fits the lewd character of the clergyman in question: Henley was infamous for his curious lectures on sexual topics (see notes Chap 7).

"Henley lay inspired beside a sink,
And to mere mortals seemed a priest in drink."
—Alexander Pope, Dunciad II 425.

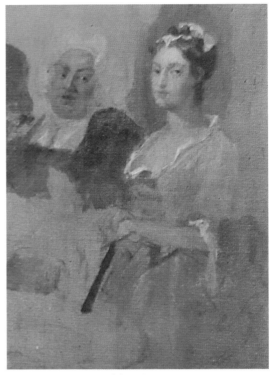

Figure 9.7: **Sketch of The Christening. British Museum.**

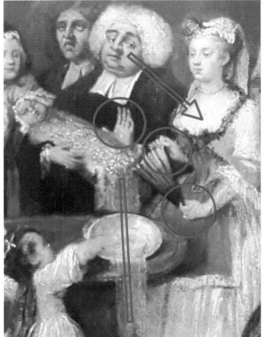
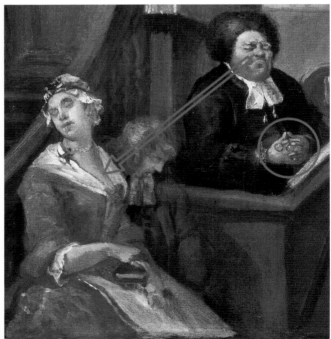

Figure 9.8

118

Henley was also known to be a drinker. Alexander Pope (who called Henley a 'Zany of the age'), made reference to his penchant for drink in his poem, Dunciad (1728):

In *Sleeping Congregation*, Hogarth gives us more evidence that the Deacon is indeed Henley by also making a reference to his drinking. Hogarth includes a clever trompe l'oeil that makes the huge communion cup from the back of the church look like it is resting upon the preacher's lectern. This is more obvious in the print where the table and lectern share the same horizontal plane *(Figure 9.9)*. This links into his phallic thumb representing the Deacon's column raised to signify 'rest' and drink, discussed in Chapter 1.

We have discovered that *Denunciation* and *Christening* are linked by the Masonic characters they mocked. In fact, most of Hogarth's early work had a Masonic link.

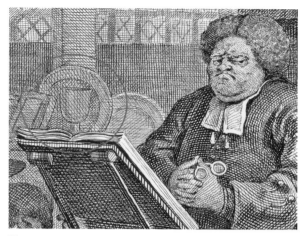

Figure 9.9

MASONIC COMMISSIONS

We have already discussed the Masonic inclusions in *The Sleeping Congregation (1728 and print of 1736); Wanstead Assembly (1728); Man of Taste (1731);*

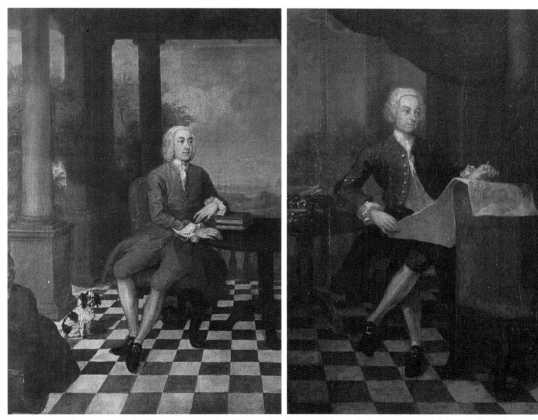

Figures 9.10 & 9.11: **Details from portraits by Hogarth of two unidentified men, probably Wyndham brothers (Einberg).**

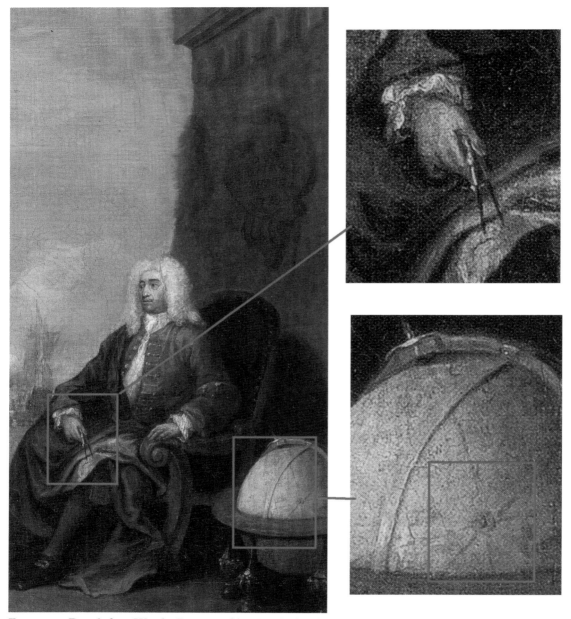

Figure 9.12: **Details from Woodes Rogers and his Family, (1929).**

Indian Emperor (1732) A Harlot's Progress and *A Rake's Progress (1732/34),* and *Night (1736).*

We have studied the Masonic messages in pre-1725 works before Hogarth was even initiated (namely *Gormogons, Bad Taste* and *Burlesque on Kent).* In Notes to Chapter 7, we add Hogarth's *Royalty, Episcopacy and Law* to his early period.

Other paintings from the artist's early years are known to be commissioned by Freemasons. *The Tempest (1728, not shown)* was commissioned by Lord Macclesfield, (a prominent Mason and Godfather to one of Desaguliers' children). In 1729, Hogarth also painted group portraits for the Freemasons *Andrew Fountaine* and *Stephen*

Beckingham (not shown). The latter has a random addition of a floating cornucopia, the symbol of the lodge steward.

Two early portraits (both between 1727 and 1730) are found in *Elizabeth Einberg's Complete Catalogue of the Paintings (2016).* Along with Masonic looking columns, both portraits feature a chequered floor which was mentioned as a 'Mosaick Pavement' in *Prichard's Masonry Dissected (1730).* King Solomon's Temple was thought to have a floor of similar pattern *(Figure 9.10 and 9.11).* Hogarth might have been joking that the dog's marking match that symbolic floor pattern. Compare the gentleman's hand positions to *(Figure 2.3)* and *(Figure N2.10)* respectively and note that one holds a compass.

I have discovered a previously unreported Masonic symbol in Hogarth's portrait of *Woodes Rodgers (1729).* The Captain holds a compass, signifying him as Master of his Lodge *(Figure 9.12 details from painting).*

More subtle is the Masonic 'all seeing eye' which is positioned on the globe (my red box). It is situated upon the 'meridian,' a geographical term that is often repeated within Masonic ritual and was introduced by Desaguliers.

There is a detail from a portrait of *Ashley and Popple Families (1730)* that has a rather obvious Jacobite owl, perched on a branch that resembles an open square or compass *(Figure 9.13).* The owl was part of the Jacobite lodge's emblem implying that they were *'all of a feather.'* One Jacobite group hooted during their meetings. (Clark)

Popple was connected with Charlwood Lawton, a known Jacobite Whig which might explain the inclusion, but more study needs to be done on this painting.

Another errant but obvious Masonic sign is sported in the centre of Hogarth's *Beggar's Opera (1728–31).* Macheath's open coat mirrors the angle made by his leg shackles, which are at an obvious compass. These are the same Masonic shapes Hogarth used in *A Rake's Progress (Figure 9.14).*

Figure 9.13: **Detail from The Popple and Ashley Families (1730).**

I call your attention to Macheath's waistcoat which is open to accommodate his hand at his chest—a Masonic hand position covered before.

Hogarth's *Before and After* paintings of 1731 (not shown) have many jokes and symbols and were painted for the fourth Grand Master, The Duke of Montagu. James Caulfield (Earl of Charlemont) is listed as another great patron and he was Grand Master of the Grand Lodge of Ireland.

Finally, I believe I can also show Masonic inclusions in one of Hogarth's *Illustrations for Butler's Hudibras: scene six (1726). (Figure 9.15).*

Figure 9.14

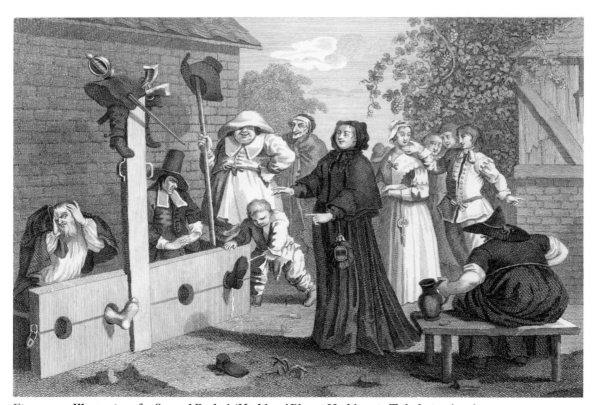

Figure 9.15: Illustrations for Samuel Butler's 'Hudibras' Plate 6 Hudibras in Tribulation (1725).

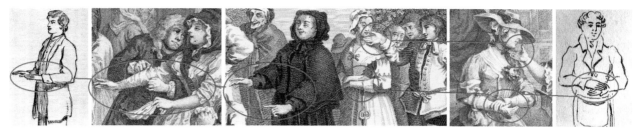

Figure 9.16

I have superimposed the same Masonic signs from *A Harlot's Progress* (which we have already studied in detail in Chapter 2). It shows that Hogarth was experimenting with these symbols at a much earlier date. You can see the same chucking sign and hand sign of First Degree (used in the Harlot's Scene 1). The woman in black is showing the Third Degree hand sign that was so obvious in the funeral scene *(Figure 9.16)*.

By including the stocks, Hogarth also includes the concept of one foot shod and the other unshod *(Figure 3.6)*. The three men on the left of the scene (two in the stocks and the man with the large hat) all have one eye covered, also mentioned in the ritual.

There were also many other later commissions from prominent Freemasons: *'With such relatively substantial Masonic connections, Hogarth's occasional representation of Freemasons and Freemasonry danced the line between irony, satire and ridicule, possibly with an eye on future commissions from affluent and eminent Masonic clients such as Conduitt, David Garrick and Martin Folkes, all of whom became patrons.'* —Foundations of Modern Freemasonry, Berman.

One very important Masonic commission came in 1735, from the Grand Lodge itself. Hogarth was asked to design the medal for the Grand Stewards in the year he was proposed to the select group *(Figure 9.17)* You can see his name listed in the Constitutions for 1735 *(Figure 9.18 my red underlines)*.

GRAND STEWARD'S LODGE

The Grand Steward's Lodge was made up of men who served and paid for the annual Grand

Figure 9.17

Stewards that acted at the *Feast* on 17 *April* 1735, who were all publickly thank'd.	
1. Sir *Robert Lawley*, Baronet,	7. Captain *Ralph Farwinter*, P.G.M.
2. *William Græme*, M. D. and F. R. S.	of the EAST INDIES.
3. *Martin Clare*, A. M. and F. R. S.	8. *Meyer Shomberg*, M. D.
4. *John Theobald*, M. D.	9. *Robert Wright*, Esq;
5. *Charles Fleetwood*, Esq;	10. Mr *Thomas Slaughter*,
6. *Thomas Beech*, Esq;	11. Mr *James Nash*,
	12. Mr *William Hogarth*,

F f 2 Sir

Figure 9.18

Feast. It was to become the lodge from which all Grand Lodge officers were chosen, and paying for the feast could have been the entrance fee to this elite group of gentlemen.

As a past Grand Warden of Grand Lodge, Sir James would have been instrumental in having Hogarth proposed to the Grand Steward's Lodge. You can imagine how this would give him great pride to see his son-in-law continue with his Masonic career. Just look at this sketch that Thornhill made of his extended family in 1733 *(Figure 9.19 my red underlines)*. Thornhill has labelled himself as the figure on the far right with 'Mr. Hogarth' on the far left. Thornhill records

Figure 9.19: **Detail from Thornhill's sketch of his family.**

Hogarth in a rather confident pose. The prodigal son-in-law must have felt fortunate to have been finally welcomed into such a revered family. He is not standing, paintbrush in hand before a group of wealthy patrons, but now appears within the painting.

In one of Hogarth's own sketches, which features a boat trip, the artist has unwittingly illustrated this idea in his own hand '*Mr. Thornhill lending a hand to Mr. Hogarth' (Figure 9.20)*. It presents a wonderful image of Thornhill as a social bridge that allowed Hogarth to leave behind his impoverished past and set sail to a better future. Becoming a fully fledged member of this famous family was certainly a sea change for the poor engraver. It was much more enjoyable to paint polite society when you were part of it!

This is actually Thornhill's son on the boat. Hogarth went on a famous spree with him and several other friends which they called a 'Peregrination.' Hogarth illustrated an account of their travel with another sketch that fits into our story. He shows

Figure 9.20: **Detail from Hogarth's Five Days' Frolic; or, Peregrinations by Land and Water.**

Figure 9.21: Details from Hogarth's Five Days' Frolic; or, Peregrinations by Land and Water.

himself as a 'nobody' in the literal sense, without a body *(Figure 9.21)*.

Hogarth was very much aware of his low-born past. He had come into Thornhill's world a poor engraver and ended up succeeding him as Sergeant Painter to the King. As this study has shown, much of it was due to the Freemasons. The contacts that Hogarth made and the commissions he received from the Fraternity resulted in his huge success and social standing.

Being proposed as a junior Grand Lodge Officer would be the pinnacle of Hogarth's Masonic career. This would have occurred in April 1734 as it gave the Grand Lodge Stewards time to organize the feast the following year. However, one month after Hogarth was proposed, Thornhill died.

After the 1735 feast of St. John the Baptist, which was the main annual event, Hogarth took no further role in Grand Lodge. He may have served as Grand Steward out of respect for his father-in-law, but as soon as he had fulfilled his position, he left the Fraternity altogether. *'There are no references to Hogarth in the minute book of the Grand Lodge after 1735.'* —Ronald Paulson, Hogarth, (Yale, 1971).

Some might accuse Hogarth of taking all he could from Freemasonry when it was popular, but then dropping it just as it had peaked. This would make Hogarth the *'Freemason's Harlot'* in the title of this book!

Not only does Hogarth seem to desert the Grand Lodge, but he begins two works that were very critical of members of the Fraternity: *Night* and the print of *Sleeping Congregation* (both of 1736).

Both works slandered Montgomery, De Veil, Desaguliers and Henley. As we know, Hogarth had mocked Henley and De Veil before, and had poured much scorn upon the Past Grand Master, Desaguliers. These high ranking officials might have given him an icy reception when he joined the Steward's Lodge, which might have explained Hogarth's turnaround.

I believe there was another reason for Hogarth's quick exit. Not only was he bored with Desaguliers, and disgusted with Henley and De Veil, he was eager to join more raucous societies and pursue his known passions for drink and debauchery—the subject of our final chapter.

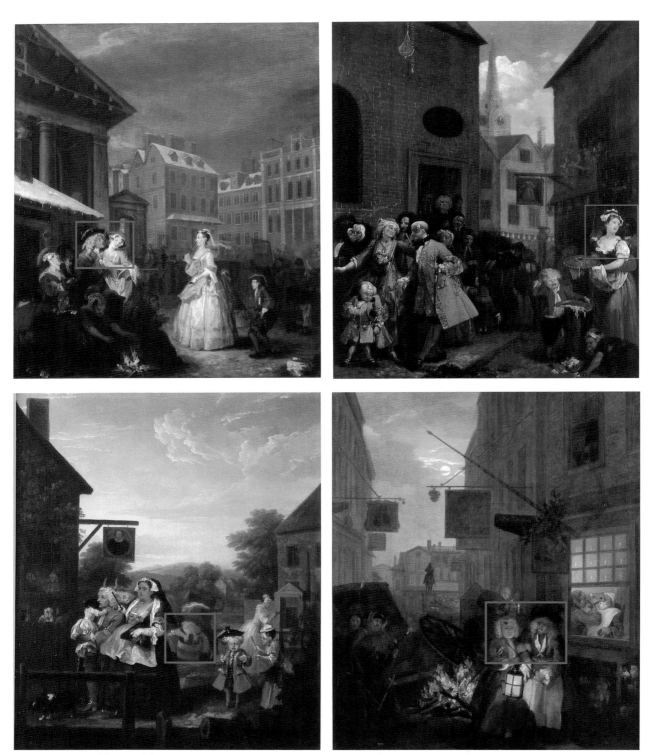

Figure 10.1: **Four Times of the Day. Morning, Noon, Evening, Night (1736).**

Chapter X
Hellfire

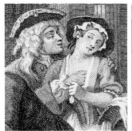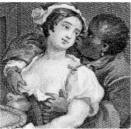

Figure 10.2

Hogarth's *Four Times of The Day* is a wonderful depiction of 18th century London life *(Figure 10.1)*. We have already studied the last scene in this series, in which De Veil has a chamber pot emptied over his head. *Night* contains another, more subtle slander of De Veil that is only revealed when all four paintings are viewed in sequence.

In the first and second paintings of the series, men are fondling woman's breasts *(Figure 10.2)*. In the third painting, Hogarth includes a seemingly random addition of a cow being milked, which continues this 'breast theme' in a rather puerile manner. I believe Hogarth wanted to continue this idea into the final painting so that he could refer to the two men as 'boobies' (an 18th century term used for both fool and breast). A modern Londoner might say 'they are complete tits!'

In the previous chapter, I uncovered a similar, subtle insult that implied that De Veil and his Grand Lodge Tyler were 'empty headed.' This 'boobies' insult would fit perfectly.

By 1736, Hogarth did not want to be associated with such men of the Grand Lodge any more. He would rather have fun with the kind of people who he had imagined cavorting around the streets of London. Look at the couple of rakes in the first scene. They burst out of a boisterous tavern having revelled there all night *(Figure 10.3)*. One of the cads thrusts his hand into the blouse of a young woman outside, while the other kisses her companion.

I believe Hogarth fancied himself as such a rake, so much so, that he cast himself as the wanton fondler. Compare this character *(Figure 10.4 bottom right)* to other self portraits to see the similarity.

The Times of the Day were commissioned for the Vauxhall Pleasure Gardens—a sumptuous 18th century London hookup joint. In return for the paintings, Hogarth received a free ticket that would admit a carriage of his friends for life. The new improved gardens, complete with Hogarth's work, were opened in the year he left the Fraternity.

Hogarth and his cronies would have cavorted with women here, and how impressive to be allowed to ride your carriage through the gates by flashing your ticket (which was in the form of an ostentatious gold medal). I would like to imagine the diminutive and rather unattractive Hogarth showing off his art to full advantage. What better way to break the ice with the single ladies than to have the booth decorated with these rather suggestive paintings? Can you imagine how the chat might have gone?

Hogarth – 'Well hello!'

Single Lady – 'Sir. My friends tell me that you painted these.'

Hogarth – 'Yes. Can you not see my likeness in this one?'

Single Lady – 'Oh, I see you there! But what are you doing to that girl in the picture?'

Hogarth – 'Come a little closer, and I'll show you!'

Hogarth would certainly have more fun with a crowd of party goers in the Vauxhall Gardens than sitting through hours of ceremony at the Premier Grand Lodge of Freemasons.

'THE SUBLIME SOCIETY OF THE BEEFSTEAKS'

Indeed, in the very year that he stopped attending lodge (1735), Hogarth helped to start a drinking club which is still known today as 'The Sublime Society of Beefsteaks.' This riotous group of actors and writers met every Saturday afternoon in a room above the Covent Garden Theatre. They washed down British steak with British ale under the patriotic emblem of 'Beef and Liberty.'

> *'After dinner, the tablecloth was removed, the cook collected the money, and the rest of the evening was given up to noisy revelry.'* —Hawkins English Illustrated Magazine, 1890.

These 'great wits and actors' had fun playing pranks on each other *(Figure 10.5)*. Here is a rare print of Hogarth's that shows a few members of the Beefsteaks playing a joke on John Highmore (manager of the Theatre Royal in Drury Lane). Hogarth and his friends waited until Highmore had fallen asleep with a young prostitute and then replaced her with an older woman of African heritage. The title of the print is *The Discovery (1743)*, but was also known as *The Black Joke* which had nothing to do with skin colour, but refers to a dirty song. It is sung by the pregnant ballad singer in the Tavern Scene of *A Rake's Progress*.

> *'The lawyer his client and cause would quit*
> *To dip his pen in the bottomless pit*
> *Of a black joke and a belly so white.'*

These were the sort of ditties that would be sung after dinner—not at all like the dull Masonic songs printed at the back of Grand Lodge's Constitutions. By all accounts, Desaguliers was running a tight ship as he was attempting to make the Fraternity attractive to royalty. This he accomplished in 1737, when Frederick Prince of Wales

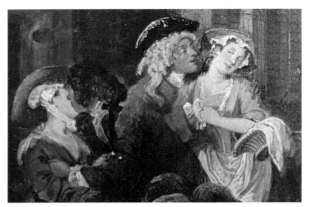

Figure 10.3

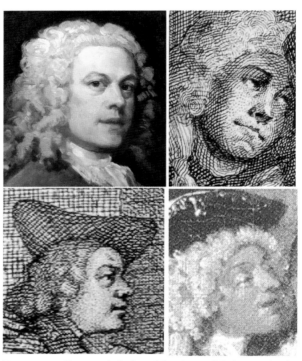

Figure 10.4: **Bottom left, from The Gate of Calais or O, the Roast Beef of Old England (1748).**

(the eldest son of George II) was initiated at Kew Palace. In the run up to this auspicious occasion, you can imagine how strict Grand Lodge would have become.

As a founding member of the Beefsteaks, Hogarth would have helped devise their jovial pseudo-Masonic ceremony of initiation. The officers were organised as a Lodge and used Masonic

128

Qui Color albus erat, nunc est contrarius albo.

Figure 10.5: The Discovery, or 'Black Joke' (1743).

sounding titles of 'President' and 'Bishop.' The candidate was known as 'boots' (a moniker used in some Masonic lodges). At the end of the introductory meal, the new candidate was blindfolded and repeated his vow (that we can presume had much to do with jokes about eating). He was then asked to kiss the Bible (an important part of the Masonic oath). Only when the blindfold was removed did the candidate find that he had actually kissed a beef bone instead.

There was another pseudo-Masonic society in Germany called *The Order of the Mopses* that had a similar kissing ceremony in which the blindfolded candidate thought he was kissing a dog's anus. When the blindfold was removed, the candidate

was delighted to discover that they actually kissed that part of a ceramic dog.

The lodge permitted both sexes, and we see a young female candidate taking her 'oath of faith' in this print of 1745 *(Figure 10.6)*. The Grand Lodge library in London has examples of these 'china dogs' on display. I particularly like this nervous looking one *(Figure 10.7)*.

There were enough Masonic elements parodied by the Beefsteaks that the Antients were affronted. In their Constitutions (1778), they include this dining club in a list of offending Societies '*whose chief practice consists in eating, drinking, singing, smoaking ETC.*' (sic) *(Figure 10.8)*. They include the *No Nose Club* for syphilis sufferers, and the delightfully

129

Figure 10.6: **Detail from 'Plan de la loge des Mopses' (1745).**

Figure 10.7

named *Farting Club*. So Hogarth quit his post as a Grand Lodge Officer, and formed a club that was blacklisted by the Masons!

Hogarth was also a member of the infamous Hellfire Club—as far removed as one could get from pious Desaguliers and his Grand Lodge. I will not describe the shocking details of the decadent orgies that took place in the underground caves of Wycombe (northwest of London). They have been covered in many books and inspired the Stanley Kubrick film *Eyes Wide Shut (Figure 10.9)*.

Many accounts tell us that Hogarth painted pornography on the cave walls. I believe this could have been a similar arrangement to the Vauxhall Gardens, to which the artist was given a membership in exchange for artistic work. I also believe these were seen by none other than Ben Franklin. In a letter, Franklin describes the artwork at Wycombe as 'Whimsical in its imagery ... evident below the earth as above it.' (*The Dashwoods of West Wycombe,' p 160*) These could have referred to Hogarth's 'whimsical' cave paintings. Franklin would have met Hogarth here—they knew each other and shared interests in printing and pornography.

Hogarth painted a portrait of the club's founder, *Francis Dashwood at his Devotions (1739) (Figure 10.10)*. It shows the notorious rake holding

The No Nose Club,	The Smoaking Club,
The Long Nose Club,	The Musical Club,
The Farthing Club,	The Beefstake Club,
The Mankilling Club,	The Kit Kat Club,
The Surly Club,	The Bucks Club,
The Atheistical Club,	The Gregorian Club,
The Ugly Faced Club,	The Salamanders Club,
The Split Farthing Club,	The Codgers Club,
The Broken Shop Keepers Club,	The O d Souls Club,
	The Cousins Club,
The Man Hunters Club,	The Albions Club,
The Mock Heroes Club,	The Free and Easy Club,
The Wrangling Club,	The Antigallic Masons Club,
The Quacks Club,	The Maccaroni Club,
The Weekly Dancing Club	The Choice Spirits Club,
The Bird Fanciers Club,	The Never Fret Club,
The Lying Club,	The Kill Care Club.

And many others not worth notice, whose chief practice consists in eating, drinking, singing, smoking, &c.

Several of those clubs, or societies, have in imitation of the free-masons, called their club by the name of lodge, and their presidents by the title of grand master, or most noble grand.

Figure 10.8

what has been described as "the first centerfold." Compare this to El Greco's *Saint Francis at his Devotions (Figure 10.11)* to see how sacrilegious Hogarth was by substituting a nude for Christ. He also substituted the skull for a mask used in the Hellfire's orgies (as seen in the poster for the film *(Figure 10.9)*.

The only thing I can add to the commentary is this peachy bum which I noticed at the base of the painting *(Figure 10.12)*.

Figure 10.10: **Sir Francis Dashwood at his Devotions, (1739).**

Figure 10.9

Figure 10.11

Figure 10.12: **Detail from Sir Francis Dashwood at his Devotions, (1739).**

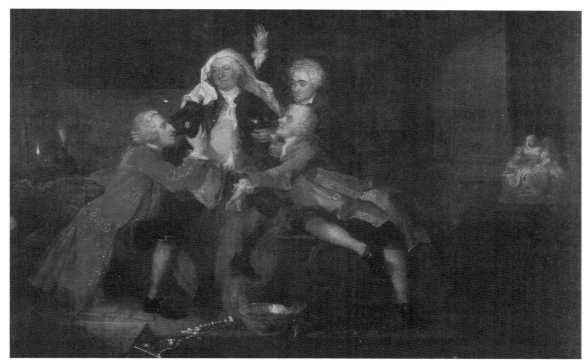

Figure 10.13: **Charity in Cellar (1739).**

Figure 10.14: **Print of Charity in Cellar (1739).**

Figure 10.15

Much drinking went on at the Hellfire Club, as with most of the clubs of the day. Just look at this print which Hogarth made of several members of a similar group who accepted a wager that they could not finish a barrel of wine together in a one night's sitting -'*Charity in the Cellar*' (1739) *(Figure 10.13 and 10.14)*.

Hogarth adds sexual overtones by positioning the men in the same form as the statue of Charity in the corner that shows a mother nursing another woman's baby, seen more clearly in the print *(Figure 10.14)*.

Hogarth mimics the statue by making it look like the men are drinking from each other's breasts. A third seems to pour wine from the central figure's penis, but it is actually a barrel upon which he is sitting. Supposedly they drank the entire barrel to win the bet!

Hogarth seems to have had much fun with his Vauxhall Garden ticket (1736) and his friends at the Sublime Beefsteaks (1735 onwards). Somewhere in this time frame, Hogarth could have been painting erotic scenes for the Hellfire club, and then commissioned to paint a portrait of the founder.

There are many reasons to explain Hogarth's sudden departure from the Craft. A final one has evidence hidden within Hogarth's very last piece of artwork—*Bathos (Figure 10.15)*.

Finis

In 1763, Hogarth told his friends he was dying and started on a work that would show him sprawled out in the eerie form of the Grim Reaper taking his final breath.

The dying figure is surrounded by a pile of verbal links to his finality: the *end* of a candle,

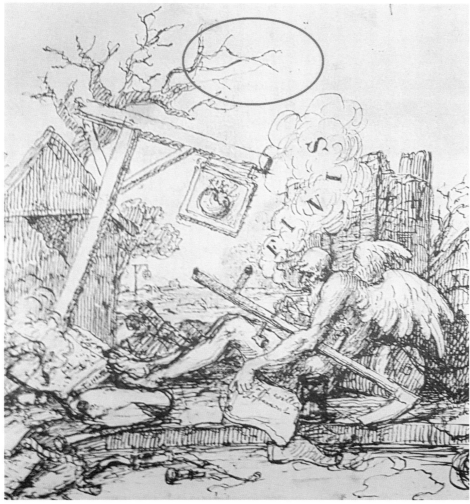

Figure 10.16

the butt-*end* of a rifle, a cobbler's *end*, a rope's *end* etc. In the distance, a ship sinks next to a gallows. There are also items that are broken: a broom, a bell, a glass, a pipe. As *'The World's End'* pub falls to pieces, Death himself has broken his scythe and breathes his last cloud of tobacco from his fractured pipe. Finis! It was a final tangle of riddles from the finest riddle maker who ever lived. *'Rarely an artist has said goodbye to the world that movingly.'* *(Tate Gallery Catalogue, 1971).*

However, one symbol has never been decoded. It is the one that represents the final state of the Premier Grand Lodge. It has always been grouped together with the list of things that denoted an 'end.' However, you can see that in the first state

to the print, *(Figure 10.16)* there was one important image that was yet to be added—the chariot in the sky.

In the very first official Masonic publication (*The Constitutions of the Premier Grand Lodge, 1723*) *(Figure 10.19)*, there is a symbol of Apollo's chariot, which represents the proud inception of the Craft *(Figure 10.17)*. The engraving was executed by John Pine, after a design by Sir James Thornhill.

Now that we are au fait with how Hogarth and Thornhill conspired to attack Burlington's faction, we can see why Thornhill would have included this warlike image. Like the Sun God, this was a new day dawning for this branch of the Fraternity— the rising sun symbolised the ascendancy of the

Figure 10.17

Figure 10.18

new and popular Grand Lodge. However, with the dawn came a protracted battle.

Now that we know the successful outcome of that conflict, we can understand how Hogarth would have retired the chariot theme in his final work. Apollo's task was completed. In Hogarth's mind, the Premier Grand Lodge had been formed to head off the aspirations of the Stuart monarchy. After the threat of Jacobite invasion had passed, the battle was over and it had retired its colours in victory. This is why the Hogarth included a defunct chariot in his *Bathos (Figure 10.18)*.

Burlington died in 1755. Kent, Desaguliers and Walpole had all passed away in the 1740s. That initial period in Hogarth's life when he was fighting the 'Red Lodge' was over. The threat from France had been chased off.

The death of his mentor and father-in-law might have been in his final thoughts as he added Thornhill's symbolism within his own death-piece.

By choosing this chariot theme, Hogarth returns us to the original intent of the Premier Grand Lodge. It had been devised for a particular purpose at a particular time. The Lodge had fulfilled its function now that the work was finished.

Hogarth's career spanned the life of this first expression of Modern Freemasonry. His success had been born out of its formation, and he saw that it was dying with him. Only the genius of Hogarth could encapsulate this entire concept within a single image.

*
* *

We are truly fortunate that Britain's greatest artist was alive during this time, to have left us this record of development of the Craft. It is interesting to look at this time in history through Hogarth's eyes.

I hope Freemasons will be fascinated to discover a new reading of their three hundred year voyage, illuminated along the way with these entertaining works of art.

Admirers of Hogarth will discover previously undetected details in his popular prints and paintings. They will also find a new level of intrigue that sheds light upon the artist's personal vendettas.

Finally, new readers to this period of history might be inspired to learn more. The story of one man's life covers several topics that were pivotal to the history of Great Britain.

I wish scholars of all disciplines luck in finding more. I believe that I have only scratched the surface of Hogarth's etchings, and exposed details that others will find useful in their studies. There must be more symbols still hidden within this artist's works that are yet to be detected.

In conclusion, therefore, I find myself quoting Hogarth's own words—'Guess and you will find more.'

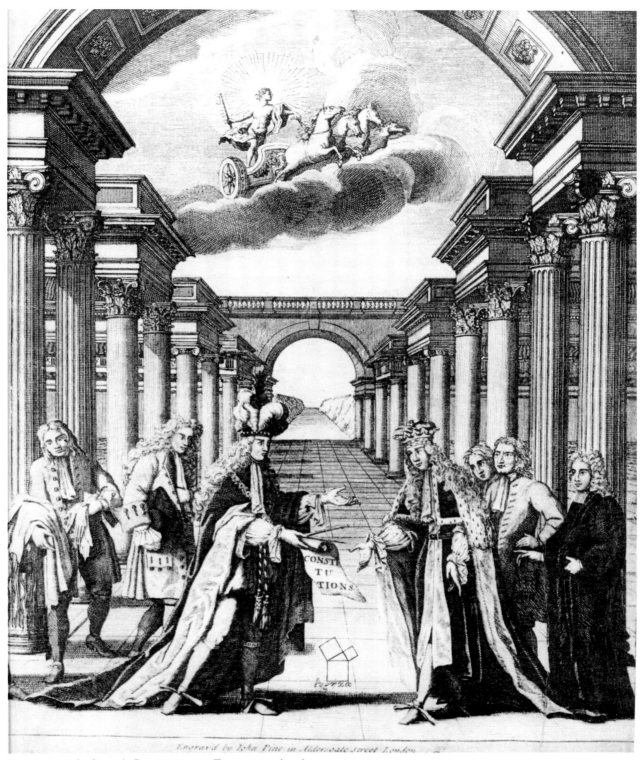

Figure 10.19: Anderson's Constitutions—Frontispiece (1723).

Epilogue

Hogarth lived in a time when Britain continually feared a Jacobite invasion from France. The House of Stuart was living in exile in France, and then in Rome, with full support of the Catholic Church. The United Kingdom was split between those who had accepted the Protestant House of Hanover, and those who longed for the return of the Stuarts. This movement made several attempts at regaining the crown and while two planned invasions were aborted, the landings in 1715 and 1745 came very close to succeeding.

Hogarth's *Invasion* print of 1756 *(Figure 11.1)* coincided with the outbreak of the Seven Year's War (1756–64). It stoked the British fear of French invasion by featuring this terrifying, inquisition-style torture. One wonders if this was another example of Hogarth being commissioned by the government to create a scare tactic. It was printed a year before the unpopular Militia Act, for which there was considerable opposition.

While many plots had been foiled, Jacobitism was still strong in England. One of the key catholic sympathisers was a member of the House of Lords, the 3rd Earl of Burlington. He had been very successful in raising awareness for the revolution, hiding his treasonous activities under a curious guise of architecture, opera, fox hunting and Freemasonry.

Parliament was very concerned about this small but fervent group. They recruited Hogarth to expose this secret agent and slander him in public. The intriguing dimension to this story is that Hogarth had a personal vendetta against Burlington and his gay lover, William Kent—a more successful but less talented artist. The two of them made an easy target for the ambitious and homophobic Mr. Hogarth.

Hogarth's offensive against the couple was brilliantly executed. The artist hid his satirical attacks within some wonderful humour, and his prints enjoyed a wide distribution, becoming the talk of the town. Indeed, many members of the nobility wanted their own paintings to include similar hidden jests.

These entertaining 'conversational pieces' were the impetus for Hogarth's long and successful career. In this respect, his fortuitous rise was partly due to the political battle between the Houses of Stuart and of Hanover. We can now view some of his early work as a form of propaganda.

At the same time, the Premier Grand Lodge of Freemasonry developed. It gained popularity partly because it appealed to those fascinated with the scientific revolution that was sweeping the nation. The new protestant monarchy was of a scientific mind. Hanoverian Britain created a culture of invention and exploration that brought the nation great wealth and trade. The rest of Europe had been left behind, partly because the Catholic Church had stifled such scientific advancement. Indeed, key elements of Galileo's work were still banned as late as 1758.

'The Sun King' (Louis XIV) believed that Royalty was appointed in heaven, to be God's representative on earth. He demanded to be worshipped with a passive obedience—to argue against this was deemed heretical.

It was generally accepted that catholic royalty could perform miracles by bestowing 'The King's Touch' to cure the sick. (Louis XIV touched 1,600 in one day.) James II gave out 'touch pieces' (called 'angels') which loyal subjects would keep secret under their tongues. His grandson, Cardinal Henry Benedict Stuart, was perpetuating this absurd belief as late as 1807.

The protestant rulers forbid any of these 'silly superstitions.' They believed more in modern medicine than in archaic miracles. George II had his whole family inoculated against smallpox in 1722 (after the vaccine had been tested on criminals). He was putting faith in empirical science and not in superstition.

The Hanoverians were moving forward with a spirit of invention that would pave the way for the Industrial Revolution and create the British

Figure 11.1: Invasion (1756) shows the undisciplined French forces boarding ships to invade Britain, leaving the women behind to work the fields. A priest prepares his instruments of torture, and plans to restore the catholic religion in Great Britain.

Empire. They were not about to let a 'heaven sent' omnipotent ruler like James Stuart return them to the past.

We can only imagine what a shift world history would have taken had the Catholic Stuart monarchy regained control. James would have put the brakes on this intellectual advancement and certainly delayed the development of modern technology.

Historians admit that the Hanoverian monarchy came close to being overthrown. Recent studies reveal just how popular the Jacobites were in Georgian Britain, with new evidence on the involvement of the 3rd Earl of Burlington.

My study has used Hogarth's art to connect Burlington to a foreign form of Freemasonry which Burlington used to garner support for his subversive and treasonous activities.

There are too many conclusive proofs that the royal house of the Stuarts cultivated Freemasonry as a political engine to be weilded for the restoration of their exiled family.
—Paraphrased from *The History of Freemasonry*, Mackey, Chapter 30. (1910) .

All these were important factors in the development of the Premier Grand Lodge, which was partly formed in order to promote the House of Hanover and recruit any gentry that might have been tempted to join Lord Burlington's rival faction.

By fostering a Hanoverian vision of progress, the Fraternity was able to topple the rival Order that had its roots in an old world of religion and irrationality.

The accession of George I (1714) was almost thwarted by James II landing in Scotland a year later. That revolution of 1715 was still being quashed in 1716. This was the year that the Premier Grand Lodge was designed, being formally 'incorporated' at the next feast of St. John the Baptist in June 1717.

This timeline is further evidence that the Premier Grand Lodge was formed as a reaction to the Jacobite threat.

'Primary purpose of 1717 Grand Lodge development appears to have been to wrest control of Freemasons from the Tory-Jacobite elements by effectively creating a Whig Hanoverian movement.'
—*Irish Jacobitism and Freemasonry*, Sean Murphy, Eighteenth-Century Ireland 9 (1994).

We should appreciate just how important the formation of the Premier Grand Lodge was as a well-timed political counterforce. Without it, the Jacobites might have succeeded in using Freemasonry to overcome Hanoverian rule.

The 'Red Degrees' would have been a perfect vehicle for the Dukes of Wharton and Burlington to recruit influential aristocrats to participate in their coup. If just one of their many plots had succeeded, the history of Britain would have been very different.

A Jacobite victory would have made Britain virtually subservient to French rule. Many historians have postulated that there would have been no American Revolution. Indeed, France had been bankrupted by supporting these colonies, and it was this that led to their own upheaval of 1789. This paradigm shift would, therefore, have also negated the French Revolution. As these two events precipitated many other revolutions around the globe, how different the world would have been.

It is fascinating that a small group of Freemasons were instrumental in preventing the French superpower from attaining true global dominance. The story is all the more amazing when you realise that there was a specific moment upon which all this pivoted … and it involved a song! Let me paint a final picture.

THE SONG THAT CHANGED THE WORLD

In 1723, the Duke of Wharton thought he had taken over the Grand Lodge when he virtually made himself the next Grand Master. However, the Duke of Montagu (the outgoing Grand Master), would only hand the post over to Wharton, if he accepted Desaguliers as his Deputy. Montagu was right to be suspicious of Wharton. At his inaugural dinner, Wharton decided to stamp his Jacobitism on the

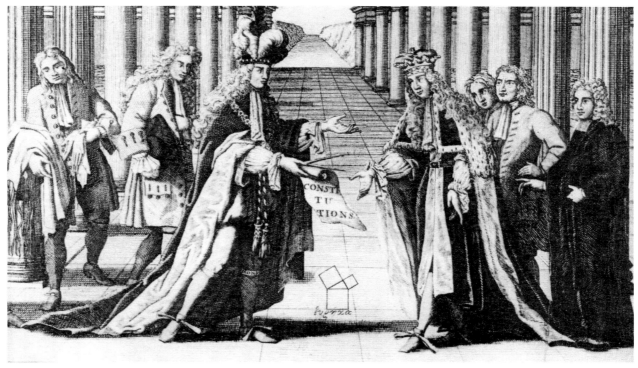

Figure 11.2

assembly by singing the Jacobite anthem: 'When The King Enjoys His Own Again.'

Desaguliers stopped him. Wharton attempted to get the band to play the melody, but Desaguliers quickly quashed it. This Deputy Grand Master had been positioned to hold the reins on Wharton and his political agenda.

You can imagine the Duke was incensed that a lowly French exile had deigned to silence a leading aristocrat. Wharton would not even refer to Desaguliers by his name, but tried to demote 'this serious man' from his controlling position of Deputy the following year. It was so narrowly defeated that Wharton called a recount. However, when it was not going his way, the Duke stormed out of the Grand Lodge 'without ceremony.' He threatened to withdraw his supporters from Grand Lodge, but he failed to start a rival organisation. His order of 'Gormogons' were quickly ridiculed, and Wharton went on to become the Grand Master of (Jacobite) Freemasonry in France (1728–29).

Wharton's departure from Grand Lodge ensued that freemasonry's relationship with the Hanoverian establishment would endure for at least the next decade under Desaguliers' influence and that of a loyalist inner circle.
—Ric Berman, Schism.

From that point on, joining the Grand Lodge was equivalent to swearing loyalty to the House of Hanover and rejecting James and the Jacobite cause. The second paragraph of the Constitutions is a virtual oath of allegiance to King George, swearing against '*Plots and Conspiracies against the Peace and Welfare of the Nation.*'

CONSTITUTIONS

This turning point in Masonic history seems to have been captured in the frontispiece of the Constitution *(Figure 11.2)*.

You can see the full length of the Duke of Montagu's unhindered train (on the left), as he hands over the leadership to his inadequate successor, Wharton, who stands on the right. Desaguliers

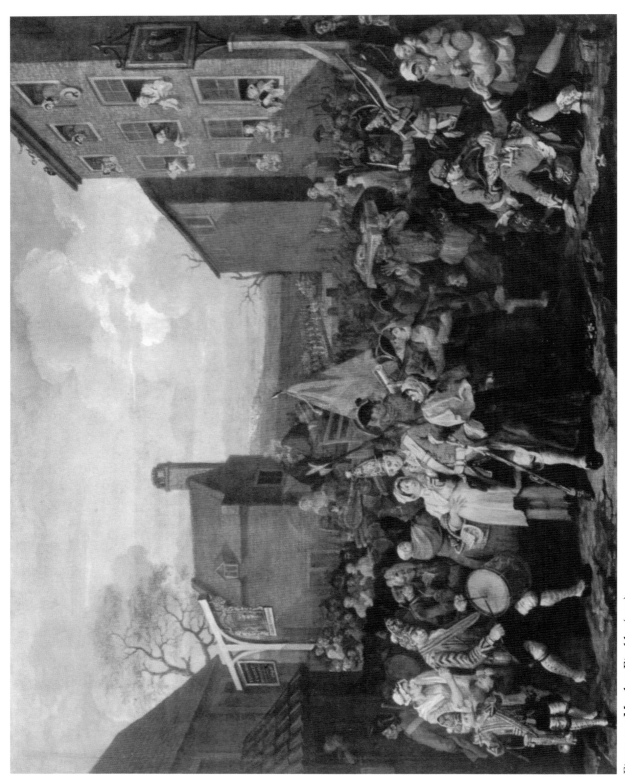

Figure 11.3: **March to Finchley** (1750).

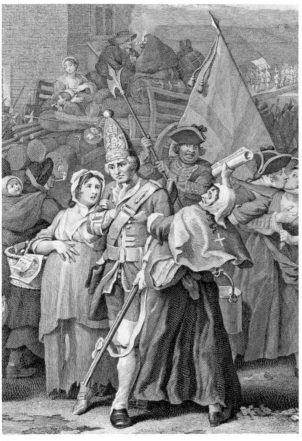

Figure 11.4

is close behind him, pointing at the handover. It looks as if Desaguliers is treading on Wharton's cloak, pulling him back to keep him in check. I wonder if this was an intentional joke by Thornhill, who designed the work.

It does leave us with the mental picture of Grand Lodge curbing the aspirations of the Jacobite faction. It was a rather convoluted situation—a Frenchman holding back the advances of the Scots (exiled in France) from taking the crown off a German King in England!

DESAGULIERS' CROWNING GLORY

Desaguliers reprinted the Constitutions in 1738 to advertise his 'crowning glory' when he initiated King George II's eldest son, Prince Frederick (1707–1751) into the Craft.

This astute move gave the Fraternity a royal stamp of approval. Frederick's brother, William Augustus, Duke of Cumberland (1721–65), was initiated soon after. The Duke became a hero to England after his victory over the last Jacobite uprising of 1745. However, he was a pariah in the north for his bloody putdown of the Scottish clans at the battle of Culloden, at which he gave order to take no prisoners. The troops allegedly slaughtered women and children. William was given the nickname 'Butcher Cumberland.'

Having made his career featuring anti-Jacobite symbolism, Hogarth recorded this final Hanoverian victory over James Stuart—the end of Jacobite aspirations. In *The March to Finchley (1750) (Figure 11.3)*, Hogarth imagined a scene where the English troops are mustering before their advance.

The Duke of Cumberland was their only hope to stop this army of Scots from continuing their successful advance on London. At one point, they had reached a position just 100 miles from the capital.

I believe Hogarth included the Duke in the very centre of this painting. Observe the soldier holding the pike *(Figure 11.4)*. He appears to be repelling the woman who is brandishing a newspaper at him.

Her weapon is a copy of *'The Remembrancer'*— an oppositional (Jacobite) publication. She also has a copy of *'The Jacobite Journal'* in her bag. Her dark cape looks almost clerical, as if she is some crazed priest complete with a large cross that hangs down her back.

Her curled hair might have added to what the English feared in the wild Jacobites north of the border. Her strong grip makes the roll of paper seem more like a dagger. Indeed, there is some shading around the point where the newspaper 'stabs' into his shoulder.

Compare the soldier's face to a portrait of the Duke to see the facial similarities *(Figure 11.5)*. The Duke's wig, hat, cockade, uniform and double chin are similar. This mezzotint was published in 1746, and so could have been copied into Hogarth's painting.

These two characters are very much connected, and yet in reality there is some distance between them. It is clever *trompe l'oeil*, for which the Hogarth was so renowned.

It is a brilliant construction. The catholic woman seems to be pulling the grenadier back. Many critics thought she was fighting for his affection. However, this body position simultaneously gives the illusion that she is being run through by Cumberland's pike. The Duke is in mid-charge, the Union Jack flying behind him. The painting predicts his victory that will put an end to the Jacobite cause.

George II was not impressed with Hogarth's work: *"What? A painter burlesque a soldier? He deserves to be picketed for his insolence! Take this trumpery out of my sight."* Could the King have been told

Figure 11.5: **H.R.H Prince William, Duke of Cumberland, print from painting by John Wootton (1682–1764).**

that his son had been parodied here? Hogarth did not mock the grenadier, and so Cumberland is only other soldier singled out and 'burlesqued' in the painting.

ROYAL LINE OF FREEMASONS

The Duke of Cumberland initiated his nephew, George IV into the Craft. This must have inspired George's brothers, as all five became Freemasons. It was at this time that the Duke of Sussex (George III's sixth son), as Grand Master of the Moderns, liaised with his brother (the Duke of Kent), who

held the same office for the Antients. This presented the perfect opportunity for some 'brotherly love,' and the two factions joined together in 1813. Sussex became the first Grand Master of the United Grand Lodge of England, and the Craft has enjoyed royal leadership ever since. Every subsequent King (except George V) has been a leading member of Grand Lodge.

Although Her Majesty cannot participate, she is 'Grand Protector of the Order.' The Grand Master of the Grand Lodge of England is her first cousin: Most Worshipful His Royal Highness Prince Edward Duke of Kent (grandchild of George V). He was installed in 1967, at the 250th anniversary of Grand Lodge in the Royal Albert Hall. As the 10th Grand Master, Prince Edward has never missed an installation. He still chooses his deputy, a tradition started by Desaguliers.

The Duke recently opened an exhibition at Grand Lodge Library entitled 'Three Centuries of English Freemasonry.' This anniversary has made many question the future of the Fraternity since none of the young royals have stepped up to the plate and taken up the baton.

I wonder if the next generation truly understands just how important the Premier Grand Lodge was in the history of the country, and how fascinating Freemasonry continues to be.

I am glad Hogarth was there to record it for posterity, presenting the next generation of candidates with this new and compelling angle on the Square and Compass.

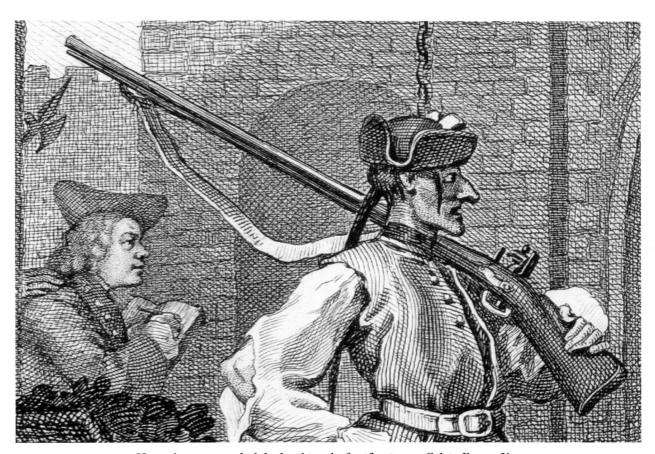

Hogarth was arrested while sketching the fortifications at Calais, France. You can see the hand and pike about to grab him from behind. This detail from 'The Gate of Calais' or 'O the Roast Beef of Old England' (1748).

Notes

NOTES TO FIRST EDITION

An appeal to scholars of both Hogarth and Freemasonry—I understand there will be many areas of this study that could be tightened up. I would welcome any assistance to make the second edition an improved version. Please consider this a peer review (!) and contact me with your comments at *www.brotherhogarth.com*. If I have missed previous identification of any of these Masonic details I would like to include appropriate credits.

A digital version of this book is available online at *www.brotherhogarth.com*.

NON-DEDICATION

I quoted only the ending of Hogarth's proposed (but never published) 'non-dedication' for his 'History of the Arts.'

Complete Non-Dedication:

Not dedicated to any Prince in Christendom, for fear it should be thought an idle piece of arrogance. Not dedicated to any man of quality, for fear it might be thought too assuming. Not dedicated to any learned body of men, as either of the Universities, or the Royal Society, for fear it might be thought an uncommon piece of vanity. Not dedicated to any one particular friend, for fear of offending another.

Therefore dedicated to Nobody.

But if, for once, we may suppose Nobody to be Everybody, as Everybody is often said to be Nobody, then is this work dedicated to everybody,

by their most humble and devoted. William Hogarth, 1753.

NOTES TO PREFACE

Novels:

– *I, Hogarth: A Novel*, Michael Dean (The Overlook Press, 2014).
– *The Hogarth Conspiracy: A Novel*, Alex Connor, (Silver Oak, 2012).
– *A Harlot's Progress*, David Dabydeen, (Jonathan Cape, 1999).

Film:

– *A Harlot's Progress (2006) starring Toby Jones aired in the UK on Channel 4.*

Books in 2016/17:

– *Hogarth's Legacy*, Cynthia Ellen Roman (Ed), (Yale, 2016).
– *William Hogarth—A Complete Catalogue of the Paintings*, Elizabeth Einberg, (Yale, 2017).

Premier Grand Lodge

Originally named 'Grand Lodge of London and Westminster' and is sometimes referred to as the 'First Grand Lodge of England.'

It All Started with Sir Christopher Wren

The Premier Grand Lodge explain how they came to form in their own words, taken from their Constitutions (1723): '*In 1683 the Lodges met and elected Sir Christopher Wren [1632–1723] as Grand Master but in 1716, neglected by Sir Christopher (by reason of his disability [he lived to 91]), the lodges were wanting an active Grand Master. They thought fit to constitute themselves a Grand Lodge and chuse (sic) a Grand Master from among themselves till they should have the Honour of a Noble Brother at their Head.*'

CHAPTER I

The Sleeping Congregation

The Minneapolis Art Museum lists their *Sleeping Congregation* painting as 'a rough oil sketch'. The gallery celebrated its 100th anniversary in 2015—one year after the 250th commemoration of Hogarth's death in 1764.

Ronald Paulson, the undisputed Hogarth expert, recognised the Masonic connection to *A Sleeping Congregation*—'the secularization of the church into a lodge.' He commented on the Masonic nature of the triangle on the wall of the church, but did not report any other Masonic details in the painting or print.

Elope

Jane was only 19 when Hogarth eloped without her parent's consent. Legally she should have been 21 years to be married. They had a very happy marriage which lasted until Hogarth's death in 1764. They had no children, but adopted through the Foundling Hospital.

Newspaper Annoucement (1726)

There will be several Lectures on Ancient Masonry, particularly on the Signification of the Letter G, and how and after what Manner the Antediluvian Mason form'd their Lodges, shewing what Innovations have lately been introduced by the Doctor and some other of the Moderns, with their Tape, Jacks, Moveable Letters, Blazing Stars, &c., to the great Indignity of the Mop and Pail.
—Quoted in Douglas Knoop, G. P. Jones, and Douglas Hamer, *Early Masonic Pamphlets*, (London, 1945). Also in F. De P. Castells, *The Origin of the Masonic Degrees*, (Kessinger Publishing, 2003).

Euclid and the Hourglass

The Hourglass—An emblem connected with the Third Degree. …. As a Masonic symbol it is of comparatively modern date …
—Mackey, Albert Gallatin. *An Encyclopedia of Freemasonry*, 1894.

The illustrations of the Hourglass and Euclid's 47th Problem are always featured together as in *Duncan's Monitor (1882) (Figure N1.1)*. Desaguliers introduced the lecture on Euclid. The hourglass might also have been one of his 'inventions.'

Another interesting illustration from *Duncan's Monitor* is a floor map of the Lodge. The enclosed detail *(Figure N1.2)*, shows the Master's position, on a dais of three steps, underneath the letter 'G.' Hogarth includes this in his painting by featuring three steps leading to a pulpit that has the form of the letter 'G' in its canopy.

The steps do not add any additional function to the painting. Their inclusion can only be explained by their Masonic message. *Duncan's Monitor* includes a lecture on the three steps (which represent the three stages in a man's life).

Desaguliers Creates the Third Degree

Desaguliers was the key generator of the third degree ritual.
—David Harrison, *The Genesis of Freemasonry*, (Ian Allan Publishing, 2009).

Desaguliers reconstructed the (third degree) ritual with dramatic and theatrical flair.
—Erik Hornung, *The Secret Lore of Egypt*, (Cornell University Press, 2001).

A growing consensus of historians are contending that elements of what was to become the Third Degree ritual were designed during this period' (early 1720s).
—Tracing the Generation of the Third Degree, Adrian T. Taylor. Research & Education Lodge (DC).

Hogarth Becomes a Mason at the Exact Time the Third Degree Ritual is Created

By Nov 1725 Hogarth had joined a lodge.
—Jenny Uglow, William Hogarth:
A Life and a World, (Faber 1998).

Hogarth became a member on Nov 27th 1725 at the Tavern at the Hand and Apple Tree, Little Great King Street. Some believe it might have been a little earlier.
—C. Revauger—William Hogarth
et la Franc-Maçonnaerie.

Serious historians agree that the third degree was devised or introduced around 1725.
—Leo Zanelli, The Square Magazine, Vol. 25.

On the Influence of Desaguliers *(Figure N1.3)*

Too few Masons of the present day, except to those who have made Freemasonry a subject of special study, is the name of DESAGULIERS very familiar. But it is well they should know that to him, perhaps more than to any other man, are we indebted to the Present existence of Freemasonry as a living institution; for when in the beginning of the eighteenth century Masonry had fallen into a state of decadence which threatened its extinction, it was Desaguliers who, by his energy and enthusiasm, infused a spirit of zeal into his contemporaries which culminated in the revival of the year 1717, and it was his learning and social position that gave a standing to the institution, which brought to its support noblemen and men of influence, so that the insignificant assemblage of the four London Lodges at the Apple Tree Tavern has expanded into an association which now overshadows the entire civilized world. And the moving spirit of all this was John Theophilus Desaguliers. *—Mackey, An Encyclopaedia of Freemasonry (1894).*

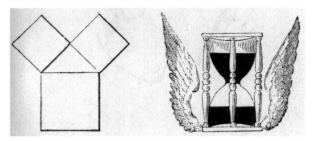

Figure N1.1

Figure N1.2

Figure N1.3: **Painting by Hans Hysing (1678–1753). Print listed as Peter Pelham (1695–1751). Insert showing wart discussed with N7.14.**

Inigo Jones

A bust of Inigo Jones (1573–1652) had recently been made by John Michael Rysbrack (1694–1770) in 1725. Hogarth painted his version of the famous architect in 1758. I have compared Hogarth's handkerchief version to William Kent's depiction, which was painted around the same time, as both would have been based on Rysbrack's bust.

In the Constitutions, Jones is listed as 'Great master mason' and 'glorious, incomparable.' It would fit that he would be part of this lodge, even in this ghostly form.

Kent and Intentional Misspelling of 'Accademy'

William Kent won a medal at the *Accademia di S. Luca*, but it was for 2nd prize in the 2nd class.

'In that capital of the arts he studied under Cavalier Benedetto Luti, and in the academy gained the second prize of the second class.'
—*Anecdotes of Painting, Walpole Vol. 1, p137.*

Kent also boasted that he was the only protestant artist who had painted a fresco in a catholic church (in Italy). In reality, Kent had only painted a small part and it was done for free (*'per mia devotione'*).

Kent signed his name with the Italian 'Kentino' and kept throwing Italian terms into his conversation. This would have annoyed both Hogarth and Thornhill, who would have enjoyed ridiculing him for this pretension.

Clown

The Goose and Gridiron was the name of the tavern in which one of the first Masonic lodges met. It may signify that the clown was mocking Burlington for moving away from the lodge that met there.

Hogarth includes a gridiron next to the goose in *A Harlot's Progress* that will be discussed later *(Figure N1.4)*.

Figure N1.4

On closer inspection, the clown is holding the gridiron at a curious angle as if the handle is placed on his behind in mockery *(Figure 1.18)*.

Hogarth's The Man of Taste

Although *The Man of Taste* was printed in 1731 (and so does not fit into the timeline of the argument of Chapter 1), I would like to include the detail that shows another column that is surreptitiously labelled with the letter 'B' *(Figure N1.5)*. The whole print will be discussed in detail in Chapter 7.

Burlington's Compasses

Another Masonic element to *The Man of Taste* is that Burlington has a pair of compasses hanging from a Masonic sash he is wearing. He is labelled 'F' for Freemason *(Figure N1.6)*. John Ireland (in 1793) assumed the compasses referred to Burlington being an architect; they obviously add to the Masonic content.

Gormogons

On the far right of the Gormogons print are two characters mocking this ridiculous parade *(Figure N1.7)*. They are laughing at the character of Don Quixote, who you can see in full armour. Hogarth has lifted these and other characters directly from an etching by Charles-Antoine Coypel (1694–1752), 'First Painter to the King' *(Louis XV)*.

Robin Simon discusses Hogarth's visits with Coypel in Paris *(Robin Simon, Hogarth, France and British Art, (Holberton 2011))*.

Coypel's original etching shows a scene from the novel by Cervantes in which Don Quixote attacks a puppet show which the foolish knight believes to be real *(Figure Nr.8)*. Hogarth positions Quixote drawing his sword against this fake-Masonic parade mocking those that believed the Gormogons to be real.

In the novel (Part 2, Chapter 26), there is a monkey which Quixote believes can talk. Hogarth dresses it in Masonic garb to further mock the gullible Gormogons *(Figure Nr.9 right)*. The mop and pail have a connection to the ritual that will be explained in Chapter 8.

The religious figure on the left of the monkey is copied directly from Coypel's work, a detail of which is included for comparison *(Figure Nr.9 left)*.

Gormogons - Full Advertisement in Mist's Weekly Journal

We hear that another ancient Society is started up, in Town, of Gormogons, of much greater Antiquity and Reputation than the Free-Masons; for whereas the latter can deduce their Original but from the Building of Babel, the former derive their some thousand years before Adam. The Order was lately brought here from China by a Mandarin, who is now departed for Rome, to establish a Lodge in that City, as he has done in London. We are informed a great many eminent Free-Masons have degraded themselves, and come over to this Society, and several others rejected for want of qualification.
—Mist's Weekly Journal (Oct 17, 1724).

I believe this was written by the Duke of Wharton, whose anti-Government stance and subsequent attempt to take over the Grand Lodge is well documented. Wharton had published many anti-government letters and pamphlets in the same opposition newspaper—Mist's Weekly Journal. The most scurrilous of them was known as *'The*

Figure Nr.5

Figure Nr.6

Figure N1.7

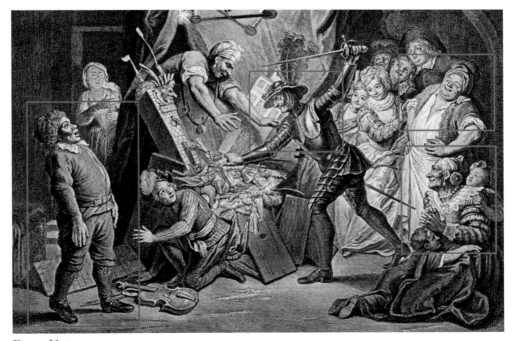

Figure N1.8

Persian Letter' (1728), which led to Walpole banning the publication.

Hogarth includes the 1ˢᵗ Duke of Wharton in the painting, standing behind Quixote. I include the Duke's portrait for you to see his likeness *(Figure N1.10 bottom right)*. Notice that this figure has his hand at his chest—the sign made by Jacobite Freemasons throughout this study.

I have also highlighted two figures at the doorway above him who are also straight out of another Coypel scene in which Quixote has a mock knighting ceremony in such a tavern. This is a further direct link and lampoon of the Order.

Old Woman's Bare Behind

Finally, let me address the detail of a man kissing the bare behind of an old woman through the rungs of a ladder(!) I believe that Hogarth took this ridiculous initiation from a poem printed in the Daily Post of London,

Figure N1.9

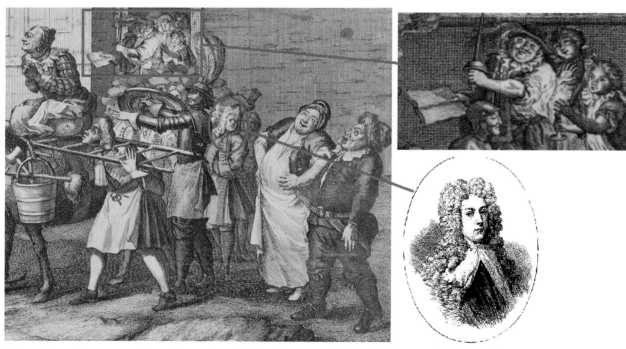

Figure N1.10: **Gorgomons Coypel figures(top right) and portrait of Duke of Wharton (bottom right).**

152

1723. '*The Freemasons: An Hudibrastic Poem*' is a long-winded and scurrilous piece of doggerel which mentions this bizarre bottom kissing ritual, along with several details from Don Quixote.

I believe that all these references to Cervantes highlight the curious (indeed quixotic) 'Order of Toboso.' This Jacobite fraternal organisation had a chivalric focus and took its name from the heroine in the novel—*Dulcinea of El Toboso*. Hogarth must have been informed of this obscure foreign group to have included so many references to it within this early piece of anti-Jacobite propaganda.

Thornhill and Hogarth Reunite

Here is the actual print that Thornhill produced after his visit to the condemned prisoner, before Sheppard's execution in Nov. 1724 *(Figure N1.11)*.

Thornhill and Hogarth are also reported to have gone together to the prison cell of Sarah Malcolm to paint this other celebrated criminal.

Figure N1.11: John Sheppard (1724). Sir James Thornhill. Engraved by George White.

CHAPTER II

SCENE 1

First Sign is Not Accurate

The first Masonic sign is unlike its modern equivalent. This may be because the sign was different in those early days, or because both Hogarth and Avery Allyn did not want to depict it too accurately for fear its copying would allow non-Masons to fake their way into a lodge.

Indeed, none of these static illustrations would help anyone to fool a Freemason who knows the full sign with its multiple parts.

Wagon from York

The wagon carrying the young candidates has arrived from York *(Figure N2.1)*. This city claimed to be the birthplace of Freemasonry and had a protracted battle with the Premier Grand Lodge of London and Westminster which claimed precedent merely because it had formed the first Grand Lodge.

These gentlemen styled themselves the *Grand Lodge of All England Meeting at York* but were short lived and were defunct by the time of the print. Hogarth makes a word riddle of this situation by featuring half of the wording on the 'York wagon' to read 'York Gon.' The letters B.R. above might refer to Bristol whose 'Grand Lodge' was also in decline.

Sharp Object at Heart

From Morgan's exposé we read that the first stage of initiation for a Masonic candidate involved a *'sharp implement piercing my naked left breast.'*

Could the rose, with its two curious shaped and shaded leaves *(Figure N2.2)*, be a continuation of the fan pointing at the candidate's heart?

Father Mother

I believe Hogarth was playing with the juxtaposition of a 'Father' on one side of the central character and a 'Mother' on the other (the old woman was known as 'Mother Needham.') They are both in black, contrasting with the virgin dressed in a large white apron *(Figure N2.3)*.

I have highlighted the line that runs between them. The shadow bisects it at a perpendicular—a Masonic construct.

Columns Up and Down

In Chapter 1, I proposed that Hogarth's initial idea of the Deacon's excited state in *Sleeping Congregation* was a joke on the 'erect column.' *'The junior Warden lays down his Column and the Senior Warden sets his up.'* —Jachin and Boaz, (1762).

This concept of one column raised up while the other is laid down is also included in Scene 1. It is formed by the two piles of buckets next to the horse. The young (female) candidate has been brought into the lodge (on the point of a compass to her heart). This means that the business of the lodge has begun, and the columns must show that. One goes up, the other comes down, represented by one of the columns of buckets falling over *(Figure N2.4)*.

Of all the Masonic clues given by Hogarth, this is the most awkward and has given rise to many non-Masonic readings of a sexual nature involving the impending doom of the young virgin. A few explanations involved Colonel Charteris, the accused rapist who fondles himself at the door.

A third representation of this concept of columns being raised is detected in Scene 6 in which the minister's glass falls next to the raised sprig of rosemary *(Figure N2.5)*. This will be of interest to Masonic scholars who previously thought the introduction of this procedure came much later, based on the first mention of it in the exposés of the 1760s.

Figure N2.1

Figure N2.2

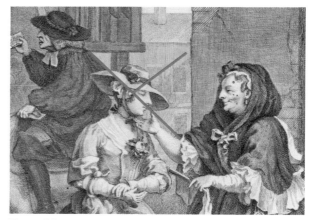

Figure N2.3

SCENE 2

The Monkey

The line of the ritual that mentions '*beasts of the field*' is presented by the harlot's keeper and a frightened pet monkey, both of whom have been scalded by hot tea. The ribbon with which the monkey plays mimics the fop's wig. They are further connected by having the same facial expression *(Figure N2.6)*. Hogarth used the device again in *A Rake's Progress* Scene 1, where a maid and a cat are given a similar scowl *(Figure N2.7)*.

On Left or Right Breast

Sometimes the correct left breast is shown, and sometimes the right side is used as the print is a reversal of the painting. However, since some of Hogarth's paintings were not reversed it gets a little complicated!

Harlot's Lover is Half Dressed

Thornhill missed the significance of the Harlot's lover who is sneaking out of the room 'half dressed.' One of the young man's stockings is falling down his calf *(Figure N2.8)*. This is described in this Masonic exposé of the time: '*One looses the garter of his right-leg stocking, folds up the knee of his breeches and requires him to deliver any metal thing he has upon him.*' —*Dundee Manuscript, 1727*.

We have already mentioned 'divulging himself of any metal' in the chapter. The fact he holds his sword might be referring to this part of the ritual.

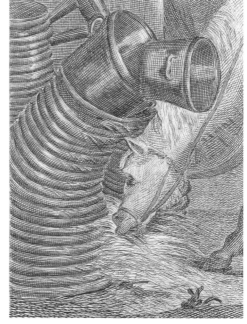

Figure N2.4

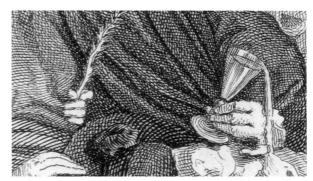

Figure N2.5

Figure N2.6

Figure N2.7

Note that the sword and scabbard are pointed toward the fop (in a trompe l'oeil), as per the ritual. This is reminiscent of the two points of the fork in the chicken *(Figure 3.11)*, which is shown in the French print on page 49.

SCENE 3

A Harlot's 'for Profit and Pleasure'

We have already looked at this Masonic phrase in *Sleeping Congregation* where the words 'labour' and 'refreshment' were highlighted in the biblical readings on the church wall: *'at high 12 at Noon, when the Men was gone to refresh themselves.'* — *Pritchard (1730).*

We find the harlot is sitting on her bed, having just had sex with a client which is her 'labour,' evidenced by a used condom being washed out. She is now being served a 'refreshing' cup of tea.

The full phrase is *'from Labour to Refreshment ... for profit and pleasure.'* The harlot's last client was James Dalton, a famous highwayman, who left in a hurry when he heard the constables who have just burst into the room. In his rush, he left his wig

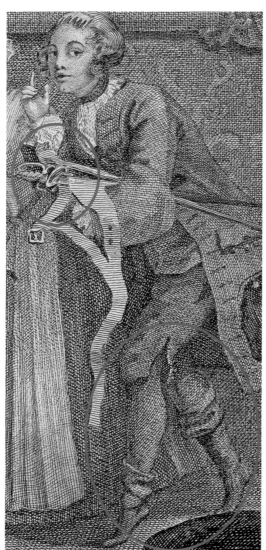
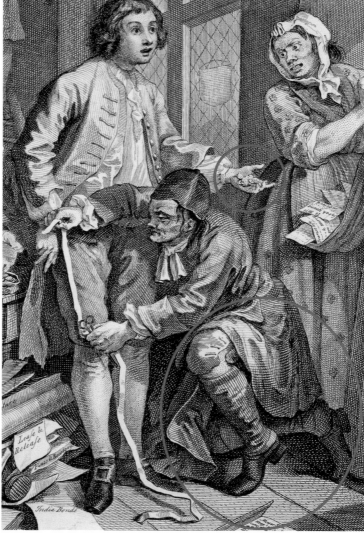

Figure N2.8

on the wall (and its box above the bed with his name on it) *(Figure N2.9)*. He has given the harlot a gold watch in return for her services. This is her 'profit' from her night of 'pleasure.'

Another Form of the Second Degree

There is another attempt to show the Second Degree sign. The harlot's hands in Scene 3 are in the same position as the fop's hands in Scene 2 *(Figure N2.10 with Allyn's illustration in the centre)*. This would also explain why she bared her left breast as per the ritual when this sign is being made.

How Scene 2 Inspired the Whole Series

'Amongst other designs of his painting he began a small picture of a 'common harlot,' supposed to dwell in drewry lane, just rising about noon out of bed. This whore's dishabille careless and Countenance & air pleased many, some advised him to make another. To it as a pair, which he did, then other thoughts increased and multiplied by his fruitful invention till he made six different subjects which he painted so naturally ... that it drew everybody to see them—which he proposing to engrace in six plates to print at, one

Figure N2.9

guinea each sett, he had daily Subscriptions come in, in fifty or a hundred pounds in a week—there bring no day but persons of fashion and Artists came to see these pictures ...' (sic)

—Vertue, Notebooks, vol. III p58,
Walpole Society, vol. 22 Oxford, 1933.

This is evidence that this first painting contained a Masonic jest and a Masonic sign that was then picked up by Hogarth's Masonic friends. They convinced him to put a different sign in every scene, so creating the rest of the series.

Harlot Knows About Raid

Sir John Gonson, a celebrated magistrate of the day has spied Dalton's wig and is making a

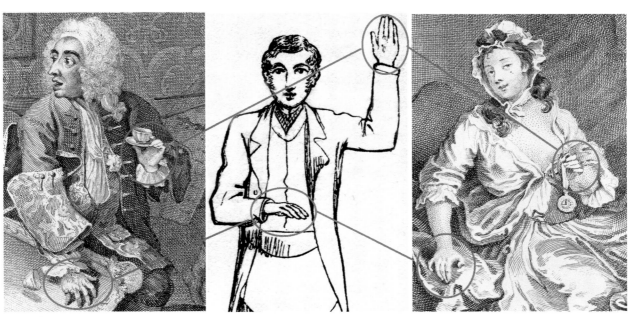

Figure N2.10

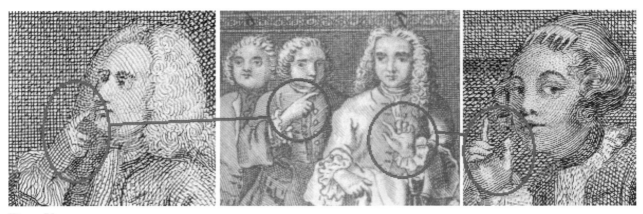

Figure N2.11

puzzled look as he deduces the situation. Many commentaries thought he was 'hushing' his surprised entry, but I believe the two women are aware of his presence. They are trying to act innocent by drinking their tea.

Gonson puts his finger to his mouth, exactly like the Masonic sign that can be found in a French exposé *(Figure N2.11)*. Compare it to details from the French prints by *Léonard Gabanon, (1740)*, full versions at the end of Chapter 4.

The same sign is made by the young man in *(Figure N2.8)* and by Bonnie Prince Charlie (the 'Young Pretender' 1720–1788) in Kent's ceiling decoration at Chiswick *(Figure 4.9)*.

Used Condom Confused for Punchbowl!

Recent commentators thought this condom was a lemon rind in a bowl of punch! In the text I have positioned another punch bowl from Hogarth's *Midnight Modern Conversation (Figure N9.4)* to show the similarity of the lemon rind. I believe the stick was added in the 'washing bowl' to give the suggestion of a punch ladle *(Figure N2.12)*.

Early critics noticed this hidden prophylactic, but only made subtle references to it that were then not picked up by more recent observers. John Trusler mentions *'the filthy equipage of her night's debauch'* in 1768. Ireland, in his commentary of 1793 notices the *'table strewed with the relics*

Figure N2.12

of the last night's revel.' —*Rev. John Trusler, Hogarth Moralized, (London, 1768). John Ireland, Hogarth Illustrated (London 1791).*

The triangular chip in the bowl is the same shape as the triangular looking glass next to it and might have been a Masonic link.

Cat in Finchley

Hogarth rudely jokes about the prostitute's past 'labour' with a client by painting a cat in this suggestive position insinuating rear entry. Hogarth used the same cat position to signify the brothel in his painting *A March to Finchley (Figure 11.3 very top right, on the roof)*.

Tea Pot

The water pouring into the teapot seems excessive *(Figure N2.13)*. It is possibly a sexual allusion to add to the cat and the curtains ('pot' being

158

Figure N2.13

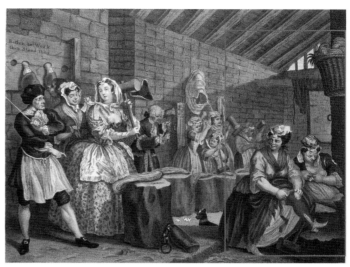

Figure N2.14

a common vulgar euphemism). It might also be in reference to a column coming down, as compared to the cat's rear going up!

Feet Positions

All positions of feet in the series are either at an obvious square or an intentional parallel:
- Feet at a square: Gonson in Scene 3; jailer and female servant in Scene 4.
- Feet not at a square: harlot as a candidate in Scene 1; also Charteris; the lover in Scene 2; the orphan in Scene 6.

SCENE 4 *(Figure N2.14)*

Controversy Concerning the Fourth Degree

I am not prepared to wade into the quagmire of Masonic research to try to unravel and explain why a detail from the Mark Degree would be known to Hogarth in 1725. However, you cannot deny that the wicket and axe from this ritual are evident in this scene.

Hogarth exposes another sign for this degree *(Figure 9.6)* declaring it to be foreign.

Both Breasts and Legs Exposed

Having previously shown both left and right breast as per the ritual for the first two degrees, Hogarth follows the system by exposing both breasts for this 'higher' degree in the right corner of the jail scene. The artist manages to hide this action by depicting the female prisoner picking lice from her bosom! This has always seemed a rather errant detail in the light of the action taking place, but now it can be explained as an important Masonic addition to the degree. It was mentioned in the ritual below.

'On entering, the senior deacon presses both points of the compass against his naked right and left breasts. He is furnished with an old pair of drawers, which are tied or buttoned just above his hips, and both legs of them are rolled above his knees.'

—Avery Allyn, *ibid.*

The Harlot's Maid is Happy

Most commentaries describe the maid mocking her mistress here, but I think she is happy at the gift of the new shoes which she has put on. She smiles over to her as she re-ties her garter *(Figure N2.15)*. This little piece of theater enabled Hogarth to have this maid character showing both of her

legs. This corresponded to the ritual for this degree mentioned above.

Indeed, Hogarth wanted to illustrate this detail from the ritual in which both legs are show, but could not have the maid exposing so much to the viewer. Hogarth places the mallet in such a position that it would be looking up her skirts at her exposed thighs.

There are actually two mallets in this corner, which form a Masonic square. This was to focus the attention of any Freemasons looking for clues. The mallet was a prop in the third degree ritual known in the lodge as a 'Hiram' and is mentioned a dozen times in Morgan's exposé. Hiram Abiff was the chief architect of King Solomon's Temple.

This same technique of using an inanimate object to 'look up' the skirts is copied in *A Rake's Progress (Figure N3.3).*

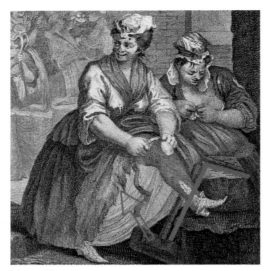

Figure N2.15

Figure N2.16

Why Do Masons Bare Their Chests?

The exposing of the leg and chest was done to prove the candidate's gender. Many Masons debate the reason for this. Here is a section from an exposé of 1758:

Q. What was the Reason they stripped you?

A. In order that all the Lodge might be well assured they were not imposed on by a Woman.

Q What Reason have they for not admitting Women into this Mystery?

A. Because it is well known that Women in general cannot keep their own Secrets, much less those they are entrusted with.

Q. What Proof have you of this?

A. We have many Proofs of this, both in sacred and profane History; but as one may serve, the Story of Samson and Delilah will be sufficient.

　—The Freemason Examin'd; or the World Brought out by Darkness into Light. Alexander Slade. (London, 1758). Copy found in Queen's University Library, Kingston, Ontario.

The term 'freeborn man' is often used. Showing one's chest proved one was 'freeborn' without a criminal's chest tattoo. Baring a leg would also demonstrate absence of manacles.

Bible Pillars

In this corner of the jail scene, Hogarth also includes a pillar which conforms to the biblical description of King Solomon's Temple, integral to the Masonic ritual. The latticework or basket chapiters with lilies and pomegranate blossoms are all

Figure N2.17

listed in the Bible: *'The capitals on top were in the shape of lilies.'* —Kings 7:22.

Hogarth incorporates these details by positioning some beaten hemp to emulate the vegetation *(Figure N2.16)*.

Jeremiah (52:21) describes the network or filigree on top of the column, which some translate as perforated basket-work, which we can see in the print.

The King James Bible (1 Kings 7:41) also mentions: *'The two bowls that were on top of the pillars.'* I believe Hogarth hid a rather rude reference to this Old Testament detail in Scene 1 where two posts ('pillars') support a washing line, each with a chamber pots ('bowl') drying out underneath! While this might be a laugh to Freemasons, it does show Hogarth making a serious insult to religious iconography.

Behind the 'pillars' in Scene 1, we see a lattice window which is a perfect reproduction of the floor map of Solomon's temple as printed in *Duncan's Monitor, (1882) (Figure N2.17 right).* It also makes an appearance in Scene 6 *(Figure N2.27)*.

More References to Pillars

The position of the pillars are important to the ritual of the degrees. In Scene 1, the minister on horseback passes directly beneath these columns *(Figure N2.18)*. From Morgan's exposé: *'The Senior Deacon having explained the columns, passes between*

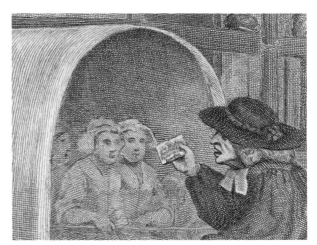

Figure N2.18

them.' I believe that the only reason that Hogarth gave the minister a letter from the Bishop was to show him as a deacon (a deacon reports to a bishop in the Anglican Church). He is in the action of riding off to the address on his letter just as the Deacon reports to the Junior Warden in the ritual. The replacing of the position of deacons by stewards in the new Premier Lodge was controversial at the time.

I do not believe the minister is lecturing the young girls in the wagon as many have thought—he is too far from them *(Figure N2.18)*. I believe Hogarth wanted to get both these groups between the columns because, in the ritual we find the

'*candidates passing between the columns,*' just as the wagon of young women are doing.

The candidates and the deacon, between the columns (with their 'bowls'), are all Masonic hints. I believe the concentration of clues in this scene give weight to each detail and more proof that the whole series has an overall intention.

Figure N2.19

Goose and Gridiron

Along with the *Rummer and Grapes*, the *Goose and Gridiron* was one of the four Lodges that formed the Grand Lodge and was therefore instrumental in instigating many of these changes. It was also the location for the first meeting of the Grand Lodge.

This is the sign that hung outside the famous tavern *(Figure N2.19 right)*. The symbols of the bird and the gridiron are quite clear in the bottom right corner of the first scene. I have not found mention of this in any commentary.

The Goose and Gridiron: (Seldom Reported History of Premier Grand Lodge)

In an obscure part of London, in an angle of St. Paul's Churchyard, this ancient hostelry had a quaint paneled bar, and a narrow winding staircase leading up to a small vestibule, and opening out of this was a dining room of considerable dimensions.

In this room, on the Festival of St. John the Baptist, in the third year of the reign of George I, was instituted the Grand Lodge of England, a memorable event in the annals of Freemasonry. From this old room rays of light emanated that struck into every quarter of the globe.

The tavern was originally 'an antiquated Stuart hostelry [and] a "Music House", concerts and musical parties being held there under the sign of the "Swan and Harp."

When the house ceased to be a music house [1672] the succeeding landlord, to ridicule its former destiny, chose for his sign a goose striking the bars of a gridiron

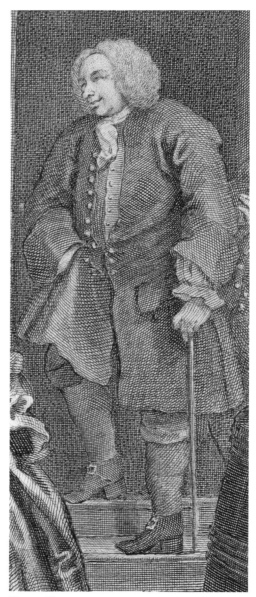

Figure N2.20

Figure N2.21

with its foot, thus making fun of the Swan and Harp, which was a common sign of the early music houses.
— *Paraphrased from: 'The Romance of Freemasonry' By Mysticus, The New Age Magazine, Volume 26. Republished by Supreme Council, Ancient and Accepted Scottish Rite of Freemasonry of the Southern Jurisdiction, U.S.A., 1918.*

SCENE 5

Notable French doctor, Jean Misaubin (1673–1734) argues with Richard Rock (1690–1777) a German doctor well-known for his treatment of venereal disease. His pills lie on the table (along with his name). Apparently the contrast between Rock (short, fat German) and Misaubin (gaunt Frenchman) is intentional.

Dr. Misaubin is recorded as Junior Grand Warden for 1732, and listed as a Grand Steward in the following year *(Anderson's Constitutions 1738, p213)*. Like Gonson, Charteris and Mother Needham, these men were recognisable characters that Freemasons would have known.

MH CU

MH can have another meaning as 'Most High' which appears 5 times in Morgan's exposé.

I invoke the NAME of the MOST HIGH, to whom be glory and honour …
— *Illustrations of Freemasonry, Preston, (1795).*

In *'The Truth About the Masons,'* author and Freemason Richard Allan Wagner gives the same letters. *'The words themselves are not important but the first letter of each word is … M, H, B.'*

Rape Master General

Colonel Charteris is standing at the door fondling himself *(Figure N2.20)*. This has always been seen as a reference to him being the infamous 'Rape Master General.' However, Hogarth has used Charteris' odious reputation to hide a Masonic password with a clever word riddle.

Tubal Cain, the artificer in Genesis, is mentioned in numerous exposés as a Masonic password. The pronunciation of his name sounds like 'two ball cane.' This has long been a Masonic joke and illustrated in the form of genitalia. Hogarth may well have been the instigator of this visual jest by showing Charteris fondling his testicles while holding a cane.

Today, the password is often represented as a golf club and two golf balls, or as a tie-pin *(Figure N2.21)*. It is also presented as '007' which fool the non-Mason into thinking that it refers to James Bond. Hogarth was the first to illustrate this now popular visual Masonic pun.

Sign of Crossed Hands

The man next to Charteris is also making a Masonic sign *(Figure N2.22)*. Compare him to

an illustration from the *Supreme Council of the Netherlands in Hague (artist unknown)*. Again, I am not going to attempt any Masonic explanation of this sign. We are only interested in Hogarth's inclusion.

Thanks to Grand Lodge Historian at the Grand Lodge of Massachusetts

I found the above illustration at the Library at the Grand Lodge of Massachusetts in Boston, USA. This is a good place to thank the Grand Lodge Historian there, Walter Hunt for his help finding many of these illustrations.

I was also well received by the curator of the Grand Lodge of Scotland, Bob Cooper who is well known for his studies that show how Scottish Freemasonry pre-dates the English Premier Grand Lodge.

SCENE 6

Hogarth Giving Gloves to a Prostitute

With classic mischief, Hogarth imagines himself presenting *his* favour of gloves to a common prostitute. The woman's state of undress and Hogarth's loving look hint at a post-coital gift.

When a Free-Mason is enter'd, after having given to all present of the Fraternity a Pair of Men and Women's Gloves and Leather Apron.
— 'A Mason's Examination,'
(The Flying Post, 1723).

A French exposé of 1737 explains the tradition that the candidate *'is given the apron of a Free-Mason, a pair of men's Gloves for himself, and another pair of ladies' gloves, for her whom he esteems the most.'*
— 'Reception d'un Frey-Macon' Harry Carr (Editor) The French Exposures, Quatuor Coronati Lodge No 2076, (London, 1971).

Third Degree Signs for A Master Mason

The other sign of the Third Degree is made by the prostitute being fondled by the minister. Her hand,

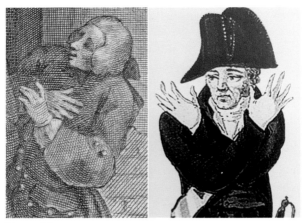

Figure N2.22

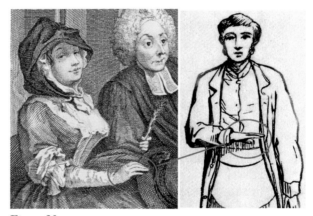

Figure N2.23

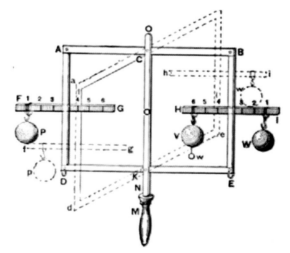

Figure N2.24

holding her hat is out in front of her stomach, is similar to the illustration in Duncan's exposé listed as 'the penalty sign of the Third Degree' *(Figure N2.23)*.

Desaguliers' Balance

Hogarth mocks the founder of modern Freemasonry several times in his paintings. Here he includes the third Grand Master dressed as an old woman. Several clues lead to his identity—the first being the bottle at his feet. 'Nants' is famous for its wine and also for an edict that offered amnesty to French Protestants. It was the Revocation of this Edict that forced Desaguliers' Huguenot family to London in the first place. The distinct upturned glass, ('refusing' the Nantes) I believe hints at 'The Revocation of Nantes.' Hogarth is famous for these word puzzles.

The bottle has a grinning face, further mocking a Grand Master in drag! It may be laughing at the legend that his family smuggled young Desaguliers out of France in a wine barrel! [Robin Simon].

Desaguliers is also known to have suffered greatly from the gout, which would explain the protruding foot squeezed into a small shoe. He was also known to always carry a white handkerchief which we see on his shoulder, as a well known Masonic sign of recognition. The doctor was indeed an Anglican clergyman, hence the praying stance, and he invented an apparatus known as *'Desaguliers' Balance,' (Figure N2.24)*. This is why our cheeky Hogarth has shown him falling off a chair!

Hogarth would use this inclusion of *'Desaguliers's Balance'* again in his painting *Lord Hervey and Friends (1738)* in which he is toppling on a chair, and looking through a telescope (Desaguliers also experimented with optics). This painting will be covered in Chapter 7.

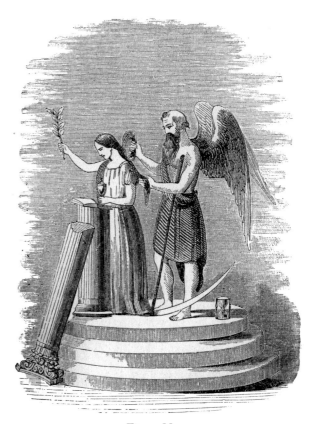

Figure N2.25

Father Time and the Virgin

This image of *Father Time and the Virgin*, often seen at Masonic graves, is attributed to Jeremy Cross (1819), but it was first suggested in Johnson, 1782 *(Figure N2.25)*. I believe Hogarth knew of this icon fifty years earlier.

> *The Weeping Virgin symbol was not invented in America… Cross may have found it in some old French engravings which he took to be of English origin. Its prominence in the Third Degree is not modern but old, is not American but is British.*
> —Mackay's Encyclopedia, (1894).

The Working Tools of a Master Mason

The degree ritual uses the tools of the stonemason's trade as props for lectures on self

Figure N2.26

improvement. It was natural that Hogarth would try to hide them within the scene. He manages to squeeze in over a dozen, most of which that have never been noticed. Here are some further details:

Square, Level and Plumb-Rule

Q. What are the Moveable Jewels? A. Square, Level and Plumb-Rule.

A. What are their Uses? A. Square to lay down True and Right Lines, Level to try all Horizontals, and the Plumb Rule to try all Uprights.

— Masonry Dissected, 1730.

A Shield of Trowels

The trowel is cleverly included within this shield which is drawn in the form of the *Ancient Order of Masons of London (Figure N2.26 left)*. Hogarth uses this same shield in *Sleeping Congregation*, inserting owls for trowels *(Figure N2.26 far right)*. This will be covered in notes to Chapter 7.

Lattice Window and Roof Rafters

The lattice window is a perfect reproduction of the floor map of Solomon's Temple, as given in Duncan's exposé *(Figure N2.27)*. The number of roof rafters refer to the seven steps, an important part of the ritual.

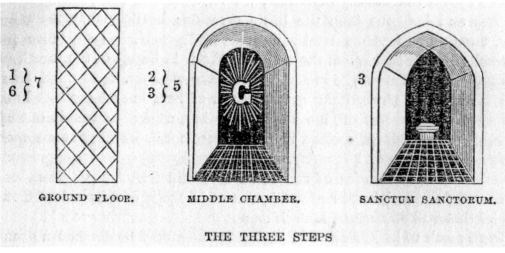

Figure N2.27

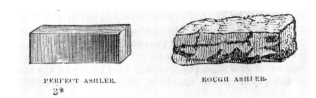

Figure N2.28

Figure N2.29

Figure N2.30

Figure N2.31

24 Inch Gauge

There is a semblance of a measuring rod within the chair rail next to the door. In later etchings it has lines representing 24 inches, which is part of the lecture concerning 24 hours.

Rough and Smooth Ashlars

The rough and smooth ashlars are such important props in the ritual, that once Hogarth had started hiding elements, he would have had to have found a place for them *(Figure N2.28 and 29)*. I believe he hid them so cleverly within the form of a window sill that many will disagree they are there. However, we must realise how difficult it was to hide these two strange shapes within the scene.

The rough ashlar was first depicted as a rough rock, which I believe is shown as a sponge used to stop up a broken window *(Figure N2.30 left)*. Agreed, it is not the clearest of symbols and is so curious that it is seldom mentioned in commentaries, even though it is quite prevalent in the picture. I think Hogarth figured the hole in the window to be in the shape of a moon which we see from an Masonic apron of the time *(Figure N2.30 right)*.

Setting Maul Drinking Glass

One of the most cleverly disguised tools has to be the setting maul in the shape of a bottle on the coffin. The lodges incorporated this old style of setting maul as a gavel for their meetings.

Sir Christopher Wren's setting mall will be used in the 300th anniversary celebrations of the UGLE.

The maid grips it like a weapon, as she stares angrily at the minister *(Figure N2.31)*. As this prop is always held by the Master of the Lodge, Hogarth gives the maid the gloves as the Master would have worn.

By featuring the maul as a bottle, Hogarth then had to add glasses to complete the image. The prostitute, resting her drink on the coffin, is always mentioned. However, the original reason for the inclusion was never fully understood. It is another example of the storyline being set by an item that was primarily used to hide a Masonic detail.

Glove Stretcher

I took a little poetic license with the idea that Lady Thornhill had read the *Memoirs of a Woman of Pleasure*. It was written in 1748, and the Harlot was

Figure N3.1

Figure N3.2

painted in 1723. However, 'glove stretcher' as a vulgar term for penis was used before it was included in John Cleland's erotic novel.

Rosemary

Some academics rejected my initial ideas and argued that the plant is actually rosemary (common in funerals for remembrance). I simply reiterate the brilliance of Hogarth for supplying another believable story to put non-Masons off the scent(!) *Prichard's Masonry Dissected*, published two years before the print, mentions the plant and its significance in the ritual *'a Sprig of Cassia at the Head of his Grave.'* Much has been written about the spelling of the word.

Hogarth in Masquerade

In the first pirated copy by Elisha Kirkall (Nov. 1732), the accompanying poem spotted Hogarth's inclusion. Here is the final line:

Should any at one posture take offence—
As all must do, who are not void of sense.
Know that (the best excuse which can be made)
The Painter's drawn himself in Masquerade.

Freemasons Enjoyed the Hunt

When I published an article on the harlot's funeral scene for *Grand Lodge of Massachusetts Magazine (2015)*, I challenged the brethren to find the signs. Many Masons found several, and Dan Madore, (Past Master of Columbian Lodge in Boston), found a few I had missed! Maybe there are more symbols still hiding.

As you see from the print at the end of Chapter 5, there are many from which Hogarth could have chosen.

Chapter III

Positive Gripe

There is some possibility that these were the original names intended by Hogarth and that he changed them to Rakewell after the publication of the piracies but the evidence is inconclusive. —David Bindman, Hogarth and his Times, (UCA Press, 1997).

Locks on Trunk

There is something curious about the trunk *(Figure N3.1)*. The keyhole is not central, nor does it line up with the actual lock mechanism. This might be another representation of the secret pattern of knocks (two short, one long, two short) that

are associated with every degree. Hogarth hid the knocks of the first degree in the door nails in Scene 1 *(Figure 2.5)*.

Burlington Mentioned in Constitutions

The first edition of the Constitutions was written by James Anderson (1679–1739) and Desaguliers in 1723. Burlington is mentioned in the Fellow Craft's Song (by Charles De La Faye): *'Then in our songs be justice done, To those who have enriched the art, From Jabal down to Burlington, And let each brother bear a part.'*

Burlington is added in a footnote as *'The best British architect of the time.'* However, in the reprint of 1738, he is conspicuously absent from that line in the song. *'From Jabal down to Burlington'* has been replaced with *'From Adam to Carnarvan down.'*

We can be sure that the change was due to Burlington's Jacobite connections because the Duke of Wharton is also missing from the second publication, having been mentioned in the first as part of the Warden's Song.

One interesting fact I discovered in researching this detail was that in one exposé (*Jachin and Boaz, 1762*), Burlington is back in the song. The book includes a note which incorrectly listed him as 'the late Grand Master.' I cannot believe that a printed Masonic exposé would make a mistake like this. Could this have been a Jacobite version that acknowledged his leadership of the Jacobite faction?

Finger Pointing at Chamber Pot

A perfectly drawn finger points at the forked chicken. However a seemingly deformed hand points at the letter G in the chamberpot *(Figure N3.2 red circle)*. This hand is so badly drawn that I feel it was added at a later date, possibly when the chamberpot was added, as it is not visible in the painting.

Rake's Age Conforms to Burlington's

The 1st and 2nd Earls both died within six years of each other, so our Burlington (the 3rd Earl)

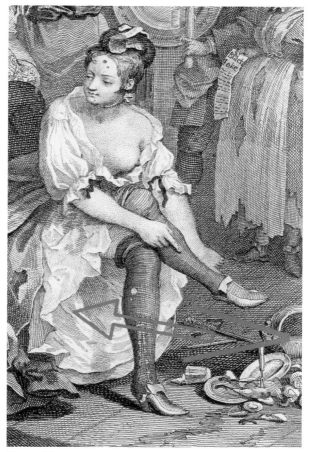

Figure N3.3

inherited everything aged ten. The age of the boy in Scene 1 therefore corresponds to Burlington when he receives his inheritance.

Clues Lie Between the Prostitute's Legs

In Notes to Chapter 2 *(Figure N2.15)*, Hogarth used two mallets at a square to look up the maid's skirts in order to represent the ritual of baring both legs. The same thing is happening in *A Rake's Progress* where the higher degree is being represented. The dagger at a right angle is positioned to 'encompass' a view of the posture woman's inner thigh *(Figure N3.3)*.

The dagger is actually behind the skirt and another example of Hogarth's trompe l'oeil.

CHAPTER IV

Red Slippers

While I am sure that it was fashionable to wear red slippers in the 18th century, I could not find any other portraits showing the same footwear.

Burlington is A. Pope

I thank Ricky Pound for alerting me to a copy of this portrait of Burlington *(Figure 4.8)* at Orleans House in Twickenham, where it is attributed to Jonathan Richardson (1667–1745) but identified as Alexander Pope. Pope never posed for a full length portrait due to his hunched back. I believe the Orleans House portrait is Burlington, and the Christie's catalogue is a painting by Richardson.

I also believe that the gardener on the right (identified as James Scott in the Christie's brochure) has had something painted over by his hands which are abnormally large *(Figure 4.8)*. In the Orlean's House painting (not shown) I suspect Burlington was pointing at something that was also painted over.

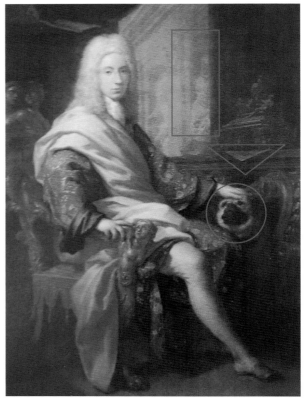

Figure N4.1: **Thomas Coke, 1st Earl of Leicester, Francesco Trevisani, (1656–1746).**

Figure N4.2

Figure N4.3

Paper Clues in Leicester's Portrait

There is a triangular shaped piece of paper on the Earl's table *(Figure N4.1 red triangle)*. Several exposes mention the Masonic significance of a folded piece of paper.

Q. 'What did you see there? A. A folded Square Paper. A Pasport to the Sanum Sanorum, (sic) and all the private Parts of the Temple.'
 —'Post Boy Sham' exposure of 1723.

I cannot ignore the statue behind the Earl which is slumped over as if dying *(Figure N4.1 red box)*. The statue's hand almost resembles a representation of acacia and therefore the statue might be that of Hiram Abiff—the murdered character central to the Third Degree ritual.

Also notice that the Earl has his fingers at a compass and is patting a pug dog, a recurring symbol for secrecy in portraits of the time. The gaudy chair is one of William Kent's designs.

More Colours in Wanstead

Hogarth has placed another two dresses of different colours in the Wanstead Assembly painting. To justify featuring the colour black, the artist has included the woman in black mourning dress, her face hidden *(Figure N4.2)*. I believe this is so that her presence might be explained as a family member who had died before the painting was finished, and so was not able to sit for a portrait. However, there is no specific documentation of the curious inclusion.

In the context of the other Masonic symbols, I believe this was added as a conversational piece that would only be understood by those in this particular Order. Green, red and blue represent the colours of the lodges *(Figure N4.3)*. Black and white are used in the ritual as described below. The woman's black dress thus combines with Lady Castlemaine's white dress to provide these colours.

'In the French and Scottish Rites, the lodge in the third degree is decorated in black and is strewn with white or silver tears, representing the sorrow caused by the death of Hiram Abif.' —Colour Symbolism in Freemasonry, Bro. Leon Zeldis. Found in masonicworld.com and seen in the French Masonic prints on page 61.

The lady in black, who represents the black tears on a white background, seems to be talking to Castlemaine's brother who has his hand at his chest. These tears might allude to an earlier 'Noachidae' ritual, mentioned in Anderson's Constitutions.

Royal Arch Link to Jacobite Degrees

We cannot hide the fact that there is a considerable body of opinion in favour of the theory that Royal Arch masonry was a creation, a 'fabrication,' of French origin, brought to England round about 1730. —Freemason's Book of the Royal Arch, Bernard E. Jones.

For all these reasons I am convinced that the Royal Arch Degree has its origins in France. —Early Ritual of the Holy Royal Arch, Thomas Smith Webb Chapter of Research No. 1798, (New York 2004).

The political climate in England at that time was not favourable to anything of Jacobite origin so the degree was dropped. Immediately the Scots Master disappeared when the Royal Arch emerged. —L.M. Sherwood, The Royal Arch; the Story of its Emergence and Development.

{When the Antients were} 'rummaging among the old records of the Order, [they] first discovered the Royal Arch Degree, which had probably lain dormant for centuries.' —Duncan's Monitor

These publications quoted above give exhaustive detail connecting Jacobite 'Red Degrees' fabricated in France to a later development of the Holy Royal Arch we know today. This book is interested in Hogarth's expose of Burlington's association.

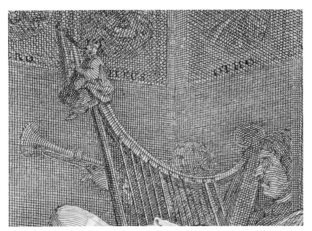

Figure N4.4

'Higher Degrees' from Exiled Irish and Scots Jacobite Militia

Freemasonry was unquestionably brought to France by Scottish and Irish Jacobites who were garrisoned there. Whether or not they were the first to do so, is still being debated by some. That they had a great impact on the development of the Higher Degrees in 18th Century France should not be. When the impact and presence of the Irish and Scots in Pre-Revolutionary France is taken into consideration, their involvement in the development of Freemasonry should not be hard to reconcile. —Richard Hayes, Irish Freemasonry in 18th Century France, (London 1932).

Burlington's Irish Ancestral Connection to the Jacobite Degrees

Another locus of early Freemasonry appears to have been in Munster, among such English settler families connected with Richard Boyle, the Great Earl of Cork.
—Irish Jacobitism and Freemasonry, Sean Murphy, Eighteenth-Century Ireland Vol. 9 (1994).

Indeed, the first mention of the Royal Arch is to be found in Youghal, Ireland—the ancestral home

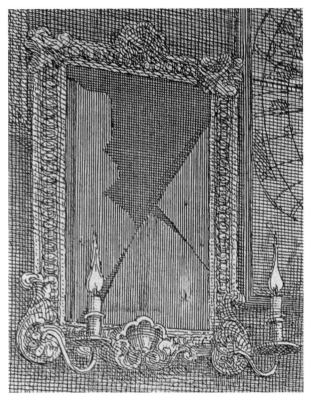

Figure N4.5

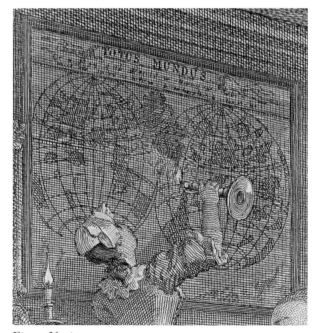

Figure N4.6

of the Burlingtons. Note 3rd Earl of Burlington (also named Richard) was also 4th Earl of Cork.

Burlington's Ancestors Were Staunch Royalists

The 3rd Earl of Burlington's great-grandfather (the 1st Earl) fought with Charles I, supplying 100 horses and money. He was helped by *his* father—'The Great Earl of Cork.' After the royalists' defeat, Cromwell fined and exiled the Earl of Cork's son. When Charles II was restored to the throne he welcomed his loyal subject back, and created him the 1st Earl of Burlington.

Burlington had strong Jacobite ancestral links. The 3rd Earl of Burlington's uncle, the Duke of Orrery, had pleaded with Cromwell to restore Charles II. Now Burlington was trying to restore James III to the crown.

Green and Blue Colours

Now that we have associated Burlington with these Irish and Scots Degrees, we can acknowledge 'the Green Lodge of St Andrew' which is still active in France and would explain Chiswick's Green Room. Scholars can find the colour mentioned in the *Order of Toboso* and the *Copaile Code*.

'*True Blue Jacobite Frock Coats*' are mentioned on page 75. Green and Blue lodges are discussed in many Masonic studies.

Returning to the Rakes Tavern to Explain the Trumpet

Burlington's Irish ancestors might have been involved in Freemasonry when the Jacobite army was first stationed there before being exiled to France. Hogarth provides a detail that links what we are calling the 'Red Degrees' with this Irish connection. It involves the trumpet player in scene 3 of *A Rake's Progress (Figure N4.4)*.

This instrument is central to the ritual practiced by the Royal Scarlet Order, part of the Royal Arch degree in Ireland (note the colour 'Scarlet'). The degree relates the story of Joshua

Scotland » Regalia » D Royal Arch

Royal Arch Principals Robes --- Price: 435.00

Figure N4.7

using trumpets to tumble the walls at Jericho. (See details in *Evangelicalism and National Identity in Ulster, Patrick Michel, Oxford, 2003*).

The addition of the harp might also be a reference to the Old Testament as David played the harp for King Saul. Hogarth is reported to have added a known harpist by the name of David Lewis.

Rake's Tavern - a Jacobite Lodge Room

Hogarth leaves several other details to identify the Rake's Tavern as Burlington's Lodge room which can only be fully understood now that we are aware of the Jacobite context.

Three Lights of Freemasonry

The French custom of having three candles supported by three very high holders can be seen in the French print *(on page 61)*. Hogarth copies these high candles by featuring three lights around the mirror on the wall *(Figure N4.5)*.

These three lights are mentioned in all exposes of the time and adorn every Masonic lodge to this day. In *Prichard (1730)* there was a note '*These*

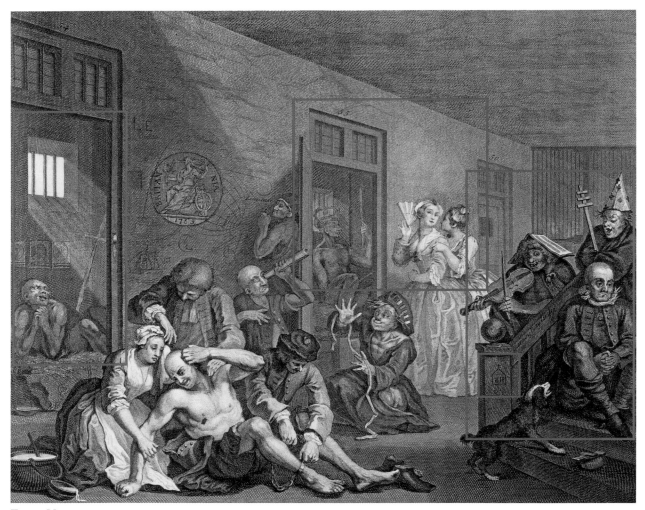

Figure N4.8

lights are three large candles placed on high candle-sticks.' Those who can only see two candles have missed the clever addition of the third candle that is reflected in the mirror between them.

By featuring the candles around a cracked mirror, Hogarth shows some disdain for this Jacobite lodge. He places this broken mirror next to a painting of double globes on the wall, a popular adornment to a Masonic lodge *(Figure N4.6)*. Double globes are also seen in Hogarth's *Denunciation (Figure N9.2)*. A maid seems to be setting the globes alight—another sign that this foreign Order is hell bent on destruction.

Burlington's seditious group is threatening to destroy the country, hence the general destruction of the Tavern. Commentators have never understood this addition of the arsonist nor the general havoc evidenced by the vandalised portraits.

Now we can also understand how Burlington is ignoring the English Freemasons and following this French Jacobite degree. He has defiled the letter 'G' by featuring it as a piss pot, and cast aside the English style initiation ritual (illustrated by the discarded forked chicken). Instead, Burlington has adopted the French degree with its sign (hand at chest) and its password (on the plate).

Lobsters with Clean Shoes

In the Royal Arch (originally our 'Red degrees') today, the Principal still wears a bright red cloak. You can see the modern version of this on sale at Victoria Regalia in Edinburgh, Scotland *(Figure N4.7)*.

The wearing of these red robes might just explain a strange line in a poem by Alexander Pope in which he writes about *'Lord Burlington's Lobster nights.'* The poet might have joked about how their colourful capes made them look like lobster backs (a derogatory British term that was used for British soldiers who dressed in that colour).

Another line of poetry that might also be explained by the slipper's ritual is John Gay's 'Trivia' which describes his arrival at Burlington's house—*'There I enter, but with cleaner shoes.'*

Burlington's Freemasonry and his alleged covert involvement in Jacobite politics, has been suggested by a number of scholars in recent years. —Steven Brindle, William Kent: Designing Georgian Britain, (V&A, 2013).

Notes from Clark's Findings on Burlington

– Jane Clark, The Mysterious Mr. Buck, Apollo Art Magazine, 129 (May 1989).
– Jane Clark, Lord Burlington is Here, in Lord Burlington: Art, Architecture and Life, Barnard and Clark, (Hambledon, 1995).

Burlington Attends Royal Wedding

In a great piece of investigative writing, Jane Clark compared the diaries of Burlington's contemporaries. Her cross referencing revealed that Burlington was not accounted for in the very month that James III got married. She deduces that Burlington attended the royal wedding at Montefiascone, Italy.

Burlington Abroad

Burlington was abroad in 1714, 1717, 1719 and 1726—all periods of intense Jacobite activity and spent over 2 months in the Netherlands and

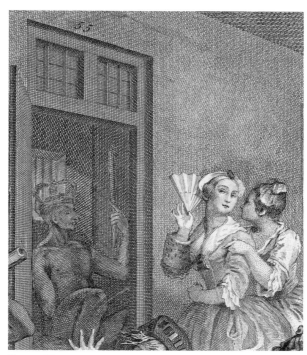

Figure N4.9

Holland, hot-beds of Jacobitism. Clark also points out that when Burlington was 'touring' he made no sketches, only bought books. Kent notices that Burlington is in a constant hurry and not really focused on the art he was reported to be collecting.

Burlington Becomes Main Agent

Jane Clark recounts how Burlington had been put in charge of orchestrating the Stuart restoration after the previous agent, the Duke of Hamilton, had been assassinated in 1714. In that year, Burlington went immediately to Paris, which Clark assumes was to fill that position before the 1715 revolution.

King's Friend

James III spoke of his *'three main friends'* and *'unknown superiors.'* Clark gives evidence that one of these is indeed Burlington. Correspondence shows that Burlington was well known to James. Burlington also had a long private interview with Charles II. Mary of Modena (wife of James II) confided in Lady Burlington.

Laundering Cash

Clark shows how Burlington's 'grand tour' and benefit concerts were used to transfer funds and launder cash for the cause. A servant writes that *'his lordship had to wait for substantial sums of money to arrive from Ireland before he could leave for Paris in 1726.'* He is told that the plan is *'secret so not a word.'* There is evidence of *'mysterious disappearance of large sums to known destinations.'*

Atterbury's Messenger

Clark suggests Burlington was beyond suspicion and carried messages and money from Atterbury to James Stuart in 1717. Atterbury's conspirators gathered at Burlington House.

There was *'voluminous correspondence of Walpole's spies concerning Burlington'* whose codename was 'Mr. Buck.'

Masonic Visits

Clark mentions the Masonic Lodge at Saint Germain-en-Laye. Burlington met with Lord Melfort there with the excuse of buying artwork.

Burlington the Jacobite

'Burlington was an intensely secretive man, who had many Jacobite friends and contacts. ... Andrew Crotty, Burlington's steward was a Jacobite agent. ... Did Burlington have a secret Jacobite agenda? ... The evidence is indeed only circumstantial, but there is a good deal of it.'

James III is the 'Masturbating King'

I believe that Hogarth leaves us several hints that the so called 'masturbating king' of Scene 8 *(Figure N4.8)* is James III ('the old pretender').

First of all, the king is not masturbating as is many times reported.

Figure N4.10

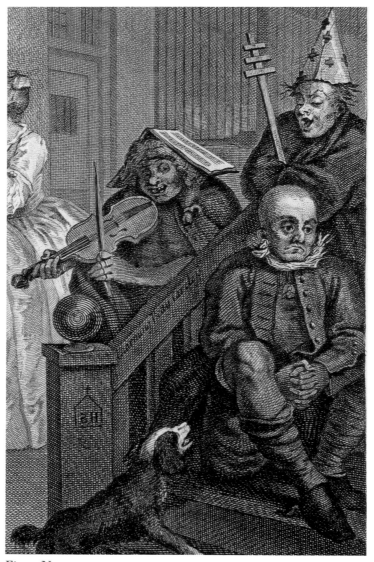

Figure N4.11

Hogarth has clearly depicted a stream of urine and not a single ejaculation *(Figure N4.9)*. As a classics scholar, Hogarth would have known the biblical term, *'him that pisseth against the wall,'* which appears six times in the Hebrew Bible. It means 'a person who hopes for progeny.' This would certainly be true of the Stuart case. It could also be alluding to the phrase that still means to waste money, which James III most certainly did.

Hogarth gives us a few extra hints that this is James III. The number three appears several times—the shadow of three bars in the cell and the windows in threes above it *(Figure 1.9)*. There are also three spines to the fan through which the inquisitive lady stares. She holds up three fingers. It is not easy to hold an open fan between thumb and forefinger in this manner.

The inclusion of the blushing lady has always been seen as Hogarth injecting a little voyeur humour into the scene, but if I am correct, she is both another clue as well as a distraction from the message.

The cell right next to the would-be king holds a religious fanatic, which might have been Hogarth's way of representing the term 'Divine Right' (of Kings) into picture form. This was a central point to the Jacobite cause and would have been repeated many times in connection with James III.

Note the madman seems to be pointing back towards the sun possibly hinting at his heavenly appointment.

Bedlam Hospital

We have always assumed this asylum was the famous Bedlam Hospital because of the letters BH carved on the stair post *(Figure N4.10)*. However, Hogarth might have been telling us that this asylum was Burlington House, implying that Burlington's Jacobite plots were the stuff of madness. The letters are surrounded by a church-like structure which would link into Burlington's Catholic cause.

Close inspection of the letters *(Figure N4.10)* shows the letter 'B' is actually a backward 'S.' This would create 'SH' (as in 'Shhh' for secrecy).

Elisabeth Soulier-Détis ('*Guess at the Rest:' Cracking the Hogarth Code, p109 (Lutterworth, 2010))* describes several Jacobite links with the characters around that stairwell *(Figure N4.11)*. She identifies the conical hat as having French fleu-de-lis and makes several links to the Royal Arch Degree. Another inmate has a halter around his neck which can read as a suicide attempt, but also as a Masonic hint at part of the ritual that involves a rope around the neck. The top of the stair post was originally a five-petalled star which that book also links to these higher degrees.

The actual staircase has no real purpose in the scene, and might have been included purely to communicate this Burlington House connection. Interestingly, Burlington's Villa at Chiswick was eventually used as asylum in the late 1800s (and a fire station in the 1930s!) Burlington's House now houses the National Gallery for which they paid a nominal rent of one pound. Hogarth's work has been exhibited there in the very house of his nemesis.

Duke of Grafton

The Burlingtons were so desperate to have a royal bloodline that they married their daughter to Lord Euston (whose father was an illegitimate son of Charles II), even though the young man was known to be a bad match. Many sources claim that Charlotte Boyle was murdered by her new husband within 7 months of the wedding. This seems to have been hushed up at the time, possibly as Burlington did not want to create a scene with a member of the future royal family.

I found an interesting relationship between the Duke of Grafton (Euston's father) and Lady Burlington, that fits into this study quite unexpectedly. Lord Hervey (of Hogarth's *Lord Hervey and Friends*) exposed the relationship between the two in his poem, *Poetical Epistle to the Queen* which he

ends with this clever slander on Lady Burlington, who he calls 'Dame Palladio.'

Her worn-out huntsman frequent may she hold;
Nor to her mason husband be it told
That she with capital Corinthian grac'd,
Has finish'd his in the Ionic taste.

A note below these lines identifies 'Dorothy Savile' (Lady Burlington), and her lover as 'The Huntsman Duke of Grafton.'

Grafton was one of the first celebrated fox hunters. There is riding term named after him (the 'Grafton trot!') The poem mentions 'her mason husband,' Burlington, as a Freemason. I believe the last line accuses Lady Burlington of performing fellatio on the Duke (with 'Ionic taste').

The 'capital' in the poem are also called 'horns' which adds the 'cuckold' joke. Could this sexual relationship have been overlooked by Burlington, who might have been so desperate to have some royal blood in the family he was willing to let his wife bear Grafton's bastard child?

Notice the fox hunter in the Rake's Levee is blowing a horn inside the room, which seems a little rude *(Figure N4.12)*. In the print, the foxhunter is fondling himself, which might be a hint to the sexual relationship he was reported to have had with Lady Burlington. Only the mouthpiece is visible, adding to the insinuation of oral sex from Hervey's poem. His furrowed brow resembles testicles!

'Silly Tom' Thynne of Ten Thousand

At first I thought that the addition of 'Silly Tom' to the jockey's cup was because 'Sil-ly Tom' was phonetically similar to 'Bur-ling-ton.' Then I came across this line in *The Roxburghe Ballads (1847)*:

This one poor silly name T.T. (Tom
Thynne) For he has money and no wit.
His nephew shall be brought to smile.
Upon their sister Lady Boyle.

Below the poem in the notes: '*Probably Elizabeth, Lady Boyle, whom Richard Boyle, (2nd*

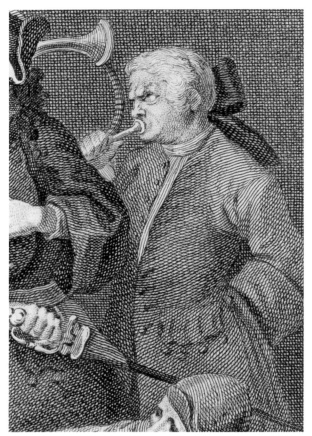

Figure N4.12

Figure N4.13

Earl of Cork, 1ˢᵗ Earl of Burlington), mentions in a letter dated July, 1682.'
— *Roxburghe Ballads, Ogles History, p96.*

This tentative connection to the Boyle family (1ˢᵗ Earl of Burlington) is all I could find to explain the rather curious addition of 'Silly Tom' on the cup which the jockey presents to the Rake *(Figure N4.13)*. It is a direct link to Burlington and cannot be ignored. Incidentally, Tom Thynne (1ˢᵗ Earl Weymouth) was Grand Master when Hogarth was a Grand Lodge Steward.

The Star in Chiswick's Tribunal Room

In the centre of the floor in this room is positioned an eight-pointed star, a potential reference to the star of the Order of the Garter which was introduced by King Charles I in 1629 and received by Lord Burlington from King George II in 1730. However, positioned immediately before the large portrait of King Charles I and his family it provides further circumstantial evidence that Lord Burlington may have received an earlier secret Garter from the Stuart Kings in exile (in this painting King Charles I can be seen wearing the blue sash of the Garter with a 'Lesser' George attached). —From Openbuildings.com

This same website has a picture of a Masonic pipe which was found on the premises of Chiswick Villa.

Chiswick Villa Winding Staircase

The existence of the winding staircase of 15 steps is of significance to Freemasons. In Prichard (1730) the candidate is asked *How came you to the middle chamber?'* The answer being: *'By a winding pair of stairs.'* A 'winding stair' is mentioned eight times in Duncan's monitor: *'this celebrated apartment was accessed by a winding staircase.'*

As with much Masonic ritual, the origin for this detail comes from the Bible. *They would go up by winding stairs to the middle storey (chamber of Solomon's temple).'* —Kings 6:8

Artaxerxes / Artaserses

Artaserses, (the opera listed on the scroll at Burlington's feet), was dedicated to James III.
—*The Stuarts in Italy, A Royal Court in Permanent Exile, Edward T. Corp, (Cambridge, 2011) p 82.*

CHAPTER V

Robert Walpole's Links to Hogarth

Hogarth helped Thornhill to paint Walpole's administration in *The House of Commons (1730)*. He was also commissioned to paint all of Walpole's children.

Robert Walpole's youngest son, Horace (1717–1797) boasted having the most complete set of Hogarth prints and had a direct relationship with the artist. Indeed, it was Walpole's collection that is the basis for the famed Lewis Walpole Library at Yale University.

Horace Walpole had this portrait painted in 1728, when he was a boy *(Figure N5.1)*. In her *Catalogue of the Paintings (Yale, 2017)*, Elizabeth Einberg explains Hogarth's hidden meaning of the cupid who points his arrow at the number ten on the sundial. It refers to young Walpole, aged ten, who was infatuated with George I and wanted to kiss the hand of the King. This was arranged to take place at ten o'clock at night, just before the King departed for Hanover, where he would die ten days later.

The work shows an early connection between the painter and Prime Minister. It also is evidence that Walpole provided Hogarth with symbols to work into his painting which is the main argument of this whole publication.

Walpole's second son, Edward (1706–1784) also had his portrait painted by Hogarth. He was also featured in the painting *A Night Encounter (1738)*, which shows him lying in a gutter as a boy steals his hat *(Figure N5.2, detail from painting)*.

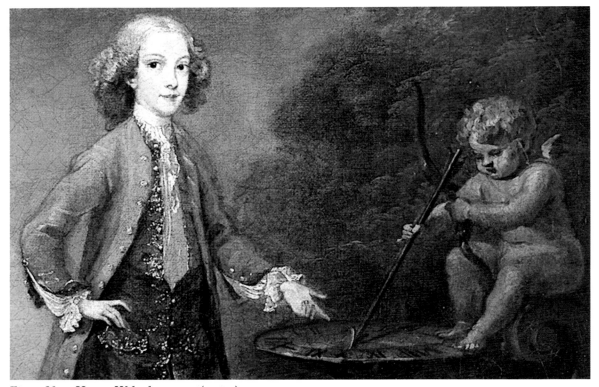

Figure N5.1: Horace Walpole, age ten (1728-9).

Again I refer you to Einberg's book for an explanation of this very confusing painting, (suggesting that Edward was depressed), which was kept hidden by the Walpole family for over a century!

I can add that Hogarth is playing with a colloquialism for the candle, which 'gutters' by falling into the wax, just as Edward falls into a gutter. This does comply with Hogarth's humour and might help sway those that do not believe this to be Hogarth's work.

Edward Walpole owned *Sleeping Congregation* painting. Hogarth dedicated one of *The Humours of an Election* series to him in 1754.

Walpole's daughter, Mary (1705–1731) was painted with her family after her death in 1731. This famous memorial painting *Cholmondeley Family (1732)* featured Walpole's grandsons knocking over a pile of books. Once more, Einberg succinctly explains a very complex piece of storytelling concerning the boys' grief. Hogarth has illustrated this with a shaft of light that cuts through the image of

a mother in the painting on the wall behind them *(Figure N5.3)*.

This technique of using a shadow to highlight a message was used in *A Harlot's Progress* to give a Masonic message *(Figure 2.4)*. I discovered the same technique within *An Election Entertainment (1754)(Figure N5.4)*, which was covered in my article in the *British Art Journal* (Winter, 2015).

The Horse is 'Burlington's Turk'

The 2nd Earl of Burlington was gifted a horse from the King of France, possibly for the family support of the Jacobite cause. The animal became known as the 'Burlington Turk' and a painting of it hangs in Chiswick Villa. As an artist, Hogarth would have been aware of this painting, and then included this link as another opportunity to slander the family for its Jacobite sympathies. *(I thank Ricky Pound from Pallas Tours for this information.)*

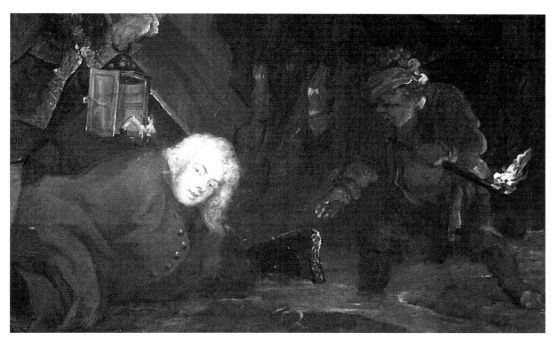

Figure N5.2: **Detail from A Night Encounter: Lord Boyne and Sir Edward Walpole outside a Tavern. (1738–39).**

Figure N5.3: **Detail from The Cholmondeley Family (1732).**

Further Evidence that Burlington's Circle was Homosexual

Kent

Kent's biography is full of details of his homosexual nature. Mowl cites this letter to Burlington: *'I don't know but why people loving and living with (a servant) may in time think the same way, as I flatter myself I do with you.'* Mowl adds: *'There is no more revealing comment on their relationship anywhere else in writing of the period.'* Burlington carefully preserved this letter from Kent.

—*William Kent: Architect, Designer, Opportunist. Timothy Mowl, Pimlico (2007).*

Pope

Pope congratulates the Earl on his Order of the Garter with this salacious comment *'Pray, if you dare, tell my Lady B. I know you are Embrac'd by something better than a garter.'* Pope asked that his other *'silly letters'* to Burlington be destroyed.

Pope on Burlington's Parties

Being a Catholic, Pope was advised to leave the country after the failed rebellion of 1715. He left Burlington's home, but stayed with Catholic sympathisers in England. Perhaps this move was necessary in order to attract less attention upon Burlington.

Gay

Residents and visitors (to Burlington House) included Alexander Pope and John Gay, both of them 'homosocial' if not homoerotic. —Thomas McGeary, Handel and Homosexuality: Burlington House and Cannons Revisited, (JRMA, 2011).

David Noke's biography of John Gay, *A Profession of Friendship (Oxford, 1995)*, proposes that *'the urgent attempts of Pope and Swift to suppress and sanitize the details of Gay's early private life would seem to confirm a suspicion that there was*

Figure N5.4: **Detail from Humours of an Election Series.**

something they wished to conceal more shameful than a mere background in trade.'

The Earl of Chesterfield might have made a reference to Burlington's relationships when Chesterfield gave his famous advice to his son in the 1760s.

...leave [architecture] to masons, bricklayers, and Lord Burlington, who has, to a certain extent, lessened himself by knowing them too well.

'The Burlington House Set' Praise Each Other

Kent illustrated the works of Gay and Pope, who both praised Kent in their poetry. Gay calls Kent 'Raphael' in a sycophantic poem. They all praise Handel.

Handel

Like Kent and Pope, Handel lived with Burlington when he first arrived in England. See article entitled *'Handel was gay and his music proves it.'* —Sunday Telegraph, Oct 21, 2001.

Castrati

'Other bisexuals among Handel's Italian patrons enjoyed lengthy affairs with castrati, those male opera stars ...' In his biography of Kent, Timothy Mowl suggests that because this was common in Italy, it would have been happening in London where the English elite copied Italian culture.

Reward

Concerning Hogarth's engraving of the Walpole salver, Paulson writes *'What happened in 1728 is something of a mystery'* and then: *'It is possible that Walpole chose Hogarth [to do the engraving] to ensure his future silence.'*

I propose that Walpole chose Hogarth to ensure the artist would keep announcing his anti-Jacobite message.

Bramston on Chiswick

Bramston's poem (*The Man of Taste, 1733*) mentions the position and huge cost of Chiswick as if the poet knew that Burlington was actually using the money to fund the Jacobite cause.

'I'll have my Villa too, a sweet abode, Its situation shall be London road: Dorick, Ionick, shall not there be found, But it shall cost me threescore thousand pound.'

Note that Chiswick Villa is on the Great West Road into London. *'No Doric or Ionic'* might have hinted that Chiswick was full of Masonic style Egyptian embellishments.

There is also another slander at Senesio:

Ye stiff-rump'd heads of Colleges be dum,
A singing Eunuch gets a larger Sum.

Burlington's Connections with The Atterbury Plot

This is explained in the strange but illuminating title: *Jacobites Under the Beds: Bishop Atterbury and the Westminster School Dormitory Case of 1721 (Clyve Jones, The British Library Journal. Vol. 25, No. 1, 1999).*

Bishop Atterbury had recruited Burlington as the architect to build a dormitory. Atterbury became embroiled in a scandal involving missing funds. During Atterbury's subsequent trial, Burlington attended every parliamentary session, along with Wharton who wrote and spoke in favour of exonerating the Jacobite Bishop. See *The Atterbury Plot, E. Cruickshanks, H. Erskine-Hill. (Springer, 2004).*

Christopher Layer

Orrery's secretary records that he met the main conspirator, Christopher Layer, *'at Lord Burlington's where he drank with him in company with Mr. Thompson, Lord Burlington's chaplain.'* Thompson christened Layer's daughter, 'Mary Clementina' in a ceremony at which there was a proxy for James III (the baby's Godfather). When this was exposed, *'Burlington did not dismiss Thompson, who was 'promoted to a good living in 1724.'* [Clark]

The Duke of Orrery

The Duke of Orrery, Burlington's cousin, was prosecuted in the Atterbury Plot. Walpole imprisoned him in the Tower for six months. From his cell, Orrery wrote, published, and sold plays to help raise his share of the 10,000 pound bail. Burlington paid the rest. The play helped to bring attention to his plight.

In the prison scene *(Figure N5.5)*, the Rake (read Burlington) shares his cell with a curious looking man selling a paper (read Orrery). The paper reads *"Being a new scheme for paying the Debt of the Nation. By T. L. now a Prisoner in the Fleet."* (T.L. might just mean 'By The Lord now a Prisoner ...') *(Figure N5.6)*

Orrery was made a Knight of the Thistle by Queen Charlotte in 1704. The discarded robes in Hogarth's jail scene have always been associated with Sarah (Tom Rakewell's ever faithful girlfriend). However, these robes look very much like a Lord's ermine *(Figure N5.7)*. Could that be a garter lying on the floor next to it, symbolising Orrery's rejection of the order in favour of the same by the Catholic court in exile?

We known that Burlington rejected a similar Knight of the Garter, given by the George II, in

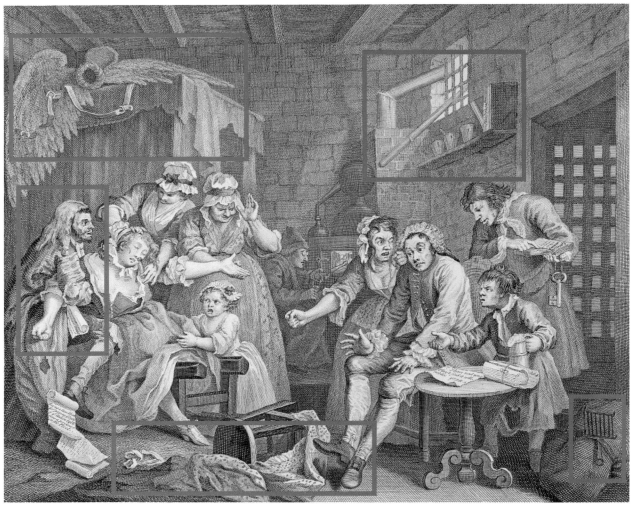

Figure N5.5

Figure N5.6

Figure N5.7

favour of the same that was given by James. Indeed, you will notice that Burlington's feet, set at a square, are in an uncomfortable looking position. They cast a rather obvious and unnecessary shadow over the said article of clothing which Orrery has rejected. Could this be Burlington's rejection of the Order, as if wiping his feet on it?

Another hint that Hogarth means to represent Orrery can be found in the prison cell. The Duke was famous for his collection of telescopes and curious scientific equipment. Hogarth added a telescope and scientific paraphernalia in the print *(Figure N5.8)*. The quotation below insinuates that Orrery travelled much to add to his collection (especially Holland, a hotbed of Jacobite activity). This was exactly what his cousin Burlington had done by using architecture to cover his tracks.

Figure N5.8

> *Orrery took no Grand tour but his diplomatic postings to the Low Countries and Jacobite missions to Paris may have offered opportunities to purchase foreign books directly. The seriousness of his scientific interests is difficult to gauge. It appears that he was never an active participant in the Royal Society despite his fellowship.*
> —The Orrery Books in Christ Church Library. (Oxford University Library Services 2007).

The first mechanical solar system model, the 'Orrery,' is named after the Duke. Incidentally, a close relation of Charles Boyle (great uncle) was Robert Boyle, the scientist who gave us Boyle's law on gases.

The wings on top of the bed frame have always been one of those errant details that commentators do back-flips trying to fit into the story *(Figure N5.9)*. Hogarth might have been referring to a line in the play which Orrery was also selling from his prison cell—*The History of Henry the Fifth* by the 1st Earl of Orrery.

> *On fancies wings I my past flight did take,*
> *But tis on Tryals wings that I fly back.*

Figure N5.9

Jacobite Image in Scene 5 *(Figure N5.10)*

I believe Hogarth felt compelled to add a Jacobite/Masonic detail in each and every scene of *A Rake's Progress* in the same way he featured a Masonic sign in every print of *A Harlot's Progress*.

Hogarth might have been told that these 'Red Degrees' (which he had been asked to expose) featured a secret vault in the ceremony, and that he should try to feature one in the series. Indeed,

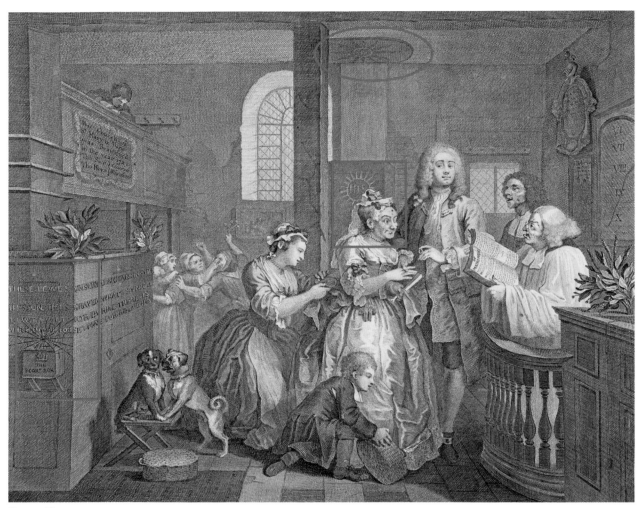

Figure N5.10

Figure N5.11

Figure N5.12

the word 'vault' is repeated 20 times in *Duncan's Monitor (1866)* in connection with the said degree.

> *There was a Scots Master Degree born in France in Jacobite (therefore, Roman Catholic) circles. It appeared in Southern England in the 1730s. The theme of the degree was the discovery of a lost word in a vault.*
> —L.M. Sherwood, The Royal Arch: the story of its Emergence and Development.

Hogarth found an inscription containing the word 'vault' in Marylebone Church (London). He simply set the Rake's wedding in that church, highlighting the text in large and rather clumsy lettering, the word 'vault' taking prominence *(Figure N5.11)*: 'These pews unscrud and tane in sunder, In stone there graven what is under, To wit a valt for burial there is, Which Edward Forest made for him and his.'

Other Jacobite Symbols Within Scene 5

The spider's web almost underlines the word 'vault' and was a Jacobite symbol being connected with the folk tale of Robert the Bruce. Hogarth concealed it within the story by making the web cover the poor box, adding to the dilapidated state of this old church.

The Christogram ('IHS') above the old woman's head was used as a Jacobite emblem and there is a star above the pulpit that can be found in Masonic prints of the time *(Figure N5.12)*.

Jacobite Reference in Scene 6

We have not mentioned the gambling in Scene 6 *(Figure N5.13)*. I believe there is a connection between the Rake's position and a Masonic sign found in Allyn's exposé. A similar body position is made by the Harlot's son in the Scene 5 of that series *(Figure N5.14)*. Note that the boy's knee is bare, a common theme throughout both series and mentioned many times in the ritual. We see

the same with the tailor (Scene 1), the rake (Scene 3) and the madman on the stairs (Scene 8). It also appears in *A Harlots Progress* with her lover (Scene 2), her maid (Scene 4) and her son (Scene 5) .

First Scene of A Rake's Progress Also Holds Jacobite Hints *(Figure N5.15)*.

We must return to the first scene to find another Jacobite connection with the coins that are falling from their hiding place. One coin has the letters 'CR' on it which stand for 'Carolus Rex' (King Charles). However, another two coins seem to show the letter 'G' for George which is confusing or maybe showing the transition from one King to the other *(Figure N5.15)*.

A line in the miser's diary mentions the *"French Ordinary"*, or tavern, which is where 'Red Lodge Masons' would have met when recruiting in England *(Figure N5.15 insert)*. There is no other reason for this than a hint at French Jacobitism. Again, this is insider information that would not have been known to Hogarth and must have been supplied by a Government informer. This mention of the French so prominently in Scene 1 deserves our attention.

Walpole Discredits Both Dukes

There is much evidence of the battle between the Duke of Wharton and Robert Walpole that is beyond the scope of this book. Burlington had more success than Wharton in galvanising Jacobite support. It would make perfect sense for Walpole to commission Hogarth to attack them both, mocking Wharton in the *Gormogons* and Burlington in *A Rake's Progress*.

> *Wharton became the Grand Master of the English Premier/Modern Grand Lodge in 1722, but was subsequently accused of trying to "capture Freemasonry for the Jacobites".*
> —Harrison, Genesis of Freemasonry, 2009.

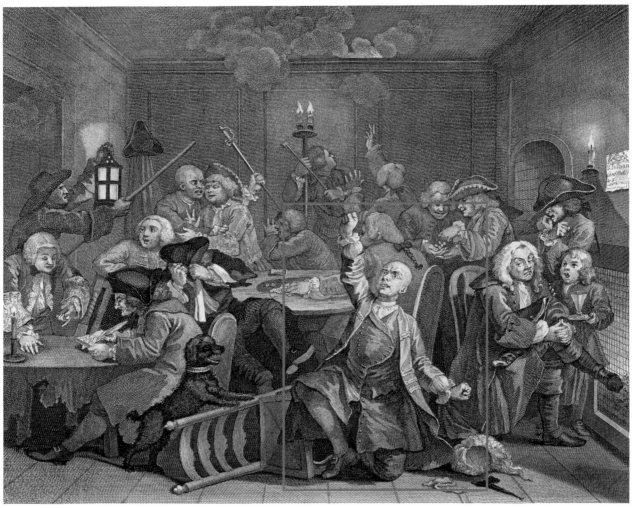

Figure N5.13

Figure N5.14

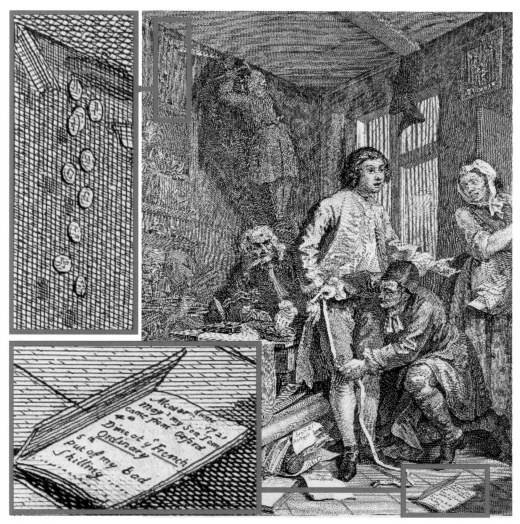

Figure N5.15

CHAPTER VI

Kent's Anti-Jacobite Burlesque

While this chapter dealt with Hogarth's attack on Kent's artistic inability, this early print *(Figure 6.1)* was first meant to expose Burlington's Jacobite connection. It is further evidence that these men were inextricably entwined). Kent's original painting included a likeness to Maria Sobieska (1702–1735), the Queen of James III, and is covered in many publications but is another example of Hogarth having access to classified information early on in his career. It shows his brilliance by being able to leak a serious accusation in a seemingly innocuous manner.

William Kent: Opportunist

William Kent (1685–1748) was great without a hint of gravitas, a con man who became one of the artistic geniuses of his age. He was a high camp Yorkshire bachelor, brought back [from Rome] by Lord Burlington.
—Timothy Mowl, William Kent: Architect, Designer, Opportunist. (Pimlico, 2014).

189

William Kent: Mantlepiece

Marks also pointed out that the carved term of the fireplace behind Viscount Castlemaine resembles the engraving of Kent after a portrait by William Aikman (1682–1731) and suggested that the inclusion of Kent's features petrified in wood or stone is Hogarth's gibe at Kent's petrified taste — but again, the painting was a commission for a private client and was never engraved, so Hogarth's subtle satire, if satire it was, would have been wasted.
—Richard Dorment, British Painting in the Philadelphia Museum of Art, (1986).

Kent with Walpole

The hall at Wanstead is another proof of his incapacity. Sir Robert Walpole, who was persuaded to employ him at Houghton, where he painted several ceilings and the staircase, would not permit him however to work in colours, which would have been still more disgraced by the presence of so many capital pictures, but restrained him to chiaro scuro. —Mowl.

Kent Strikes Back

When we look at Hogarth's work sequentially, we see that the artist attacked Kent several times before Kent eventually struck back. Hogarth took the first punch back in 1724/25 with *The Bad Taste of the Town* and the *Burlesque*. He followed it with *'Kent can't hold a candle to me'* at *Wanstead (1728)*, and then called him a KNT a second time in *The Man of Taste (1731)*.

Having sustained several attacks from Hogarth, Kent finally struck back in 1734 by blocking a royal commission for Hogarth to paint a portrait of the wedding of Anne, (Princess Royal) and Prince William of Orange.

William Kent was given the job of decorating the chapel for the ceremony, and pulled strings to have Hogarth banned from making potentially lucrative drawings of the wedding setting. Now that he was so snugly settled in the queen's favour, Kent found himself easily able to swat aside annoyances such as the infringement of an old enemy upon court ground. In the battle of the painters, Kent had finally had the last laugh.
—The Courtiers: Splendor and Intrigue in the Georgian Court at Kensington Palace, Lucy Worsley, (Bloomsbury, 2010).

Kent also managed to block Hogarth from contributing illustrations to a publication of Don Quixote in 1735.

"Sad mortification to the Ingenious Man. but its the effect of the Carricatures with which he had heretofore Touch't Mr Kent and diverted the town—which now he is like to pay for when he has least thought of it." —from the notebooks of George Vertue (1684–1756), reported by Walpole in his Anecdotes of Painting, (Murray, London, 1887).

CHAPTER VII

'Knt' Standing in the East *(Figure 7.1)*

By taking the letter 'E' from Kent's name, and printing it beside his figure, Hogarth makes a Masonic jest. The letter 'E' stands for the 'East,' the corner of the lodge room where the Master sits *(Figure N7.1)*.

As the Sun rises in the East and opens the Day, so the Master stands in the East [with his Right Hand upon his Left Breast being a Sign, and the Square about his Neck] to open the Lodge and to set his Men at Work.
—Masonry Dissected, Prichard (1730).

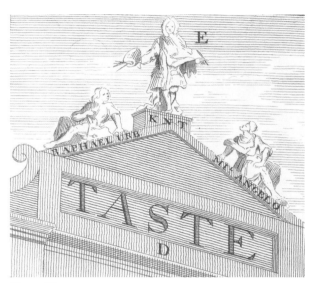

Figure N7.1

The Code that Accompanied the Print

A. Ppe a Plasterer white washing & Bespatting
B. any Body that comes in his way
C. not a Dukes Coach as appears by ye. Crescent at
 one Corner
D. Taste
E. a standing Proof
F. a Labourer.

In the code above, that accompanied *The Man of Taste*, Hogarth plays a word game with Kent's identifying letter *'E. a standing Proof.'* Take the first four letters of these words and you spell East. (E,a st -anding). I also think Hogarth played a word game by labeling 'Taste' with the 'D' to create the word 'Tasted.'

By listing Alexander Pope first, Hogarth was also able to make a joke out of his name. By adding an A and missing the 'o,' Hogarth spells 'A Ppe' or 'APe - Ape.' Pope was hunchbacked and was mercilessly mocked for a simian appearance. Hogarth might have been the first to taunt him with this word riddle. It was then copied many times by satirists.

I cannot fathom why Burlington would be linked to the word 'Fal' in his code 'F. a labourer.' As he is featured up a ladder, maybe it means 'Fal'

Figure N7.2

as in fall. I could find no insulting use of 'Fa la' but maybe I am missing something here.

Paulson doubted that this was not Hogarth's work, but this certainly seems like his humour.

'Crescent at One Corner'

I draw your attention to another part of this letter code which has never been explained: *'C. not a Dukes Coach as appears by ye. Crescent at one Corner.'* Observe the crescent moon at one corner of the coach's roof *(Figure N7.2)*.

I recognised the same crescent moon in Hogarth's print *Royalty, Episcopacy and Law (1725)* where they embellish the King's sceptre, orb and his chain of office *(Figure N7.3)*. I discovered a description of crescent moons in a fresco in the Palazzo Balestra, Rome. This house was gifted in 1718 by Pope Clement XI to James III on his marriage to Maria Clementina Sobieska. The Royal couple lived there for 40 years and had both sons born there. James III died in the house in 1766.

The symbol is a heraldic detail of 'cadency' adds a distinguishing code to a family coat of arms to identify other members of the family within the same crest. A crescent moon is the recognised code to signify the second son. Hogarth was an engraver of such designs and would have known this arrangement. The moon would identify James II (1633–1701) as the second son of Charles I (1600–49) and so the rightful ruler.

This symbol, connecting James II to the carriage in *The Man of Taste*, would insinuate that representatives of the deposed House of Stuart were travelling to Burlington's home. We know from Clark that Burlington House was a meeting place for the Atterbury Plotters of 1722. There also seems to be a similar, crescent moon shape, made by the stone ball adorning the wall directly above the carriage *(Figure 7.1)*.

Royalty, Episcopacy and Law has always been interpreted as mocking King George II and the Anglican Church, and not James II and the catholic one. Trusler saw the King's crescents *'alluding to his lunar situation.'* However, Hogarth is reminding us that James II ruled with a corrupt Catholic Church and the hard rule of law (represented by the Judge with the mallet for a face) until he was deposed or, to use a line from the long title *'since the last eclipse.'* The judge might have been meant for the Lord Chief Justice George Jeffreys, the notoriously severe 'hanging judge' under James' rule.

Full Title of Print *(Figure N7.4)*

Some of the Principal Inhabitants of ye Moon, as they Were Perfectly Discover'd by a Telescope brought to ye: Greatest Perfection since ye. last Eclipse; Exactly Engraved from the Objects, whereby ye: Curious may Guess at their Religion Manners, &c. (Royalty, Episcopacy and the Law).

In the title above, Hogarth hints that one should question the artwork with the words *'ye: Curious may Guess at their Religion Manners, &c.'* Hogarth had used a similar verbal hint to go further

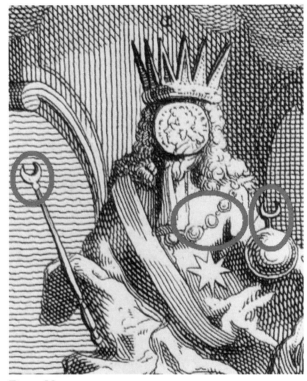

Figure N7.3

into the work when he added the words *'Guess at the rest and you'll find more'* to a previous print.

Note the eight pointed star to the left of the King's orb *(Figure N7.3)*. This is the Order of the Garter, which James continued to bestow on Jacobites. Indeed, both Burlington and his father commissioned portraits to feature themselves wearing this same eight pointed emblem.

The circle sign at the base of the King's throne is a sign of perpetuity, insinuating the House of Stuart would rule forever *(Figure N7.5 left)*. However, it also might have been copied from this French Masonic print *(Figure N7.5 right)*. This would further identify James with the French Order that had begun when he lived in Paris. Note that the King's elevated platform is covered in material, like the French backdrop.

The Pope Figure *(Figure N7.6)*

Next to the King is a figure of a Pope, identified by his iconic hat and the fact he rests his feet

Some of the Principal Inhabitants of yᶜ MOON, as they Were Perfectly Discover'd by a Teleſcope brought to yᵉ Greatest Perfection ſince yᵉ last Eclipſe; Exactly Engraved from the Objects, whereby yᵉ Curious may Gueſs at their Religion, Manners, &c.

Figure N7.4

on a cushion (a Papal custom, as seen in the accompanying print *(Figure N7.6 right))*. Hogarth gives his figure several such foot cushions thus mocking this indulgence. The House of Stuart was closely aligned with the Papal State which recognized James III as the true King of Great Britain to his death in 1766.

Note that 'Episcopacy' means a church governance by bishops and has nothing to do with the Episcopal Church. You can have a catholic 'episcopacy.'

Hogarth is making a more personal exposé of the Jacobites. Next to the Pope is a figure representing the law, with a mallet for a face *(Figure N7.7)*. Many saw this as a huge Judge's gavel. Hogarth is cleverly exposing the two authors of Jacobite propaganda—Alexander Pope and David Mallet.

David Mallet (1705–1765)

Mallet, due to the success of his play [Eurydice, 1731] and the patronage relations he had

Figure N7.5

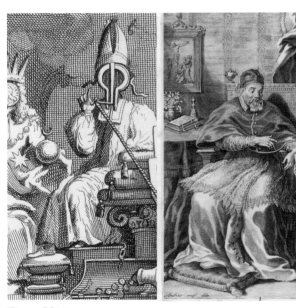

Figure N7.6

Figure N7.7

established in the 1720s, could have been considered as a potentially dangerous author of allegorical propaganda against Walpole's person and administration. J.A. Downie has remarked that 'Walpole spent over 50,000 pounds funding an expensive counter-propaganda campaign in the last ten years of his ministry. —David Mallet, Anglo-Scot: Poetry, Patronage, and Politics in the Age of Union. By Sandro Jung, (AUP, 2008).

Mallet also wrote *Mustapha (1739)*, which was directed against both King George II and Robert Walpole. Pope and Mallet were friends. In 1730, they jointly composed the prologue to Thomson's *Sophonisba*.

Alexander Pope (1688–1744)

To cast Pope as a *Pope* was obvious. The poet was Catholic, and an ardent Jacobite. His famous poem, *Rape of the Lock (1712)*, has been reviewed as being 'crypto-Jacobite.' Hogarth illustrates a section of this poem in his print by featuring bodies comprised of common objects *(Figure N7.8)*, most pointedly the figure with a teapot for a head, a detail that was taken directly from Pope's verse:

Unnumber'd Throngs on ev'ry side are seen
Of Bodies chang'd to various Forms by Spleen.
Here living Teapots stand, one Arm held out,
One bent; the Handle this, and that the Spout.

The poem mentions a King: *'Th' embroider'd King who shows but half his Face,'* which would conform to Hogarth's use of a coin for the king's head, as a coin showing half of its 'face.'

Under close inspection of the coin, the numbers 'II' identify James II *(Figure N7.9)*. Hogarth's King also has what looks like a bagwig. A 'bagwig' is listed in the description of the Medal commemorating the flight of James II, *(Catalogue of prints and drawings in the British Museum, Div 1, Vol.1. Item number 1180).* See Einberg's *Complete Catalogue*, (Yale, 2017) *p106*.

Figure N7.8

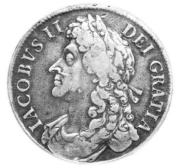

Figure N7.9

Pope's poem also mentions the word 'trump' several times. This may have given Hogarth the idea to figure Pope's face in the form of that instrument. The 'trump' was also known as a *'gewgaw,'* which was defined as *'a showy trifle, a toy, trinket, ornament or decoration.'* This would sum up Pope perfectly!

This anti-Jacobite print now joins the list of other works that Hogarth would have been commissioned to design.

Ronald Paulson on Royalty

Ronald Paulson's complete coverage of Hogarth's life and work in the 1970s is the main reason for this recent resurgence of interest in the artist. If it were not for his study, I could not have written this book. While I agree with almost all of Paulson's readings, I see this print in a completely different light. I attribute this to Hogarth's skill of selecting ambiguous details that can create an alternative reading.

In *The Modern Moral Subject, (Vol 1. p111)*, Paulson identifies King George as the monarch, and so interprets the print as a mockery of the corruption of Walpole's government. Paulson then has to explain why Hogarth would later switch to promote the Whigs.

My reading of *Royalty* as another criticism of the Jacobites fits perfectly into my proposition that Hogarth was being supplied with political details by the government in order to slander Lord Burlington for his promoted of these 'Red Degrees' that advocated for James Stuart.

Burlington Has a Crescent Moon in Burlington House

Let us return to Burlington House, where Hogarth featured this 'crescent moon carriage.' It is interesting to note that Burlington commissioned a painting of the goddess Diana, (with her icon of a crescent moon) to hang in Burlington House *(Figure N7.10)*. I enclose a detail of the painting *Diana and Endymion (1713)*, by Sebastiano

Figure N7.10: Diana and Endymion (1713), Sebastino Ricci (1659–1734).

Figure N7.11

Figure N7.12

Ricci (1659–1734). It was taken to Chiswick Villa. William Kent designed a chimneypiece featuring the same moon goddess for the summer parlour. I would like to thank Ricky Pound of Pallas Tours for bringing these to my attention.

I also noticed crescent moons hidden in Hogarth's *Burlesque on Kent's Altarpiece* which already features the hidden depiction of James II's wife, Maria Clementina Sobieska *(Figure 6.1)*. The two putti (marked G and I) have crescent moons in their hair, which are cleverly disguised as curls *(Figure N7.11)*.

'Bishop's Hat' is Part of Royal Arch

What many thought was a Bishop's hat (in *Royalty, Episcopacy and the Law*) is the same one used in the modern Royal Arch. We have linked this modern degree to the original Jacobite 'Red Degrees' many times now *(Figure N7.12)*.

Bute Prints

Space does not allow me to include all the satirical prints that attacked Hogarth in the 1760s. Many artists slandered Hogarth for accepting money from Bute's Government in return for his satirical artwork. I believe that if Hogarth was taking bribes from the Marquis of Bute in the 1760s, then he could also have been taking the same from Walpole in the 1720s.

Paul Sandby (1731–1809) draws Prime Minister Bute in the act of guiding Hogarth's hand as the artist designs his attack on Wilkes *(Figure N7.13)*. It was Wilkes' public condemnation of Hogarth for *'dipping his pencil in the dirt of faction'* that pulled Hogarth into politics towards the end of his life.

Desaguliers Fixes His Gaze Above the Church

The Reverend Desaguliers was granted a ministry by the Duke of Chandos (St Lawrence, Little Stanmore). Desaguliers was more interested in his scientific research than his ecumenical duties however, and Chandos complained that the Reverend

Figure N7.13: **Tit for tat, or W. Hogarth Esq. by Paul Sandby.**

was not paying attention to his congregation. This could be why he has not focused his gaze upon the Church that stands on the hill in the background.

Erotic Posts in Hervey

The posts are positioned close to the water without any connecting fence, which makes a curious addition to the scene. The great Hogarth scholar, Ronald Paulson, noticed the awkward positioning of this background detail but thought it was a sexual symbol in what he reported to be a homo-erotic scene.

Indeed, the two main characters of John Hervey (Lord Ickworth), who commissioned the painting and Stephen Fox, (later 1st Earl of Ilchester), seated at table, were a known homosexual couple.

Horace Walpole reported that Fox had a copy of the painting in his home.

Desaguliers Was Not One of Hervey's Friends

In her *Complete Catalogue of the Paintings (Yale, 2017)*, Elizabeth Einberg first states that Desaguliers was identified as the minister in the painting by Horace Walpole (who knew him well). Einberg then questions why Desaguliers was included, when he was not a part of Hervey's circle. This fits into my reading that Hervey's group were all 'on the level,' and that Desaguliers felt that he was above them. The minister is seen reaching beyond his station and toppling in the process. I also believe there is a facial similarity to other depictions of Desaguliers. He seems to have been the type of character who could have been added in as a joke, rather like in the *Indian Emperor*.

Desaguliers' Wart *(Figure N7.14)*

Compare the face of Desaguliers on the left (taken from *Sleeping Congregation*) to the supposed depiction in the Harlot's Funeral (old woman crying). The protruding lip and chin are similar, as is the closed eye. You can also see the same position of Desaguliers' wart (covered by a plaster on the face on the right).

You can see the wart quite clearly in one version of the print of a lost portrait, painted by Hans Hysing *(Figure N1.3)*.

Figure N7.14

F.R.S. and Grand Lodge

The fact that some 45% of the fellows of the RS were masons in the 1720's demonstrates the proximity between the two organisations.

—Paul A. Elliot, Enlightenment, Modernity and Science, (I.B.Tauris, 2010) p108.

Sleeping Congregation Shield

This shield on the wall of *Sleeping Congregation* is the same form as that of the London Company of Masons *(Figure N7.15 first illustration on left)*. It is similar to that hanging in the Harlot's Funeral scene *(second illustration)*. In between these images is a mason's trowel which has been copied onto the shield. These were disguised as spigots which Jenny Uglow *(William Hogarth: A Life and a World, Faber, 1998)* believed were of a sexual nature. These trowels replace the castles from the first shield.

Figure N7.15

The next illustration is from the print of *Sleeping Congregation*. Here, Hogarth has substituted the trowels with owls. I believe Hogarth was having fun with this rhyming word play 'trowels for owls.' You can just make out the faint indentation of the compasses in the middle of the chevron, similar to those in the first shield.

The only previous explanation (written by John Ireland in 1791) identifies the hereditary shield as that of the Nicol's family, who he connected to the church through a documented marriage. However, the marriage to which he refers occurred 45 years after the painting.

Sleeping Congregation 'Dieu et mon Droit'

Hogarth's work is full of word riddles, which he is reported to have enjoyed. By omitting the word for God from the church banner, Hogarth makes a statement about the deChristianisation of the Premier Grand Lodge. Hogarth uses this same idea when he mocks a Judge in *The Bench (1758)*.

The painting is not shown here because the detail is so difficult to read. However, there is a faint banner in the work with the royal motto "*Honi soit qui mal y pense.*" This motto hangs above the Judge's head, but by just showing half of it, Hogarth only shows the words "*Mal y pense*". This mocks the Judges below it, who were only thinking '*bad thoughts.*'

I include this note to show that Hogarth used the same concept of missing words to create a different message. I discovered another example of this in his using 'York gon' *(Figure N2.1)*, the *'horible Bible' (Figure 3.2)* and the riddles with 'East' and 'Ape' for Pope at the beginning of this Chapter.

There is No Sleeping Congregation

In her recent anthology of essays *Hogarth's Legacy, (Lewis Walpole Library, Yale, 2016),* Cynthia Roman uses *Sleeping Congregation* as an example of a mislabelled piece of art. She points out

that it was not Hogarth who named this piece, but a later commentator. In Chapter 1, we discovered that this painting was never meant to be a congregation either, but a lodge of Freemasons. Furthermore, the painting only shows one couple asleep. It was only in the print of 1736 that Hogarth showed the entire congregation asleep.

This observation might also explain why the minister in the painting looks nothing like that of Desaguliers in the print. Again we must realize that it was later commentators who assumed that it was Desaguliers in the print; it must have been the same minister in the original painting.

Although it does not change any of my argument of Chapter 1, the man in the pulpit might be Nathaniel Blackerby, another famous orator of the time. Blackerby was Deputy Grand Master in 1728 and so would have been the one lecturing the lodge in that year. This observation actually gives more weight to my proposal that in 1736, Hogarth wanted to criticise Desaguliers in particular for being a fastidious bore, and placed Desaguliers as the minister in the pulpit because he could put a congregation to sleep!

Hogarth Represents the Lodge With Triangles

In the initial painting of *Sleeping Congregation*, Hogarth represents the concept of a Lodge of Masons by placing the men in the form of a pyramid (a shape with strong historic Masonic context). In the print, Hogarth creates the same concept of a lodge by featuring the number seven. '*Seven make a lodge*' is a common Masonic phrase, and refers to the bylaw that a lodge must have a minimum of seven members present in order to hold a meeting.

Hogarth represents this important Masonic number by including exactly seven triangles in the print. Along with the large triangle on the wall, we can count 4 tricorns and 2 conical hats *(Figure N7.16)*. The latter were fairly common for women of the time, however, some commentators have misconstrued them as witches or Quakers.

Seven Make a Lodge

Q. Where was you made a Mason?
A. In a just and Perfect Lodge.

Q. What makes a just and Perfect Lodge?
A. Seven or more.

Q. What do they consist on?
A. One Master, two Wardens, two Fellow-Crafts and two Enter'd 'Prentices.

— *Masonry Dissected, 1730.*

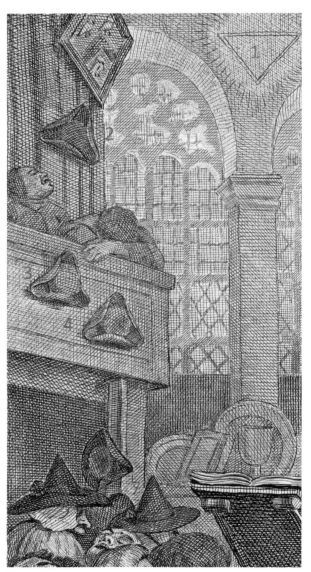

Figure N7.16

Euclid's Importance to the Ritual

The largest triangle on the wall of the church possibly represents the Master in the scheme described above. It is overtly Masonic. You can see the same form with a radiant fringe on a Masonic apron of the time *(Figure N7.17)*. One commentator believed this fringed shape was included by Hogarth to symbolise a pudenda complete with pubic hair!

To the Freemason, the equilateral triangle represents Euclid's first proposition, which was constantly mentioned by Desaguliers. Euclid's 47th proposition (Pythagoras' famous equation) was used to 'square' the corner of a building at a perfect right angle.

Grand Master Desaguliers used this in his new ritual as a moral analogy, and it is still central for Freemasons today. Candidates are encouraged *'to square their actions,'* and *'act upon the square.'* It was the central icon to the frontispiece of the' Constitutions *(Figure N7.18)*. Printed in 1723, it was engraved by John Pine, but assumed to have been designed by Sir James Thornhill.

The Antients' Constitution Mocks the Moderns' Geometry

It was also thought expedient to abolish the old custom of studying Geometry in the lodge … that might be drawn and represented upon Bread, Beef, Mutton, Fowls, Pies &c. as demonstratively as upon states or sheets of paper. —Antients' Constitution

Comment on Desaguliers and 'Architect of the Universe'

The Antients accused the Moderns of replacing the concept of 'God' with 'The Grand Geometrician of the Universe.' Desaguliers was a Calvinist minister. In the 16th century, John Calvin himself often used the term 'Architect of the Universe.' For a society that modelled itself after the builder's trade, this was an excellent title for the deity.

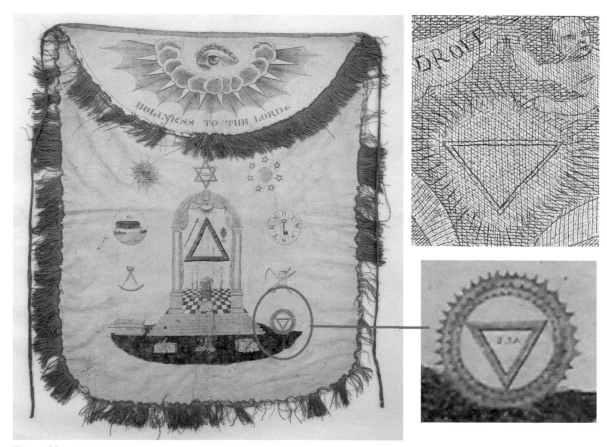

Figure N7.17

Another Possible Henley Inclusion
in Sleeping Congregation

In Chapter 9, we identified the Deacon as Orator Henley. In the year of the painting, (1728) Orator Henley lectured on the biblical legend, curiously titled *'The Seven Sleepers and the Dormouse.'* Could this possibly have been what Hogarth was contemplating when he included seven sleeping faces in his print *(Figure N7.19)*?

An eighth head leans far back, rather like depictions of the dormouse in hibernation. Dormouse comes from 'dormir,' Latin for sleep, but I think Hogarth might have been joking around by misspelling it 'door-mouse.' This would explain the rodent-like fingers that rest upon the door, pointing towards the hinge. When compared to the finely finished fingers of the other subjects nearby, these have always seemed claw-like in comparison.

Hogarth was both a Latin and biblical scholar, and this passage might have come into his mind as he

Figure N7.18

connected the church with sleep. This is one plausible explanation for these prominent details. Or, I could be completely wrong!

Other Curious Titles from Orator Henley's Lectures

'*Oratory Transactions. No. II. containing a list of the theological subjects of the Oratory (1728).*' *(Available on Google books).*

'*Matrimony and the single life,*' and '*Freemasons no husbands and episode on the Word sex*' listed as being delivered June 5, 1728.

His mention of the '*seven sleepers and the dormouse*' is on the same page, (July 12 1728).

'*Whether a Jew can be made a mason, or a Mason can be made on a Sunday,*' (Sept 30, 1732).

Hogarth and Thornhill

We must consider that all this criticism of Desaguliers might have come from Sir James Thornhill. I cannot believe that Hogarth would have mocked the Grand Master so mercilessly without the sanction and possible encouragement of his mentor and father-in-law. Thornhill would have been much closer to Desaguliers than Hogarth because they would have worked together in Grand Lodge. When Desaguliers introduced the 'Hiramic play,' Thornhill, as Grand Warden would have had a long part to learn.

Paulson gives the impression that Thornhill was somewhat prickly and did not get along with authoritative figures. Thornhill might have resented Desaguliers' power and position and thus enjoyed these side-bar jests that Hogarth was hiding in these popular prints. Hogarth did not know Desaguliers well enough to be privy to these character flaws. Hogarth was being helped.

Figure N7.19

Chapter VIII

Night for Knight

Night also might have been a play on the concept of De Veil as a knight with his sword. He was actually knighted after the print was made.

Reasons for Moderns vs. Antients

In his book *Schism: The Battle that Forged the Freemasonry*, Ric Berman lists the causes for the breakup. Most of these reasons can be found pictured in Hogarth's *Night*. Here is Berman's list, with corresponding details from *Night* in parentheses:
- 'failing to use a sword in the initiation ceremony' (wooden sword);
- 'omission of Christian symbolism' and 'over-secularisation' (cross on wooden sword);
- 'changes to the procedure in which initiates were prepared' (De Veil's staggering steps);
- 'use of stewards to undertake roles performed by deacons' (steward's rods);
- arrogant and self-obsessed (haughty nature of De Veil, and ignoring beggars).

Evolution of the Freemason's Apron

It is intriguing to see how the modern apron developed. This protective clothing of the stone mason was redesigned by the Moderns in order to look less like that of a workman. The circular bib became more angular to reflect the straight lines of

Figure N8.2

Figure N8.1

architecture. The tassels developed into metal chains that hang on either side of the modern apron.

In the 18th century, the gentry began making their aprons from silk and decorating them with the intricate Masonic designs that we often see presented in Masonic museums *(Figure N7.17)*.

Passing the Chair

Known as 'passing the chair,' the phrase is mentioned in an anonymous poem to accompany Hogarth's *Marriage A-la-Mode*. One verse refers to the alderman who, having served his time as Mayor of London: *'His chain he never ceas'd to wear, To let you know he'd pass'd the Chair.'*

The Antients installed a new Master of the lodge every six months, which provided a flow of elected officers in a more democratic system. The Moderns however, elected their officers for a longer term with an annual investiture around a grand feast.

Traditionally, the six month change of Lodge Officer was based on the saint's days of St. John the Baptist (24 June) and St. John the Evangelist (27 December). These are the 'St. Johns' you hear mentioned in Freemasonry. The move to an

annual investiture was yet another way in which the Moderns were modifying the Christian nature of the Craft.

Note, the Moderns' date of formation is recorded as June 1717. My date of publication is June 2017.

Antients' Complaint of the Tyler

Lawrence Dermott (innovator of the Antients) criticized the introduction of this armed guard by the Moderns. This paid position was intended to bar the entrance of eavesdroppers, and to some extent prevented unwelcome members from the Antient Lodges. Dermott complained about the role of Tyler while making a reference to the lodge's drinking habits.

> *Nor is it uncommon for a Tyler to receive ten or twelve shillings for drawing two sign posts with chalk &c and writing Jamaica (rum) upon one, and Barbadoes (rum) upon the other, and all this (I suppose) for no other use than to distinguish where these Liquors are to be placed in the Lodge. (sic)*
> —Antients' Constitution, (1756 edition).

Tyler Payment Today

In some jurisdictions, the Tyler enters the lodge with his sword drawn demanding payment for his services. The master places a coin on his sword and the Tyler returns to his post. Nowadays, the Tyler is often an elderly member of the lodge who receives a stipend for his position.

'Mop and Pail' - Full Quotation

> *There will be several Lectures on Ancient Masonry, particularly on the Signification of the Letter G and how and after what Manner the Antediluvian Mason form'd their Lodges, shewing what Innovations have lately been introduced by the Doctor and some other of the Moderns, with their Tape,*

Figure N8.3

> *Jacks, Moveable Letters, Blazing Stars, &c., to the great Indignity of the Mop and Pail.* —Quoted in Douglas Knoop, G. P. Jones, and Douglas Hamer, Early Masonic Pamphlets 1945. (London). Also found in F. De P. Castells, The Origin of the Masonic Degrees, (Kessinger, 2003).

Ecce Signum

The barber's sign might also be showing the 'ancient penalty' associated with the first degree *(Figure N8.1)*. 'Having one's tongue cut out by the root' is mentioned in many exposés.

The Barber Might Be the Harlot's Lover

A recent commentator thought that the barber was female because of the strange-looking head adornment. *(Figure N8.2)*

This is just a comb that the barber sticks into his hair when he was not using it. In *A Harlot's Progress*, we see the lover creeping out of Scene 2 with a similar head-piece. Maybe this young barber was well known enough for Hogarth to have made a jest by casting this man as the Harlot's lover.

Appendix to Chapter 8 Concerning the History of the Barber Surgeons:

A fuller account of my research of the Barber Surgeons is published in *Hogarth: 50 New Essays: International Perspectives on Eighteenth-Century English Art, Bernd W. Krysmanski.*

At the time of Hogarth's painting, 'The Company of Barber Surgeons' were going through a similar schism that the Antients and Moderns were experiencing.

Never smooth, the professional relationship between the barbers and surgeons began to show signs of severe distress at the outset of the eighteenth century. … By 1712 the surgeons and barbers were at each other's throats again. —History of the Royal College Physicians and Surgeons in Glasgow, Geyer-Kordesch, (1999).

Ever conscious of his working-class background and his love-hate relationship with the upper classes, Hogarth would have seen this as a similar struggle he could include alongside the Freemasons. Here was another situation in which an elite minority was distancing itself from a more common group of labourers. This was precisely what was happening in the Grand Lodge.

Higher freedom and admission of fines for surgeons served to emphasize their superior status over barbers. —Geyer-Kordesch, ibid.

The surgeons questioned the operational competence of barbers. Barbers were criticised for their rush to bleed patients and their practice of placing dishes of blood on windowsills to advertise their trade *(Figure N8.3)*.

No barbers shall be so bold as to put blood in their windows, openly or in view of folks. —Annals of Barber Surgeons, (Blades, London, 1890).

However, at this time, surgeons legally still had to go to barbers to get shaved and bled as they were prohibited from performing these simple services on each other. I believe the man being shaved is therefore a surgeon.

There was also a law that barbers could not service after ten o'clock. Hogarth is also showing this infraction taking place in his *Night* scenario.

Always one to record a fight, Hogarth must have delighted in illustrating this interesting situation by envisioning a surgeon, frightened at having his throat cut by a dribbling drunk barber!

The Surgeons finally followed their Scottish brethren, who achieved separation from the Barbers in 1722. Their act of separation passed in 1745. Hogarth would have witnessed the struggle, as he was painting *Night* in 1735.

As a printer, Hogarth would have been aware that a copy of the famous Holbein painting of Henry VIII granting a charter to the Barbers and Surgeons had recently been made. The inscription on this print omitted the word 'Barbers' as a snub. The print came out in 1736, the very same year as *Night*.

This inscription, written at a time when the relations between the Barbers and the Surgeons of the company were becoming strained was evidently drawn by a Surgeon who cooly ignored the Barbers throughout. —Annals of the Barber-Surgeons of London. P94.

CHAPTER IX

The Denunciation - Professional Transgressions

In The Denunciation, a pregnant unmarried woman stands before a corrupt magistrate and falsely declares that the father of her unborn child is the dour, miserly dissenter who stands nearby with his arms and eyes raised theatrically upwards. The accuser—who may well be a prostitute—is being coached in her performance by the whispering figure of the real father, who trains her up just as the girl sitting next to the magistrate trains up her puppy. We are invited to imagine that the venal Justice will declare on the pregnant woman's behalf, having already come to some kind of financial arrangement with her. —Tate Gallery Catalogue.

Further Evidence That De Veil Was A Corrupt Magistrate and Sexual Deviant

A stronger case could be made regarding the accusation that De Veil accepted sexual favours from prostitutes in exchange for a favourable outcome in their trials. —Memoirs of the Life and Times, of Sir Thomas Deveil (sic), Knight, (Cooper, London 1748).

Chamber Pot Linked to Fielding's Play Rape Upon Rape (1730)

Another reason for this jibe (which fits better into this reading of the corrupt magistrate) is to be found in Fielding's play *Rape upon Rape (1730)*. It focused on the corruption in the legal and political arena. The play was influenced by the rape case of Colonel Francis Charteris (fondling himself in first scene of Hogarth's *A Harlot's Progress*). The corrupt 'Justice Squeezum' was said to have been inspired by De Veil. Fielding succeeded De Veil as Bow Street magistrate in 1747 and would have known him and his reputation well.

In Act IV of the play, a curse was directed at De Veil's character: *"I must give the justice one wish. May Heaven rain small-beer upon thee, and may it*

Figure N9.1

Figure N9.2

corrupt thy body till it is as putrefied as thy mind." Small beer was a euphemism for urine, hence the chamber pot jibe.

De Veil Walking Down the Streets of London

We have other proof that De Veil was mocked for his simple nature. I discovered his name in John Gay's poem *Trivia*, that contained several elements copied into Hogarth's composition.

You'll sometimes meet a Fop, of nicest Tread,
Whose mantling Peruke veils his empty Head,
At ev'ry Step he dreads the Wall to lose,
And risques, to save a Coach, his red-heel'd
Shoes. —Trivia or a Walk down the Streets
of London (1716), John Gay, (Book Two)

We can see 'the coach,' and the 'red heeled shoes' *(Figure N9.1)*. This French fashion style might have refered to De Veil's father, a French-born Hugenot. De Veil is staggering drunk and so 'dreads the Wall to lose.' John Gay must have had De Veil in mind as his name is cleverly contained in the second line of the verse—with '*veils* his empty head.' This was the very slander that was the focus of the Chapter 9: 'Empty Headed.'

Evidence That Hogarth Fights With De Veil

In 1736, Hogarth found himself at loggerheads with one Sir Thomas de Veil (1684–1746), a justice of the peace and a member of the Lodge meeting at the Vine Tavern, Holborn which Hogarth also frequented. It was this antagonism between the two Brethren that led to the publication of the set of four prints collectively titled 'Times of Day,' of which 'Night' was the fourth. —Yasha Beresiner, William Hogarth: The Man, The Artist and His Masonic Circle, (Pietre-Stones Review of Freemasonry).

Pendant Portraits

The Christening and The Denunciation. Painted at the same time and displaying strikingly similar themes and dimensions. The Christening may well have been executed as a companion-piece to The Denunciation. Both painted in 1729, Oil on canvas they both measure exactly 495 x 660 mm. —Tate Gallery Catalogue.

Double Globes (Figure N9.2)

Denunciation features the double globes on the wall (not visible in the detail shown). The same were hung in the Rake's tavern scene *(Figure N4.6)*. This wall hanging is often seen in depictions of Masonic Lodges of the time. The escutcheon next to it (not shown) is of the form of Freemason's guild as seen in *Sleeping Congregation (Figure*

N7.15). There are also two men on the left of the painting in white gloves observing De Veil. All these elements give weight to the Masonic theme of this pair of paintings.

Orator Henley is a Freemason

'The Freemasons have made choice of Rev. Mr. Orator Henley as their Chaplain.' Printed in Reed's weekly Journal (June, 1733). Also reported in St. James Evening Post (1734). —Ars Quatuor Coronatorum Vol 29. P 368.

Grand Lodge Chaplain was made an official title in 1775. The delay might be explained by Desaguliers preferring science to religion in the early days of Premier Grand Lodge.

Like Desaguliers, Orator Henley was famous for his scientific lectures.

The Christening in the News

In 2016, the Minister for Culture, Matt Hancock, placed a temporary export ban on Hogarth's *The Christening* giving UK buyers the opportunity to match the asking price of £1.2 million.

Also in the news at the time of printing was a headline in the Glasgow Sunday Herald— '*Alexander Naysmith hid secret Masonic symbols in paintings of Robert Burns.*'

In the same month, the *Journal of Clinical Anatomy* revealed that Michelangelo might have concealed sexual symbols in his frescos for the Sistine Chapel.

Henley Drinking in Midnight Modern Conversation

Henley is also identified in Hogarth's *Midnight Modern Conversation (1732)* where he holds court around the punch bowl. The face bears strong resemblance to the other two sightings of the minister in *Sleeping Congregation* and *Christening. (Figure N9.3 showing central character in Conversation, Congregation, and Christening).*

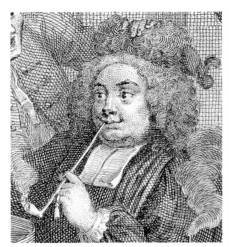

Figure N9.3

Midnight 'Modern' Conversation

We know that two of the men in the scenario were Freemasons, and I am trying to research the others to show that the *'Modern'* in the title was a Masonic reference. There was a complaint that some Modern lodges had no ritual at all, and would therefore just involve a late night dinner.

One character is reading the *'Craftsman newspaper'* (read 'Craft') while smoking *'Freeman's Best'* tobacco, (read 'Freemason'). These seem to have a Masonic connection.

There is the semblance of a square made by the punch ladle and pipe *(Figure N9.4 red lines)*. On the table, another square is made with the bottle and a pipe that does not look like it could balance in that position. It creates a curious shadow.

If you were going to feature a triangle and letter 'G' in the print, you might do no better than the triangular shaped parasol of the oriental character on the punchbowl, and the 'G' shape to the lemon rind beside it.

The figure of the parson, identified as Orator Henley, raises a column of liquid with his ladle, as the gentleman across from him pours his down on his adversary (not shown). This action overlaps a candlestick that is laid down, while the other is

upright. All of this reminds us of the columns up and down listed in Notes to Chapter 2.

The fallen man (identified as the boxer James Figg) might have been hit on the head because he has not been able to prove himself to be a bona fide member of the Moderns. In the painting, he is pointing at the door (whole piece not shown).

A Toast 'To the Whigs'

I believe that Hogarth has painted a glass being raised 'to the Whigs.' Observe that the proposer is holding his wig next to that of Henley, creating the plural. The Moderns were all supporters of that political party.

Henley's White Wig

Henley wears a black wig in this print. The original painting was lost. However, in a copy of the original painting (Paul Mellon Center for British Studies at Yale), Henley's wig is white. One might argue that it was easier to show the 'Toast to the Whigs' idea in the print, when both wigs were black.

In *Sleeping Congregation*, Henley's wig was also originally white (explained on page 117), as it is in *Orator Henley Christening a Child*—further proof that Hogarth was including Henley in the scene.

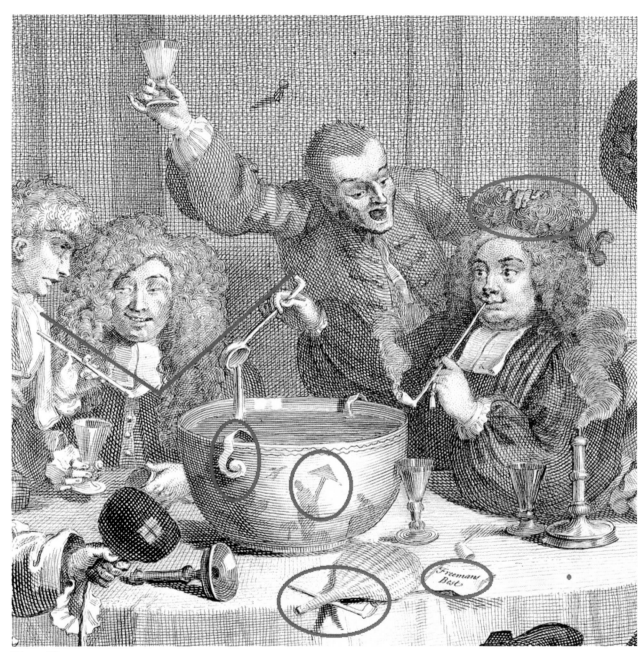

Figure N9.4

It Is Not Midnight in 'Midnight'

I believe the incongruity between the time on the clock and time in the print's title is a Masonic joke.

Both print and painting have the clock showing four in the morning. By adding 4 hours to the time, could Hogarth be playing around with the Modern's recently adopted convention of adding 4,000 years to every date? Adding 4 to 'midnight' would explain the clock showing four o'clock in the morning.

Gosling's 'Dark'n Stormy' Rum Punch

It was this wonderful drinking print that first piqued my interest in the history of Rum Punch. I had been asked to research rum consumption in the 18th century for a presentation I was doing for Gosling's Rum out of Bermuda.

Since that day I have been an advocate for their delicious cocktail known and loved the world over as the 'Dark'n Stormy.'

Were it not for Gosling's Black Seal Rum, I would never been able to finish this research! Thank you, Malcolm!

Paulson on Hogarth's Working Class Roots

Paulson imagines that Hogarth, with his working class roots, felt more affinity to the traditional (Antient) Freemasons than the gentry of Premier Grand lodge:

It is important to note that Hogarth, a Mason by the early 1720s, was one of those who would have seen the transition from operative to speculative Freemasonry from the viewpoint of the operative; he was an apprentice who in effect chose the more prestigious way of Freemasonry over membership in the old guilds. —Paulson.

Graphic Example of Hogarth Disrespecting the Church

Hogarth went in for sheer outrageousness. In the churchyard at Hoo, the painter, needing a bowel motion, with characteristic lack of respect for social niceties, "untruss'd upon a Grave Rail in an unseemly Manner." Evidently this was bad manners even in those less uptight days, as Tothall, "administered penance to ye part offending with a Bunch of Nettles." This painful lashing of Hogarth's buttocks led to a fight, "which Ended happily without Bloodshed and Hogarth Finish'd his Business against the Church Door." —Martin Gayford, 'Hogarth and the lads go out on the town,' (Telegraph, 27 Jan 2007).

Steward's Lodge Argument

We hear of a disruption to the formation of Lodge of Stewards which resulted in 'the closing of Grand Lodge without a decision.' This also might have been a final cause of exacerbation for Hogarth just before he left the Fraternity. I intend to study this in greater detail.

CHAPTER X

Captain Graham's Cabin

I am not the only person to find Hogarth hiding in his own work. Bernd W. Krysmanski, a prodigious Hogarth scholar, found a character resembling the artist in the painting *Captain Graham's Cabin (1745) (Figure N10.1)*. Hogarth sits at the table, as his pug dog conducts a singer.

I will let Bernd explain why Hogarth was sitting with these fellow Masons in his book: *Hogarth: 50 New Essays: International Perspectives on Eighteenth-Century English Art (soon to be published).*

Another must-read for a comprehensive list of all Hogarth's more titillating details is *Hogarth's Hidden Parts, Bernd Krysmanski, (Georg Olms Verlag*

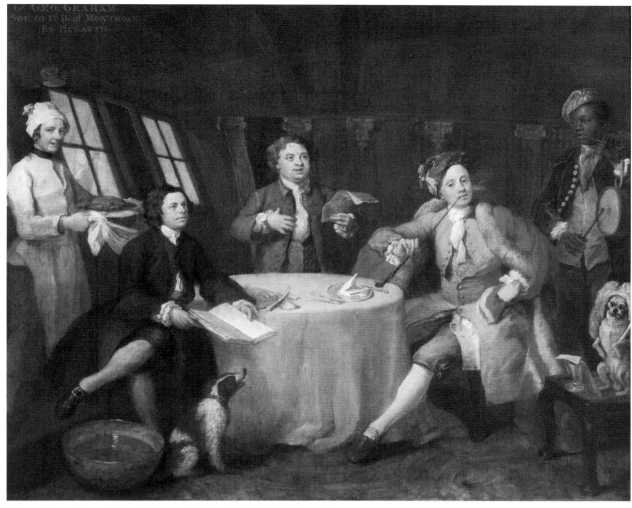

Figure N10.1: **Captain Lord George Graham in his Cabin (c.1745).**

AG, 2010). Bernd also has a website that lists all recent scholarly work in the field.

I am very grateful to Bernd for allowing me to include his discovery here, because it shares a trait with the three self portraits of Hogarth that I have found.

Observe the plate of food which the chef is carrying *(Figure N10.2).* The gravy is pouring down Hogarth's back! Hogarth has made himself the centre of a conversational piece by being the butt of his own joke.

In *Morning,* I believe Hogarth has included himself cavorting with a prostitute, and in

Figure N10.2

the Harlot's funeral we find him in a comedic, post-coital situation. In *Sleeping Congregation*, he is in the act of dropping a rose, and now we have him pictured with gravy being poured down his back. These scenes all feature the artist in self-deprecating situations, evidence that he was quite happy to include himself in such a humorous fashion.

While these details brought attention to his character, no one recognised his likeness. Many still think there is an 'unidentified minister' in Captain Graham's cabin. For centuries, critics thought that 'a funeral director' was pulling off the prostitute's gloves in the Harlot's funeral scene. It is amazing that the artist famous for catching likeness could not catch his own!

I refer you to Elizabeth Einberg's *Complete Catalogue of Paintings* which gives a fascinating link of Captain Graham to the Freemasons. Hogarth and Graham were both nominated as Grand Lodge stewards in the 1734, but only Hogarth took up the post. This enabled Hogarth, in the persona of his ubiquitous pug, to orchestrate the evening with his steward's 'staff.'

Hogarth's pug dog conducts the singer who has been identified as fellow Freemason, John Pine. The song was apparently well known at Grand Lodge.

When one brings all these details together, the cases made by both Krysmanski and Einberg give one another more weight.

Summary of Hogarth's Masonic Works

1724 *Gormogon* : anti-Wharton (likeness) anti-Red Degree (ladder, monkey, mop and pail)

1724 *Bad Taste of the Town* : anti-Kent (KNT) anti-Burlington (foreign tastes) anti-Red Degree (signs and letter on column)

1725 *Burlesque* : anti-Kent (art) anti-Burlington (Sobieska) anti-Jacobite (Sobieska)

1725 *Royalty, Episcopacy and the Law* : anti-Jacobite (Pope and Mallet).

1725 Hogarth was made a Master Mason

1726 *Hudibras* : Masonic signs.

1728 *Sleeping Congregation (painting)* : Mark Master sign, anti-Henley (lech)

1728 *Denunciation* : Grand Hailing sign

1729 *Wanstead Assembly* : anti-Burlington (connect to Red Degrees), anti-Kent (herm)

1731 *A Man of Taste* : anti-Burlington (gates) anti-red (crescent) anti-Jacobite

1732 *A Modern Midnight Conversation* : details

1732 *A Harlot's Progress* : pro-Grand Lodge (signs)

1734 *A Rake's Progress* : anti-Kent, anti-Burlington (sodomy) anti-Burlington (many other references) anti-Red Degrees (3 lights) anti-Jacobite (James jail, Orrery)

1736 *Sleeping Congregation (print)* : anti-Premier Grand Lodge (deChristianise) anti-Desaguliers (bore), anti-Henley (lech, drinker)

1736 *Night* : anti-De Veil, anti-Grand Lodge

1739 *Hervey's Friends* : anti-Desagulier (balance, gate shut and globes)

1739 *Indian Emperor* : anti-Desagulier (prompter) anti-Premier Grand Lodge (play)

1745 *Captain Graham's Cabin* : Steward's detail

1747 *Industry and Idleness* : many obvious Masonic details not covered in this book

1755 *An Election Entertainment* : Masonic details covered in my article for British Art Journal, (Winter 2015 Vol.15).

1764 *Bathos* : pro-Premier Grand Lodge (chariot)

Hogarth's work with Jacobite themes include *The Stage Coach (1747)(not discussed); March to Finchley (1750) and Invasion (1762).*

Note: I have not included several other of Hogarth's work with Masonic details because they did not fit into the flow of this book. I will be covering them in subsequent publications.

Trompe L'Oeil and Visual Tricks

Hogarth loved *trompe l'oeil*, and actually created *Satire on False Perspective (1754)*, showing some that he would then use within his work *(Figure N10.3)*. Here is a list of those I found within Hogath's work:

Figure N10.3: Satire on False Perspective, (1754).

1.13 cleavage; *2.4* darkness to light; *2.5* nails for knocks; *2.13* hat on axe; *2.25* jailor's hat; *3.11* looking up skirt; *3.18* chamberpot 'G;' *5.3* oil and horse; *5.5* fencer challenge; *5.9* penis in scroll; *5.14* penis in pants; *5.15* 'horible' Bible; *6.11* penis in Castlemaine; *7.6* fart catcher; *7.15* telescope; *7.17* angel; *8.7* foot position; *8.8* hidden letter; *8.9* hidden foot; *8.11* monkey holds mop; *8.12* cross; *8.14* square; *8.15* Pythagoras; *8.17* square and compass; *9.3* 'barrel head;' *9.5* Grand Hailing Sign ; *9.6* hand on breast; *9.9* drinking cup; *10.12* peachy bum; *11.3* Cumberland; *N2.8* swords at heart; *N2.15* mallot up skirt; *N2.18* between columns; *N3.1* locks for knocks; *N3.3* dagger up skirt; *N4.2* black on white; *N4.5* candle in mirror; *N4.9* James III; *N4.10* SH; *N4.12* oral sex; *N5.2* guttering candle; *N5.3* shadow (found by Einberg); *N5.4* arrows of light; *N5.7* shadow *N7.11* hair curls; *N7.17* triangle; *N5.11* web underlines vault; *N9.4* midnight Square and Compass; *N9.4* Whigs.

Word Play

2.21 virgin; *2.19* 'revoking' the Nantes; *7.17* 'Dieu et mon droit;' *2.20* Tubal Cain; *3.2*; grip; *5.10* 'Will Stab;' *10.2* complete tits; *N2.1* York gone; *N2.26* owls for trowels; *N7.1* East and ape; *N7.4* Pope and Mallet; *N7.19* dormouse; *N8.1* 'beware' sign.

List of Characters Exposed

1.2 Sir James Thornhill; *1.10* Inigo Jones; *2.19* Desaguliers; *2.24* William Hogarth; *3.15* Lord Burlington and William Kent; *4.4* Lord and Lady Burlington; *4.9* Queen Sobieska; *5.1* Burlington *5.12* young Burlington; *6.3* Kent; *7.6* Desaguliers as fart catcher; *7.14* Desaguliers with Henley; *9.8* Orator Henley; *10.4* William Hogarth; *11.3* Duke of Cumberland; *N1.10* Duke of Wharton; *N7.4* Alexander Pope and David Mallet; *N4.9* James III; *N7.3* James II; *N9.11* Charles Edward Stuart.

Figure N11.1

EPILOGUE

On March to Finchley (1750)

The Jacobite Journal (held by the catholic woman) was actually a satirical publication by Hogarth's friend Henry Fielding.

The *Oxford Student* of 1751, notices another character: *'A fine gentleman of the army, as I suppose the painter deigned him without character, I shall therefore only observe that he is a very pretty fellow and happily the contemplation of his own dear person, guards him from the attempts of the wicked women on his right.'*

Could this be Bonnie Prince Charlie? Tradition has it that he secretly visited Britain in order to promote the cause. I compare his features to a portrait to show the long neck, tight neck stock, and fine features (*'a very pretty fellow'*) for which he was famous *(Figure N11.1)*. Notice his hat ribbon, unlike any other I have seen, is in the shape of a crescent moon!

The other characters around the Prince are all interrelated within a rather complex narrative. I have drawn red boxes around these figures, showing their interactions. In comparison, I have drawn a red oval around the one person who is unconnected to them and stands erect and focused, as if he is spying on the muster *(Figure N11.2)*.

Jacobite Plots and Risings

– Ailesbury plot (1691), Fenwick plot (1695), Assassination plot of 1696 (against William of Orange).
– Atterbury plot (1722), Cornbury plot (1733), Elibank plot (1749).
– Jacobite risings of 1689–92, 1715, 1719, 1745.
– Additional planned invasions of 1708, 1744 and 1759.

Freemasonry Used As A Political Instrument

The Lodges in France naturally became the rendezvous of the adherents of the exiled king, and the means of carrying on a correspondence with their friends in England.

The Jacobites quickly came to see the Masonic Lodge as a fitting vehicle by which to accomplish their political aims.

They saw Masonry as a perfect channel to promote the Stuart cause and bring about the restoration of the Stuarts to the British throne. Behind the convenient wall of Masonic secrecy they pursued their revolutionary goals.

—John Robison, *Proofs of a Conspiracy (1798).*

Premier Grand Lodge Is A Huguenot Conspiracy

No group was more against the threat of a French invasion than the Huguenots (French Protestants). The first Grand Master of Grand Lodge, Anthony Sayer, was a Huguenot exile, as was Desaguliers.

The first 'noble' Grand Master, The Duke of Montagu was also of Huguenot stock. Montagu's grandmother was a French Huguenot, and met Montagu's grandfather when he was Ambassador to Paris.

De Veil's father was also a French Huguenot which might explain his red heeled shoes in *Night*. Zenophobic Hogarth seemed to hate French-born Desaguliers and De Veil.

On Inoculation

Inoculation was introduced into England during the reign of George I, who had put a definite end to the royal touch in his kingdom. The royal family strongly supported it, but it was controversial medically as well as politically and theologically. The medicine historian Adrian Wilson described it as "the Whig and Hanoverian equivalent of the Stuart practice of touching for scrofula … But whereas the Royal Touch mobilised divine powers, based on hereditary right, inoculation deployed natural powers harnessed by man, with the monarch as the benevolent onlooker rather than indispensable participant.

The Whig politician Lord Macaulay (1800–1859) ridiculed the 'Royal Touch' as an 'absurd superstition of a pre-enlightened age.

Voltaire (1694–1778) scornfully wrote that he had lost confidence in the royal touch upon hearing that a mistress of Louis XIV died of scrofula "despite being very well touched by the king!"

—Wikipedia.

On Superstition

The contrast between old world superstition and modern science is perfectly illustrated by Hogarth's print, *Credulity, Superstition and Fanaticism (1762) (Figure N11.3)*. It was one of his final prints, which Horace Walpole claimed was his greatest. *'It surpaseed all his other performances and would alone immortalize his unequalled talents.'*

Freemasons, Science and Politics

In his *Preface to 'Foundations of Freemasonry,'* Ric Berman unwittingly gave me some encouragement in connecting the Grand Lodge to the Scientific Revolution and the Hanoverians.

[There is a] need for a detailed examination of the economic, social, political and intellectual background to the establishment of modern English Freemasonry in the early decades of the 18th c. and for the subject to be placed in a broader historical context.

Many books have been written on the supposed origins of Freemasonry but relatively few on its intimate connection with the development of the Scientific Enlightenment and the political changes that accompanied the Hanoverian accession and its Whig ministries.

—Ric Berman.

Revolutions in America and France

Historians give much credit to one man for getting French support for the American Revolution—Benjamin Franklin. Stacy Schiff's book on *Franklin, France and the Birth of America* tells this amazing story of how the scientist and statesman was able to gain access to the court of Louis XVI and persuade it to fund the Revolution.

There is much evidence that shows how Freemasonry allowed Franklin quick access to influential aristocrats. He was a Grand Master of the Grand Lodge of Pennsylvania, and reprinted the Constitutions of the Premier Grand Lodge in the colonies (1734). He was Master of a Lodge in Paris ('Loge des Neuf Sœurs') and inducted Voltaire. Many scholars surmise that if it were not for Franklin's Freemasonry, he would never have received the support of the French nobles, and Royalty would not have backed the American Revolution.

It was the huge financial support of the Revolution that bankrupted France, and this sowed the seeds for the revolution on French soil that eventually deposed the monarchy there.

Hogarth would have been delighted if had lived long enough to know that France fell. He would have been interested to know that Franklin was an instigator, as these two great men were friends.

In fact, if we were to end this book by describing the last minutes of Hogarth's life, we would find him writing to none other than Benjamin Franklin. Hogarth was half way through writing a letter to Franklin when he died.

FINIS

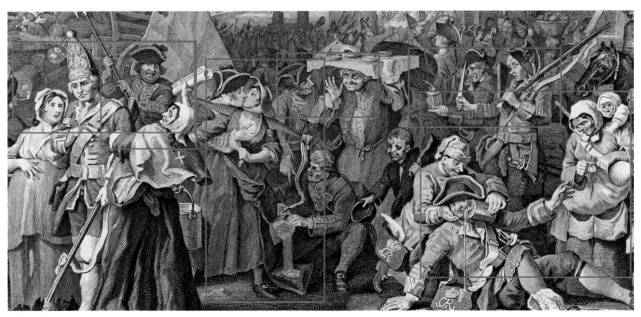

Figure N11.2

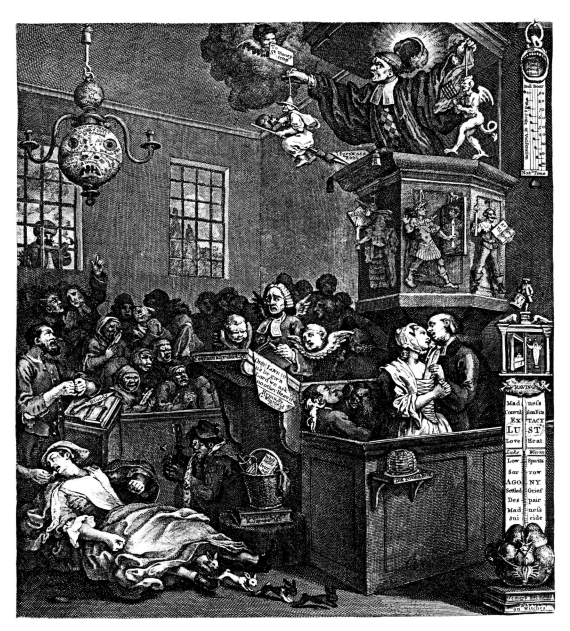

Figure NII.3

Index of Books
MODERN SOURCES

Barnard, Toby and Jane Clark: Lord Burlington: Architecture, Art and Life. Hambledon Press, 1995.

Bell, Jeremy: British Art Journal, 'An Election Entertainment' Winter 2015 Vol.15.

Bell, Jeremy: British Art Journal, The Freemason's harlot : William Hogarth's Harlot's Progress in a masonic light, British Art Journal, Vol. 16, 2015.

Bell, Jeremy: Hogarth's Night, one of the essays in Krysmanski's *Hogarth: 50 New Essays: International Perspectives on Eighteenth-Century English Art. (Publish date to be announced.)*

Bell, Jeremy: Article in 'The Trowel' : Magazine of the Grand Lodge of Massachusetts, Boston. 2015.

Berman, Ric: The Foundations of Modern Freemasonry—The Grand Architects. Sussex Academic, 2012.

Berman, Ric: Schism—the Battle that Forged Freemasonry. Sussex Academic, 2013.

Bindman, David: Hogarth and His Times. UCA Press, 1997.

Clark, Jane: 'Lord Burlington is Here' Chapter in Lord Burlington: Art, Architecture and Life, edited by Toby Barnard, Jane Clark. Hambledon Press, 1995.

Corp, Edward (Ed) Lord Burlington: The Man and his Politics: Questions of Loyalty. Lampeter, 1998.

Einberg, Elizabeth: William Hogarth, A Complete Catalogue of the Paintings. Yale, 2017.

Harrison, David: The Genesis of Freemasonry. *Lewis Masonic, 2009.*

Hoyos, Arturo de: Light on Masonry: The History and Rituals of America's Most Important Masonic Expose. Scottish Rite Research Society, 2008.

Krysmanski, Bernd: Hogarth's Hidden Parts, Georg Olms Verlag AG, 2010.

Krysmanski, Bernd: (Editor) Hogarth: 50 New Essays: International Perspectives on Eighteenth-Century English Art. (Publish date to be announced.)

Mowl, Timothy: William Kent: Architect, Designer, Opportunist. Pimlico, 2007.

Paulson, Ronald: Hogarth: His Life, Art and Times. Yale University Press, 1971.

Paulson, Ronald: Hogarth. Rutgers University Press, 1991-3.

Roman, Cynthia Ellen (Ed): Hogarth's Legacy. Yale, 2016.

Shesgreen, Sean: Engravings by Hogarth. Dover, 1973.

Shesgreen, Sean: Hogarth and the Times-Of-The-Day Tradition. Cornell, 1983.

Soulier-Détis, Elisabeth : 'Guess at the Rest:' Cracking the Hogarth Code. Lutterworth, 2010.

Stevenson, David: The Origins of Freemasonry: Scotland's Century, 1590 to 1710. Cambridge, 1990.

Simon, Robin: Hogarth, France and British Art. Holberton, 2011.

Jenny Uglow: William Hogarth: A Life and a World. Faber, 1998.

Knoop, Jones, Hame: Early Masonic Pamphlets. London, 1945.

William Kent: Designing Georgian Britain: Victoria & Albert Museum Exhibition Catalogue, 2013.

Biography of William Kent: Victoria and Albert Museum. Accessed February 8, 2015.

EXPOSES AND OLDER BOOKS

Anderson's Constitutions, 1723 and 1738.

Allyn, Avery: A ritual and illustrations of freemasonry accompanied by numerous engravings. Reeves, 1880.

Duncan, Malcolm C : Duncan's Masonic Ritual and Monitor, 1866.

Dundee Manuscript, 1727.

Ireland, John: Hogarth Illustrated. London, 1793.

Jachin and Boaz, 1762.

Mackey, Albert Gallatin: An Encyclopaedia of Freemasonry and its Kindred Sciences. Everts, 1894.

Morgan, William: Morgan's Freemasonry exposed and explained, 1882.

Prichard, Samuel: Masonry Dissected, 1730.

Preston, William: Illustrations of Freemasonry, 1795.

Three Distinct Knocks, 1760.

Trusler, Rev. John: Hogarth Moralized. London, 1768.

Timbs, John: Anecdotal Biography, 1860.

Walpole, Horace: Anecdotes of Painting in England (1762–71). London, Murray, 1887.

Paintings

IDENTIFICATION, AND LOCATION

All Hogarth prints public domain from Wikimedia Commons.

Other works a combination of copyright free from Library of Congress, author's own collection, books published before 1923, public domain and requested downloads from the British Museum.

Please contact author with any concerns. Better quality illustrations will appear in proposed 2nd edition with permission from galleries for higher resolution copies.

1.1 Sleeping Congregation (1728)—Minneapolis Institute of Art, MN, USA.

1.3 Detail from self portrait of Thornhill from the St Paul's Cathedral collection.

1.10 Inigo Jones (left) from ceiling painting from Chiswick Villa. Photo credit Ricky Pound.

1.20 Illustration for 'Jack Sheppard' written by William Ainsworth, 1839. Illustration by George Cruikshank (1792–1878).

2.1 A Harlots Progress. Prints coloured. Narrative taken from Royal Collection.

2.21 'Father Time and the Virgin,' by Amos Doolittle (1754–1832). From True Masonic Chart, Jeremy Cross (1819).

2.23 Hogarth Self portrait, c 1735. Yale Center for British Art, Paul Mellon Collection, CT.

3.1 A Rake's Progress, Sir John Soane's Museum, London.

3.15 (illustration #2) and 4.1 (illustration #2) and 4.8 : 'Man, probably Burlington. Attributed to William Aikman,' from a Christie's Catalogue.

Ricky Pound alerted me to a copy of the portrait (without the bible or canal background) owned by the Orleans House Gallery, Twickenham. (Discussed in Notes to Chapter 4.)

3.15 (illustration #4) and 4.7 Portrait of Richard Boyle, 3rd Earl of Burlington, Jonathan Richardson (1667–1745), National Portrait Gallery, London.

4.1 (illustration #3) and 6.6 William Kent (1723), by William Aikman (1683–1731). National Portrait Gallery, London.

4.1 (illustration #4) Thomas Coke, 1st Earl of Leicester (fifth creation), Francesco Trevisani, (1656–1746). Location unknown.

4.4 Assembly at Wanstead House (1728–1731). The John Howard McFadden Collection, Philadelphia Museum of Art, PA.

4.5 Rt. Hon. Richard Boyle and Lady Dorothy Savile (1723), William Aikman (1683–1731). Harris Museum and Art Gallery, Preston, England.

4.9 Detail of Putti at Chiswick Villa (also in 'open buildings' website). Photo credit Ricky Pound.

4.10 Cascade at Chiswick, England. Photo credit Ricky Pound.

4.11 Tribunal Salon, Chiswick Villa, London. Photo credit Ricky Pound.

4.12 Ceiling from Blue Velvet Room, Chiswick Villa, attributed to William Kent. Photo credit Ricky Pound.

4.13 Detail from Charles Boyle, 2nd Earl of Burlington (1660–1704); with Evelyn Pierrepont, 1st Duke of Kingston-upon-Hull and John Berkeley, 3rd Baron Berkeley of Stratton, by Sir Godfrey Kneller (1646–1723). Private collection.

5.16 Detail from George Henry Lee, 3rd Earl of Litchfield, and his Uncle the Hon. Robert Lee, Subsequently 4th Earl of Litchfield, Shooting in 'True Blue' Frock Coats, (1744) John Wootton (1682–1764). Tate Britain.

5.18 Walpole Salver—Victoria & Albert Museum. Made by Paul de Lamerie, (1688–1751), engraved by William Hogarth. Inherited by Horace Walpole.

6.1 A Burlesque on Kent's Altarpiece at St.Clement Danes (c.1725). Original by Kent destroyed in fire during Blitzkrieg.

6.2 Details from various paintings by William Kent.

6.3 Detail from Wanstead Assembly.

6.5 Portrait of Kent (1718) by Benedetto Luti (1660–1724). Chatsworth House, England.

6.13 A Medusa in the marble fireplace in the drawing room of Kensington Palace, along with garlands of acorns (Jacobite symbol).

6.15 George Lambert and Hogarth—View from Cascade Terrace, Chiswick Villa (1741). .

7.1 The Man of Taste or Burlington Gates (1731).

7.7 A Performance of 'The Indian Emperor or The Conquest of Mexico by the Spaniards' (1732–1735). Private Collection.

7.12 The Hervey Conversation Piece (c.1740). Ickworth, The Bristol Collection, National Trust.

9.5 The Denunciation (1729). National Gallery of Ireland, Dublin.

9.6 The Christening (1729). Private collection.

9.10 and 9.11 Details from portraits by Hogarth of two unidentified men. National Gallery of Ireland, Dublin.

9.7 Sketch of The Christening. British Museum.

9.12 Details from Woodes Rogers and his Family (1929). Caird Collection, National Maritime Museum, Greenwich, London.

9.13 Detail from The Popple and Ashley Families (1730). Royal Collection Trust.

9.15 Illustrations for Samuel Butler's 'Hudibras' Plate 6 Hudibras in Tribulation.

9.17 Hogarth Jewel, designed for Grand Stewards (1735). Worn today by Pro Grand Master.

9.19 Detail from Thornhill's sketch of his family. The Burghley House Collection, England.

9.20 and 9.21 from Hogarth's Five Days Frolic or, Peregrinations by Land and Water. Illustrated by Tinted Drawings, made by Hogarth and Scott during the Journey. Republished, Nabu Press (2010)

10.1 Four Times of the Day: Morning, Noon, Evening, Night (1736). Tate Britain, London.

10.5 The Discovery (1743). The British Museum, London.

10.6 Detail from 'Plan de la loge des Mopses' from L'ordre des Franc-Maçons trahi et le Secret des Mopses révélé (1745).

10.10 Sir Francis Dashwood at his Devotions (1739). Private collection.

10.11 St. Francis Meditating (c. 1595). El Greco (Domnikos Theotokpoulos), (1541–1614). Fine Arts Museums of San Francisco, CA.

10.13 Charity in the Cellar (1739). Private collection Print engraved by William Satchwell Leney (1769–1831). Published by Baldwin and Cradock. (1822). Original Plates restored by James Heath.

11.1 The Invasion: France (Plate 1) (1756).

11.2 March to Finchley (1750). Thomas Coram Foundation for Children, London.

11.4 H.R.H Prince William, Duke of Cumberland. Mezzotint by John Faber Jnr. (1684–1756). From painting by John Wootton (1682–1764) and Thomas Hudson (1701–79).

PAINTINGS IN NOTES

N1.3 Desaguliers (1683–1744). Engraving listed as by Peter Pelham (1695–1751) after an original painting by Hans Hysing (1678–1753).

N1.8 François de Poilly the Younger after Charles Coypel (1694–1742). Les Principales Aventures de L'Incomparable Chevalier Errant Don Quichotte de la Manche (Miguel de Cervantes).

N1.11 John Sheppard by George White, after Sir James Thornhill. Mezzotint, (c. 1724).

N5.1 Horace Walpole age Ten (1728–29). Private collection.

N5.2 A Night Encounter: Lord Boyne and Sir Edward Walpole outside a Tavern (1738–39). Boyne collection, Ireland.

N5.3 The Cholmondeley Family (1732). Private collection.

N5.4 Detail from Humours of an Election Series, (1755). Sir John Soanes Museum, London.

N7.10 Diana and Endymion (1713), Sebastino Ricci (1659–1734). English Heritage, Chiswick Villa. Installed 1729.

N7.13 Tit for tat, or W. Hogarth esq. by Paul Sandby (1731–1809), printed by J. Pridden.

N10.1 Captain Lord George Graham in his Cabin (c.1745). National Maritime Museum, London.

N11.3 Credulity, Superstition, and Fanaticism: A Medley (1762).

Time Smoking a Picture, (1761).